THE
CAMPUS
AS A
WORK
OF ART

THE
CAMPUS
AS A
WORK
OF ART

Thomas A. Gaines

PRAEGER

New York
Westport, Connecticut
London

Library of Congress Cataloging-in-Publication Data

Gaines, Thomas A.
 The campus as a work of art / Thomas A. Gaines.
 p. cm.
 Includes bibliographical references and index.
 ISBN 0-275-93967-7 (alk. paper)
 1. Campus planning—United States. 2. Universities and colleges—
United States—Buildings—Planning. I. Title.
 LB3223.3.G35 1991
 378.1'962—dc20 91-8027

British Library Cataloguing in Publication Data is available.

Library of Congress Catalog Card Number: 91-8027
ISBN: 0-275-93967-7

First published in 1991

Praeger Publishers, One Madison Avenue, New York, NY 10010
An imprint of Greenwood Publishing Group, Inc.

Printed in the United States of America

The paper used in this book complies with the
Permanent Paper Standard issued by the National
Information Standards Organization (Z39.48-1984).

10 9 8 7 6 5 4 3 2 1

for Kay,
who allowed me to plagiarize
her fresh and cheerful thoughts
as we criss-crossed this land

Contents

Introduction		ix
1	What Makes a Successful Campus?	1
2	The Campus Components	13
3	The Urban Campus	49
4	Contemporary: The Whole-Cloth Campus	61
5	Regionalism	75
6	Disappointments and Missed Opportunities	115
7	The Campus as a Work of Art	121
Appendix: The Top Fifty Campuses		155
Bibliography		157
Index		163

Introduction

The first thing to know about the campus as a work of art is this: It rarely is.

Unlike the two-dimensional art of painting, the three-dimensional art of sculpture, and architecture, in which the fourth dimension is function, a campus has a fifth dimension: planning. The well-planned campus belongs among the most idyllic of man-made environments and deserves to be evaluated by the same criteria applied to these other works of art. Yet it remains an uncelebrated art form. The creative impulse that produced the collegiate-built environment has not been recognized by art critics and historians.

Seeing the college campus as a work of art should not require an especially refined cognition. This work sets out to show that campus design has as much claim on our artistic attention as other such unique American creations as the skyscraper and the musical comedy.

The enemy of a well-designed campus in the United States is the lack of aesthetic tradition that pervades even the civilized halls of the academy. (Students can always study music appreciation, but how often are they offered a course in visual taste?) This is why our colleges produce educated but uncultured citizens—historians who lack visual appreciation, mathematicians who do not go to museums, biologists who live in unlovely homes. "The richness of Wesleyan's curriculum results from the conviction that things intellectual should be partnered by things emotional and physical,"

says Professor Richard Winslow. But what about things cultural? The truth
is that much of America is artistically brain dead.

If the donor of a campus building is stronger in finance than in refinement
and wants a say in how his or her structure should look, the college should
know better. Alas, it usually does not. Thus most of the 2,000 four-year
colleges and universities in the United States are condemned to visual
mediocrity. As *Architectural Forum*'s Aymar Embury II summed it up,
"The average American university is an architectural mess."

Mitigating this melancholy conclusion is the fact that a few excellent
campuses do exist. (Frederick Law Olmsted, the nineteenth-century land-
scape architect, and his successors consulted on 150 campuses.) Further-
more, most have "places" that look like a practiced hand has passed
through. Some perfect spatial moments on otherwise disappointing cam-
puses include Washington University's glorious Gothic entry; UCLA's
Pergamene sculpture garden; Smith's landscaped library green; the tree-
studded, barn-sided atrium at Governors State University; the University of
Chicago's Olmsted-designed Botany Pond; MIT's McDermott Place, where
the Green Science Building redistributes space; the University of Illinois at
Chicago's rooftop amphitheater; and the landscaped dell between Iowa
State's union and bell tower—all of which we will meet again in this book.

Indeed, the college campus has an ambience all its own. Like the historic
village, the world's fair, the theme park, it is a place we want to go to, be in,
identify with; there is a there there.

When we visit a campus, we want to lock step with the students on their
hurried way to class; we want to see the faculty show at the college art
museum; we want to sign petitions for whatever causes currently occupy
the student consciousness. We want to scan the panoply of campus struc-
tures and warp through architectural time—the original schoolhouse in
Georgian style, the Greek Revival education building, the Victorian liberal
arts hall.

What follows is an attempt to enhance the appreciation of campus
making as an artistic discipline. It is one observer's estimation of successful
and not-so-successful campuses and how they got that way.

THE
CAMPUS
AS A
WORK
OF ART

1

What Makes a Successful Campus?

The period which abandons the style at its disposal soon finds itself
empty-handed.

André Malraux

While universities in England and throughout Europe were large and cen-
tralized, in North America the mandate for democratic growth called for
the creation of many small colleges accessible to all. Thus in the nineteenth
century, every railroad siding seemed to lead to a campus. Ohio had 37
colleges by 1880; Kentucky had 11, Illinois 21, Iowa 13. At the same time,
England, with a population of 23 million—several times that of these
states—supported only four degree-granting institutions. The college mor-
tality rate in the United States, was high, however. By 1860, some 700 had
come and gone.

In their haste to open these new democratic schools, most administrations
forgot that a concern for aesthetic vitality is crucial to developing any cul-
tural center. Hence they never defined the qualities that make for an attrac-
tive campus. What then are these qualities? What does it take for a college
ground to be a work of art? This book will attempt to say. For starters, here
is one definition: A good campus consists of a group of harmonious
buildings related by various means (such as arches and landscaping) that

create well-proportioned and diverse urban spaces containing appropriate furnishings—benches, pools, fountains, gazebos, and walkways.

Observers with a trained eye—architects, planners, artists—will agree on whether a building is or is not well designed, since they are judging professionalism. But they will differ on whether or not they like the work, for now taste is involved. "All architecture is what you do to it when you look upon it," Walt Whitman put it.

Accordingly it is possible to establish objective criteria for good campus design—ideals to measure against. Once we do so, the beholder's taste (in this case, mine) will then certainly intrude, but in a secondary way. Shakespeare acknowledged as much when he said, "Beauty is bought by judgement of the eye."

Of the many elements that make for good design, what must be regarded as the sine qua non of fine campus work is space. Space undelineated is a void; William Blake's character Los says, "Space undivided by existence struck horror into his soul." (Blake, by the way, hated the academy.) We do, on the other hand, like well-proportioned areas bounded with grace and consistent style. While architecture deals with interior space and the effect of particular buildings, overall campus planning must be concerned with

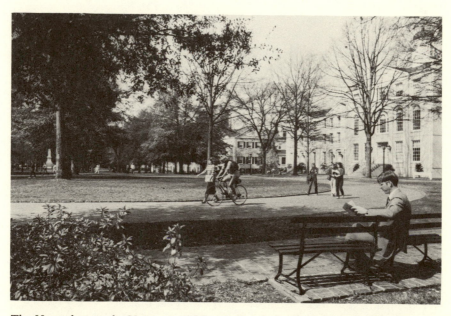

The Horseshoe at the University of South Carolina is one of campusdom's perfect spaces—perfect by dint of outdoor scale, landscaping, and unusual Federal architecture. (Courtesy of the University of South Carolina)

outdoor or urban space and how architectural elements work with each other. "Every cubic inch of space is a miracle," Whitman said.

Urban space is reactive. It results from the placement of structures—buildings, monuments, towers, landscape furnishings. And it is planning that determines whether a campus will be Oxbridge quadrangles, plantation greens (like the University of Virginia), an informal land-grant spread, a disciplined Beaux Arts axial, a no-holds-barred modern, or the very latest style: nonplanning take-it-as-it-comes. (Quadrangles and other core spaces have colorful local designations: the Oval at Michigan State University, the Heart at Earlham College, the Yard at Harvard, the Pasture at the University of Wyoming, the Crescent at Indiana University at Bloomington, the Horseshoe at the University of South Carolina, the Lawn at the University of Virginia, the Meadow at Mills College, the Plaza of the Americas at the University of Florida.)

In any case, it is attractive urban space that a campus must have to succeed as a work of art. If this is accomplished with less than first rate structures, the campus may still work (e.g., the University of North Carolina at Asheville). The reverse, however, will not work. Poorly designed spaces bounded by good buildings do not a campus make. America's great campus builders understood this—Benjamin Latrobe; Robert Mills; James

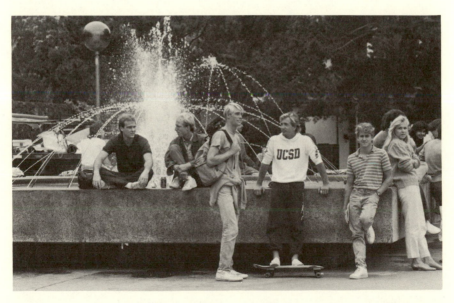

Outdoor furnishings like this Revelle Plaza fountain at the University of California, San Diego, divert the eye and provide student meeting places. San Diego has many such highlights on its campus. (Alan Decker)

Renwick; A. J. Davis; Walter Cope; Charles Coolidge; Ralph Adams Cram; Charles Klauder; Cass Gilbert; the Olmsteds; Stanford White; William Pereira; John Carl Warnecke; Thomas Church; Walter Netsch; Hugh Stubbins; Harry Weese; the firm Caudill Rowlett Scott; Edward Larrabee Barnes; and I. M. Pei.

It all boils down to the proper manipulation of buildings, fences, plantings, gazebos, monuments, and walkways while respecting natural phenomena like hills, trees, and water courses. If the spaces relate to the enclosing elements (not too small, making an elevator shaft; not too large, creating a void), if the expanses shoulder through, open out, and curve around their structures, then they will provide an ever-changing, ever-interesting movement. Speaking of ever-changing, the botanical parts of the campus plan have a way of growing, and this alters the way the various elements relate to one another. In the past 50 years, for instance, the tree-lined mall at Notre Dame has become a forest, hiding the character of the structures that outline it.

Sometimes a focus or signature will make the whole more legible—the castle at Brandeis; the clock tower at the University of Texas; the amphitheater at the University of Illinois at Chicago; the "dimple" at Wheaton College in Massachusetts; the free-standing church steeple at Amherst; the cannon at Princeton; the anemometer at Hampshire College; Norman Tower at Regis College in Massachusetts; Mary Lyon's grave at Mount Holyoke.

To succeed as a work of art, a campus should be the collaborative product of social scientists, planners, architects, landscape designers, scholars, and naturalists. But too often a campus's aesthetic development has more to do with immediate needs, the college administration's artistic sense (if any), the success of frenetic fund raising, and, sad to say, chance.

This depressing scenario may be less true now than in the past. Early American campus "planners" began with one building and a vague idea for a future quadrangle. (Berea College holds the record for most humble beginnings: a tiny log cabin in the Cumberland Mountains of Kentucky. This tuition-free college is dedicated to educating poor Appalachian students and is surely the only school that rejects students if they can afford to pay.) Few of the earliest planners anticipated what would happen after the first structure. That is why today's old campuses like Harvard and Brown have ragged edges and creep amorphously into neighboring cities. (In spite of this, Brown and the nearby Rhode Island School of Design have not had a deleterious effect on Providence's adjacent residential area. "College Hill" is still the location of choice after 100 years—a unique example of neighborhood stability.)

As the main delineators of urban space, buildings should be concerned less with surface and more with volume. In our enchantment with slick facades, we have forgotten that walls are not an end but merely the means

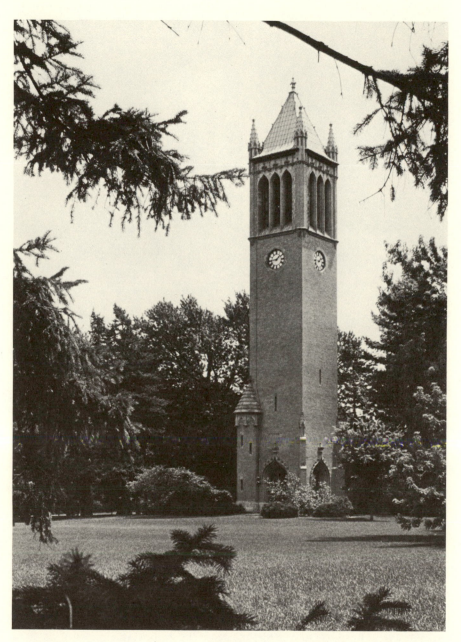

The landscaped area between Iowa State's union and campanile is a perfect botanical place. The Stanton Memorial campanile with its turret and loopholes is a well-scaled campus focus. It contains one of 170 manually played carillons on American campuses. (ISU Photo Service)

With all the beauteous elements of UNC at Chapel Hill's campus, this Old Well has satisfied the human need for visual symbols and is used as the university logo. It also serves a dynamic function by forcing space to flow around it. The university thought enough of its turn-of-the-century Greek bauble to have Eggers and Higgins redesign it in 1954. Somehow it turned more Roman. (Will Owens)

of creating space. The seventh-century B.C. Chinese philosopher Lao-Tsu said, "The quality of the building is the space within." And buildings should provide continuity leavened by diversity. Such a nice balance is rarely achieved, however. On one hand, there is Duke University, whose uniform Gothic paraphernalia overwhelms with its relentless homogeneity. On the other hand, Wesleyan University in Middletown, Connecticut, has an epicene campus; it houses specimen examples of all architectural styles, but without an artistic focus.

Architectural fashion reflects the hopes and aspirations of the times. Although blurred at the chronological edges, styles can be distinguished in differing treatments of plan, massing, structure, materials, fenestration, and decoration. The particular style may not be important, as long as it is carried out with a deft hand. ("You hear of me as a respectable architectural man-milliner; and you send for me, that I may tell you the leading fashion" John Ruskin said.)

The first styles used on American campuses were formal. In the beginning, there was Georgian, the only eighteenth-century American style,

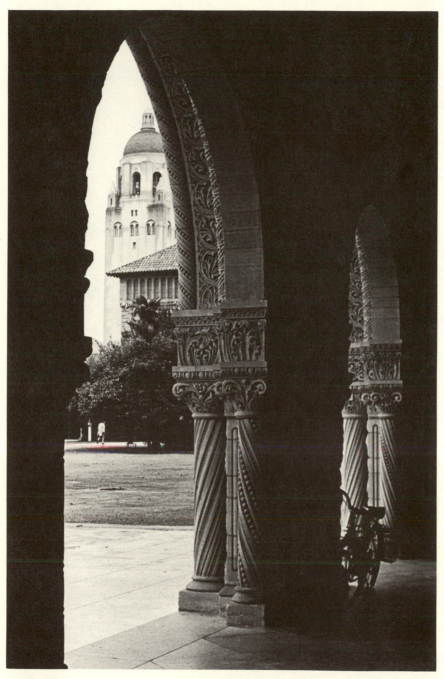

Stanford University does not have a Beaux Arts plan and would be visually better without the Art Moderne intrusion of Hoover Tower. This high central structure afflicts an otherwise low, coherent campus. (Stanford News Service)

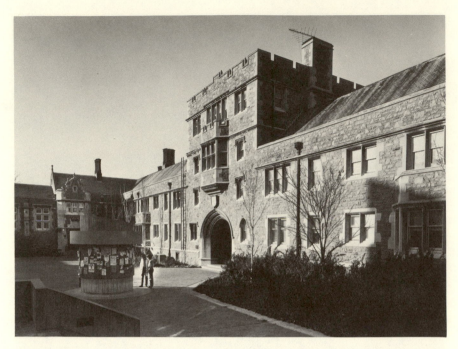

Washington University's Bowles Plaza illustrates how new construction can create pleasing spaces that were not there before. The Mallinckrodt Center and Edison Theater were placed to the south of Umrath Hall (shown here), which made a paved gathering area entered through the imposing Gothic arch. The ubiquitous kiosk provides a place for announcements. (Herb Weitman, Washington University in St. Louis)

called by the British "survival" rather than "revival." The Georgian period in architecture roughly overlays the eighteenth century when the English Georges ruled the colonies. It is characterized by axiality, symmetry, low-hipped roofs, robust columns, and pavilions. The style gave human scale to large structures, such as William and Mary's Wren Building and Princeton's Nassau Hall.

The Federal and Greek Revival styles were also throwbacks to the classical; in the first years of the nineteenth century, architects engaged in an orgy of rediscovery. These were open, democratic styles rather than dark and feudal ones. The Adamesque or Federal style showed attenuated columns, blind arches, graduated window openings, delicate festoons, and fanlights. Greek Revival then thrived for some 20 years during which the United States regarded itself as the aesthetic heir of ancient Greece. (Lord Byron's "Isles of Greece" helped.) In addition to the Greek orders, there were butted siding, sidelights, and low-pitched pediments (originally developed thanks to light snow loads in Southern Europe). These elements

The difficulty of maintaining a campus core's design quality is illustrated at Louisiana State University. The fine cloistered quad is to the right of the stadium. The rest of the campus has grown grid-like but does maintain an acceptable standard of architecture and plantings. The Mississippi River borders the western side of the campus.

touched our collective consciousness; the University of Alabama in Tusca-
loosa, a kind of academic Graceland, displays this period style.

Then the artistic sands shifted, this time to informal. The Victorian ebul-
lience of the Gilded Age marched joyously through the rest of the nine-
teenth century. It was, on one hand, a picturesque and flamboyant time and,
on the other, an antinaturalistic, chaotic reaction to discipline—a bacchanal-
ian fancy dress ball in Gothic Revival, Italianate, Second Empire French,
and Queen Anne attire. These are prominent on land-grant campuses in the
Midwest. Subsequently, ivy was planted everywhere to dampen the explo-
sive diversity of styles. (The term *Ivy League* was coined by a sportswriter
for the *New York Herald Tribune* in the 1920s—not with reference to the
land-grant colleges, of course.)

Meanwhile, Romanesque and Gothic Revival buildings with foliated
ornaments that required the stone carver's skill were employed to cut deep
within our cultural memories and recall the cloistered medieval campus.
Wellesley's Academic Triangle has endured visually not for its style but for
its timeless design.

As the eighteenth-century neoclassical style in Europe was a reaction to
the excesses of the Baroque period, so was formalism called forth by the
muses to tame the wild Victorians. Best exemplified (and influenced) by the
1893 Columbian Exposition in Chicago, the "city beautiful" movement re-
turned us to dignity and discipline, following as it did the axial planning of
the French Ecole des Beaux Arts. In addition to embracing this coherent lay-
out, a few campuses actually adopted the Beaux Arts style for their build-
ings: University of California, Berkeley; the University of Minnesota at
Minneapolis; the Naval Academy at Annapolis, Maryland; Columbia Uni-
versity in New York; the University of Maryland; and MIT in Cambridge,
Massachusetts. Ecole-trained William Welles Bosworth's plan for MIT was
one of the first examples. The construction of Memorial Drive along the
Charles River threw a monkey wrench into Bosworth's careful draftsman-
ship, but much of his plan was carried out.

Modern campuses extract what they want from each of these stylistic
periods. The first of the moderns, Mies van der Rohe's Illinois Institute of
Technology was—in spite of itself (see Chapter 4)—a planned Beaux Arts
campus. After World War II, the era of ambitious but unattainable master
plans ended in favor of establishing general principles of growth. Conse-
quently, in places like Yale and Harvard, new buildings were forced to
stand on their own, with no concern for coherence.

Finally, in the 1970s, retro-postmodernism reared its trendy head. If, as
Goëthe said, architecture is frozen music, this style is the 12-tone scale. A
mannered gesture to things past, it is a series of historical one-liners and
recycled images with a surfeit of tubular columns, cardboard arches,
stepped glazing, and striped courses (exposing today's craft limitations).
Although there are some good examples of postmodern campus design,

most represent a plundering of architectural history, a necrophilic disturbing of the graveyard—more archeology, in fact, than architecture. Actually, this failure of original thought characterizes most revival movements.

In all of these styles—from the Georgian to the postmodern—there are both successful campuses and failures. It depends, in a nutshell, on the felicitous handling of the structures' mass and their placement so as to provide harmonious urban spaces.

Is formal competition a viable means to achieve these design goals? Contests produced plans for West Point, Goucher College, Johns Hopkins, the University of Pittsburgh, the University of Minnesota, Washington University, and—the biggest of all—Berkeley. All these campuses have excellent qualities, but none appear on our top list (see Chapter 7 and the Appendix).

And in the end, does it matter whether students toil in homely vineyards? I think it does. Sixty percent of college-bound students told the Carnegie Foundation that visual environment was the most important factor in choosing a college. Education is an endeavor that is most sensitive to ambience; students respond all their lives to memories of the place that nourished their intellectual growth. Ray Casati, the architect of Indiana University, points out that standards set by the fine Indiana campus can be used later by students when they have control over other environments. "In other words, you won't settle for anything less than you've had here."

2

The Campus
Components

A man of sovereign parts he is esteemed;
Well fitted in arts, glorious in arms:
Nothing becomes him ill that he would well.

William Shakespeare
Love's Labour's Lost (II.i.44–46)

In the days of campus yore, donors gave money for buildings without much thought as to their use. This made for flexibility in changing circumstances. Schoolhouses were turned into dormitories, dormitories into libraries, libraries into refectories. Specialization now makes this more difficult. It would be hard to convert a student center into an atom-splitting track. In fact, all laboratories need specific and often built-in equipment; even libraries with their new sophistication cannot be easily retrofitted.

This means that more emphasis than ever before must be placed on planning so as to determine longer-term needs, programs, and budgets. This is exactly the kind of planning the State University of New York (SUNY) has been doing well for many years. Appropriately designed in the first place, many of its fine structures continue to perform their original functions long after being built. The highly successful categories of buildings in the SUNY system, as well as new approaches to building types, are covered in the section that follows.

Libraries

The function of a college library is to obtain, catalogue, and shelve printed matter, and—through architecture, among other means—to suggest the importance of the printed word.

Thomas Jefferson was the first to see the library as the main feature of a campus; it was also Jefferson who introduced research as a function of the university. Although college libraries always require stacks as well as circulation, reference, periodical, reading, and computer rooms, archives, card files, music listening rooms, microfilm-viewing and data-retrieval sections, there is no best arrangement of all these elements. Accordingly, architects have had a field day with spatial and stylistic manipulation.

One design-rich specimen is architect Francis Allen's 1905 Thompson Library at Vassar—a Collegiate Gothic masterpiece complete with crenellated and pinnacled tower. One enters into a high space with traceried quatrefoil windows around the four sides, this supported by a wide frieze and cornice. From the entrance looking through the building to the west, the eye is arrested by a leaded glass window that covers most of the

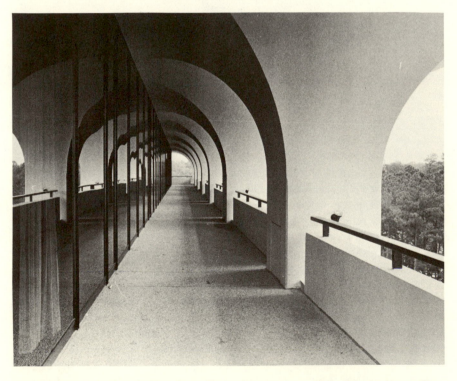

An enfilade of modern half-arches offers a fine campus prospect from the top floor of Emory University's Woodruff Library. (Emory University Photography)

opposite wall. It portrays Elena Lucrezia Cornaro Piscopia receiving the first doctorate awarded to a woman, at the University of Padua in 1678.

Between the entrance and the window wall, spacious rooms glisten with a tasteful offering of Gothic details, sculpted, perforated, carved, and poured. The gabled roof is supported by natural wood rafters reinforced by king posts. A stone fireplace occupies one corner of the main room, and there are ribbed walls through which can be seen stairways with elongated quartrefoils.

This Gothic tour de force of an entryway has a rural New England counterpart in the converted barn and silo of Colby-Sawyer College in New London, New Hampshire. Here one must enter through a restored silo where cattle feed was once kept. (Looking up is a disorienting experience.) Robert Burley of Waitsfield, Vermont, designed this library complex to be a deliberate blend of old times and new. Pre–Civil War barns have been converted into modern comfortable facilities while retaining their historic character—old shingle nails, barn boards, original sliding doors, hand-hewn timber frames.

The casual reading room is in the old hayloft where a 150-year-old hayfork has been left hanging. Catwalks permit a view of all five floors at once—reminiscent of the days when kids balanced on the high collar beams, risking only a drop into the hay. There is still the old-barn sense of cavernous space. Through the renovated windows, students can see Mount Kearsarge and Mount Sunapee. The whole is a study in rustic elegance, and the students obviously appreciate it. Usage has been running three times what it was in the old facility.

The undergraduate library at the University of South Carolina in Columbia has perhaps the best setting of any library in collegiate America. With its large reflecting pool surrounded by brick paving, it can cast its own shadow and then some. The landscaping design by Innocenti and Webel includes plantings of willow oaks, Tiffine Bermuda grass, East Palatka holly, and English ivy. The building itself—by Lyles, Bissett, Carlisle, and Wolff with Edward Durell Stone, associate—is glass-walled on its long sides with marble on the ends. The glazed area on the southside is screened from the sun by gold-anodized aluminum honeycomb. And, with Edward Stone's influence showing, square columns support the broad roof overhang. Also Stone-like are the perfect proportions of the mass itself and the window divisions and pillars.

High-rise libraries make for special problems; students must travel up or down to go from catalogues to stacks to circulation. Nevertheless, high rises are used in urban environments or where proximity to a central core is essential. Both of the libraries at the University of Massachusetts—at Boston and at Amherst—are elevator buildings, and both, given the obstacles inherent to high-rise design, have been handled well with respect to planning interior movement. Instead of being upwardly directed, Boston

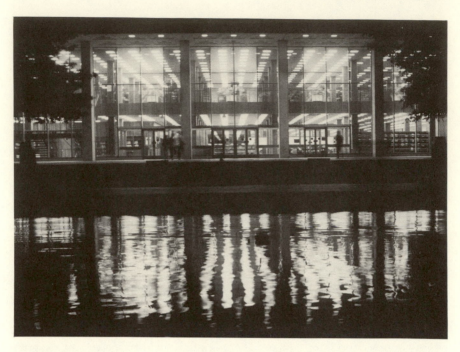

Edward Stone's Thomas Cooper Library at the University of South Carolina with its own brick parvis and reflecting pool has the most perfect setting of any campus library. (Courtesy of the University of South Carolina)

College's Tip O'Neill Library is a modern see-down library, the subgrade floor visible through first-floor glazed walls.

Molding form to serve their respective design purposes, the architects of the libraries at Berkeley and Oberlin have created strong modern buildings. John Carl Warnecke placed the Moffitt Library on one of Berkeley's slopes and projected it laterally in a contrapuntal response to the high Beaux Arts buildings surrounding it. Meanwhile the Seeley Mudd Learning Center (library) at Oberlin was built by New York architects Warner, Burns, Toan and Lundy with a stylistic nod toward the Boston City Hall. A capacious pile of a building, the library is divided into three parts to dilute its massive impact. Three bridges at various floor levels step inward and down to funnel outside movement into the building. This regressed space provides a semi-sheltered welcoming aspect to the entrance. Any alternative new library solution would have necessitated the destruction of several old and revered campus structures. In the end, the administration accepted consultant Arthur Drexler's advice: "There is little to recommend a college concerned with the humanities if it substitutes 'improvement' as a euphemism for the vandalization of its own history."

Many smaller colleges have well-designed libraries, proving again the old truism that aesthetics have nothing to do with budgets. A disciplined and comely library graces the campus of Framingham State College in Massachusetts. Designed by Desmond and Lord, this modern brick and brute concrete structure has a Piranesi-like atrium containing catwalks and peekaboo spaces that disappear overhead. It is bright with clerestories and lightwells.

The Robert Hutchings Goddard Library at Clark University in Worcester, Massachusetts, is a riveting assembly of architectural elements juxtaposed, cantilevered, tilted, and angled. Using board-formed concrete, brick, and glass, architect John Johansen has sculpted a tour de force of volumes and cavities. His concrete supports grow in clusters at the bottom like mangrove trees. This building's interior space has a mind of its own that flows through, around, and over the brick walls and concrete bulkheads, terminating at scenery-filled glazed walls. Linear skylights on the fifth-floor roof carry light down through glass floor channels and brighten even the downstairs main area.

Neither does this seminal contemporary building ignore the past. Outside the entrance to the archive room is a large bronze plaque depicting the symbols of war and peace and dedicated to the nine Clark students who lost their lives in World War I. This Saint-Gaudens–like bas relief by Hermon MacNeil was sensitively preserved from the original 1909 library.

Clark's Goddard Library has a price to pay for all its spatial wonder, however. Warm air follows the same upward path as the eye, leaving the lower floors cool in winter. At the other extreme, single-pane glazing installed just before the energy crunch causes overwarming in summer. And the hard finish of brick and concrete makes for a very unlibrarylike sound-bouncing effect.

Washington University in St. Louis has integrated a fine contemporary library building within its Gothic environment; so has Grinnell College in Iowa. Tufts University in Medford, Massachusetts, has a slick, if over designed, modern library. Bryn Mawr and Swarthmore in Pennsylvania have each used local stone in order to adapt an earlier style to contemporary use, and both have done so successfully.

In very recent times, with the shortage of space at college centers plus an awakened sense of the need to preserve green space, some libraries have been built underground. This has been tastefully done at the University of Illinois where the undergraduate library was added to the main library beneath a secondary quad to the south, thus preserving the original structure. At Harvard, the Pusey Library was installed within a berm that students now walk over without always knowing it is there. This saves the essential green of the yard near Quincy Street. At space-starved Columbia University, too, the Avery Library Extension was placed below a small green.

Finally, a cheer for Skidmore, Owings and Merrill, who designed the

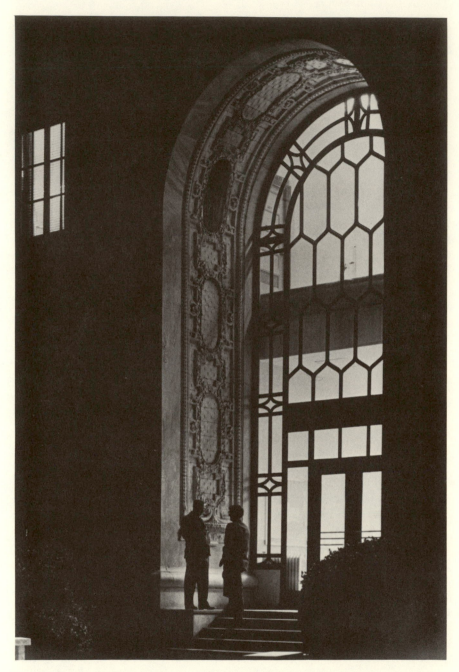

Until the advent of deconstructivism, inviting entryways were considered an appealing invitation to students. This one is an example of the exquisite work done at Emory University by Henry Hornbostel. It is Michael Carlos Hall and was built in 1916. Ironically, museum renovations inside were designed by postmodern architect Michael Graves. (Emory University Photography)

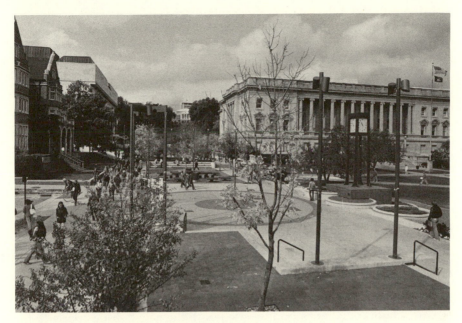

The Library Mall at the University of Wisconsin was once the muddy lower campus where pre-football bonfires were held. Varied paving and outdoor furnishings like modern lights, a clock tower, and benches have made it an attractive gathering place. (University of Wisconsin–Madison, News and Information Service)

modern Beinecke Library at Yale! Looking at this solid block that sits on its four points, one would never guess the special visual experience to be had inside. The architects have provided a rose-hued interior daylight by siding the building with thin translucent marble slabs. Beinecke houses the rare book collection and is climate controlled at all times.

Schoolhouses

Most eighteenth- and nineteenth-century colleges started out with one building that not only acted as the schoolhouse but also served other necessary functions: refectory, residence, library. In fact, this building was often the home of the president. Where any of these structures are still in use, as at Colorado, Princeton, Vassar, and Swarthmore, they now function as administration buildings and are often referred to as the "Old Main," as at Penn State, the University of South Dakota, and the University of Arkansas at Fayetteville. (Arkansas's Old Main is a copy of Illinois's now-destroyed 1874 University Hall with its mansarded end towers and central pavilion.)

When classroom buildings were simple and cellular with hallways opening into boxy rooms, architects were somewhat limited in their

creativity. But this did not prevent accomplished designers from producing well-scaled and detailed buildings. Stanford White did so in his double-towered English building at Illinois and his Palladian-derived Fayerweather Hall at Amherst.

Cass Gilbert, too, was successful in his quadrangle for the graduate school of theology at Oberlin, where capitals are decorated with the faces of notable men in Oberlin's history. (John Ruskin would have appreciated this kind of programmatic architecture.) Fine traditional school buildings stand at Wellesley's Gothic academic quad, Yale's towering law school, and Louisiana State University's Renaissance group (especially Atkinson Hall and Foster Hall).

Classroom structures today are more complex and often include laboratories, libraries, computer rooms, display areas, and snack bars. All this complexity invites an imaginative design response; the modern massing of materials can reflect the new happenings inside. Mies van der Rohe's Crown Hall at the Illinois Institute of Technology, for example, is a one-story, completely open room for architectural students; its function as a classroom for learning grand design is visually reflected in a strong exterior structural statement.

Law school compounds lend themselves to the new holistic approach to classroom buildings that require not only traditional recitation and lecture rooms but amphitheaters, libraries, reading rooms, and computer rooms. All such public access areas can add spatial pleasure to the school environment.

This can be seen at Gunnar Birkerts' roundish Boyd Law Building at the University of Iowa, with its horizontal thrust capped by an observatory-type dome—a complex commission that Birkerts won in 1980.

At the University of Missouri's law school, the modern chiaroscuro facade gives way to a surprisingly generous and bright lobby inside with the law library readily accessible. At Washington University in St. Louis, the well-massed concrete Mudd Hall contains the contemporary law school and law library. Although concrete is a jarring material for this Gothic period campus, the capacious modern structure—though it connects directly with the old Eliot Hall—manages to belong.

The unique property of concrete as a sculptural material is particularly well displayed in two other modern-day schoolhouses: the humanities building at the University of Wisconsin–Madison, and the fine arts center at the University of Massachusetts–Amherst. In 1966 Harry Weese of Chicago designed Wisconsin's humanities building of stone, concrete, and copper. Weese incorporated several traditional campus elements like outside walkways and tunnels for access from one part of campus to another, and he used them here in a pleasing contemporary vernacular that combines fresh ideas with a touch of historicism. Entry to the building is cleverly made at the third level from Bascomb Hill via a concrete bridge that spans Park

Street. The U. Mass. classroom of concrete—its fine arts center designed by Kevin Roche—is a symphony of volumes and voids, and it functions as a horizontal foil for the vertical Lincoln Student Center across the campus park core.

Another modern approach to the classroom was designed for the University of Colorado in Boulder by, again, Harry Weese. His astrophysics tower is a high-rise that, though contemporary in mien, clings to Charles Klauder's rural Italian vision in an earlier campus design. Weese adapted the same Lyons stone and the same broad-brimmed roof of red tile. The tower's ten stories are defined in concrete with the pinkish sandstone as filler. Though neither massed nor detailed like the earlier buildings, it manages to fit in with them quite well.

The multidisciplinary function of the lecture hall, as opposed to the usual departmentalized rooms for instruction (English, science, etc.), is a relatively new concept. Designs for its structure sometimes reflect this freshness of approach, as at the University of Illinois at Chicago (UTC) and the Evergreen State College in Olympia, Washington. UIC (formerly Circle Campus—the only college ever named for an intersection of two highways) has a group of lecture halls that are part of what could be called a peristyle. The roof of the classrooms is the main promenade of the campus. The rooms themselves are reached by descending into an amphitheater that occupies the middle of the open area. No other campus has an approach to classrooms quite like this. At Evergreen the lecture halls make a free-standing helical—an intriguing and innovative architectural idea on a campus where such qualities have come to be expected.

Administration Buildings

Because they are the planning center of any campus—as well as usually its structural hub—administration buildings play a key role in the aesthetic success of the entire campus. Their centrality explains why such structures are the last to disappear during campus renovation. It would not do to lodge the president, the financial people, the admissions, the registrar, and the university relations offices out in the boonies. The fact that many of these great maters were originally the whole school has helped them to avoid obsolescence; when the size and functions of colleges expanded, there was enough room in the original buildings to handle the ever-increasing demands of administration.

Thus, the most interesting college administration buildings and environs are the surviving old ones. Where new administration structures are added to existing campuses, they have not been so very successful. The modern John Hannah Administration Building at Michigan State has more of an office-building look than a college one and does nothing to enhance the campus. Compare that impersonal mass with the 1871 Mills Hall at Mills College in

Oakland, California. This friendly Second Empire grande dame with her round and hooded dormers, pavilions to soften her great mass, openwork fire escapes, and wonderfully detailed homey interior is an unreproducible Victorian treasure. And it perfectly defines Toyon Meadow on its north side and the Oval on the south—two excellent urban spaces. This building was seriously damaged in the 1989 earthquake. Being of such indisputable value, it is now being restored rather than replaced.

Massive old Second Empire administration buildings with multiple mansard roofs and richly ornamented orders that successfully delineate the surrounding space can be found in Parrish Hall at Swarthmore College in Pennsylvania and in James Renwick's Main Building at Vassar College in Poughkeepsie, New York.

Some administration buildings are in the Georgian style with hipped roofs, dormers, neoclassic detailing, and cupolas. Good specimens are still in use: the Old Capitol at the University of Iowa (cum Greek Revival), Reynold's Hall at Wake Forest University, and Princeton's Nassau Hall.

The last mentioned—Nassau Hall, one of the largest buildings constructed in colonial America—was designed of Trenton sandstone by Dr. William Shippen and builder Robert Smith and rebuilt by Benjamin Latrobe in 1802 and John Notman in 1835. In the rebuilding, entrances were eliminated, towers enlarged, roofs raised, and the central entrance redone in a Florentine arch style. After the Revolution, George Washington made a contribution of 50 guineas to the struggling college. In turn, the trustees requested that he sit for a portrait by Charles Wilson Peale. It now hangs in Nassau Hall's faculty room.

The relatively modest administration building at Harvard—University Hall by Charles Bulfinch—is significant less for its style than for its placement. This simple granite structure turned the campus inward and, in doing so, forever changed the course of the university's planning and design. Another undersized executive structure is Cass Gilbert's 1915 Cox Administration Building at Oberlin. Helping to define Tappan Square, the Mediterranean Romanesque sandstone jewel with its arcaded windows is perfectly symmetrical. This very rigidity has proved to be its functional problem, however, and constant remodelling has never succeeded in making the interior right. Cox's skimpy dimensions do not help, either. President Robert Fuller of Oberlin once said, "The small amount of power in the administration is symbolized by the size of the Administration Building."

Noble Italian Renaissance administration buildings still stand at the University of Wisconsin–Madison (Bascomb Hall) and Iowa State University (Beardshear Hall). Washington University has a medieval revival administration building that is still in use and that continues to define urban space: Brookings Hall. This Gothic structure offers an imposing main entrance on the east and articulates the main quad on the west. Antioch University's

Charles Bulfinch's Federal-style administration building, University Hall, turned Harvard inward in 1813. The only statue in the yard is that of John Harvard sitting in front of the building. Since nobody had the slightest idea what he looked like, it was safe to make him handsome and reflective. (Joe Wrinn, Harvard News Office)

twin-towered Romanesque structure, Antioch Hall, which now houses administration and was formerly the whole school, provides a character anchor for the Yellow Springs, Ohio, campus. Georgetown in Washington, D.C., houses its administration in the Romanesque-style Healy Building. It too has towers (though not twins) plus pavilions to relieve its long facade. And Gallaudet, also in the District of Columbia, has a medieval administration structure of immense size and character that redeems much of the later architectural work.

While Bertram Goodhue planned the spacious campus at Rice University in Houston, it was Ralph Adams Cram who provided architectural drawings for the administration building. Cram had some agonizing to do in his choice of styles. Dedicated to the Gothic Revival as the highest architectural expression of humanitas, he nevertheless felt the style to be inappropriate for the hot Gulf Coast. (Another Gothicist who rejected the style was Charles Klauder at Boulder.) Cram also eschewed the mission style— Texas's only cultural tradition—as that "strange and effulgent Renaissance of Mexico."

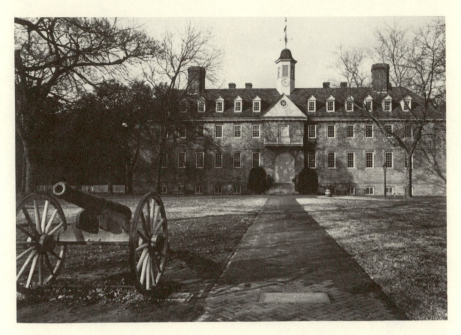

It is possible that Sir Christopher Wren actually designed the Wren Building at the College of William and Mary in Williamsburg, Virginia. But the great English architect had mostly retired by the time this structure was built, 1697, and it does not seem likely. (C. James Gleason, College of William and Mary)

Eventually he decided on a surprising amalgam of Mediterranean styles that, taken together, produce a genuine sense of unity. According to Cram, this eclectic choice included elements of "Syrian, Constantinian, Byzantine, Lombard, Dalmation, French, Italian and Spanish Romanesque with a covert glance at the Moorish art of North Africa." Cram fashioned a structure with five-part massing; a great central round-headed splayed arch, rusticated stone base; high, rounded multicolumned windows with balconies; and very elaborate overall detailing. The result is a building of undeniably strong exoticism.

The only Beaux Arts structure worthy of mention in the category of administration buildings is Low Memorial Library at Columbia University in New York City. Though it continues to be called a library, it no longer is, and in fact Low never performed that function very well. The rotunda reading room was its best feature, but not for its usefulness as a reading room (see Chapter 7). However, it remains a domed Roman Pantheon of great presence and still dominates the campus visually.

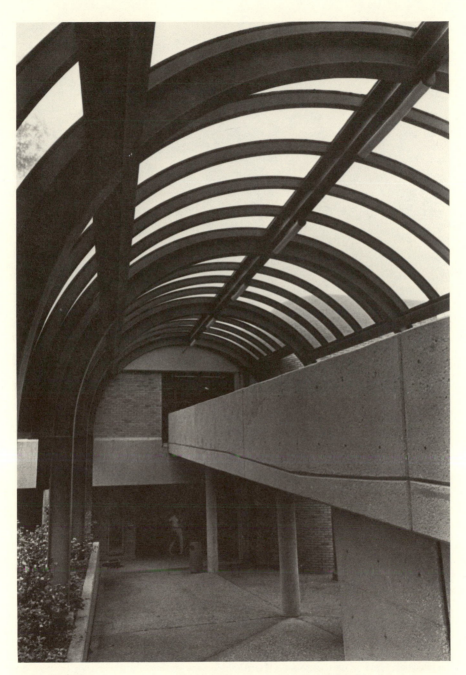

The transparent cover of the Dodson Complex connecting walkway at the University of West Florida permits students to appreciate how its buildings have been designed in harmony with nature. This facility offers wheelchair access to both levels of the faculty office building. (University of West Florida photo by Tom Carter)

The Romanesque Revival 1852 administration building outsoars the trees at the small Olmsted-esque campus of Antioch University in Yellow Springs, Ohio. Not many of these original campus buildings remain. Where they do, they provide an incomparable center of quality and grandeur. (Robert de Gast, the Barton-Gillet Co.)

Student Centers

The student union movement started innocently enough. Many such buildings were constructed in the early years of this century to provide an on-campus place for students to relieve tensions and engage in nonacademic activities. This simple and worthy purpose still applies at community colleges and downtown universities where students have no dorms to repair to

This dreamy setting of the medieval Healy Building above the Potomac River at Georgetown University makes good fodder for viewbooks. But the River is barely visible from the structure. After this fine character building, Georgetown's architecture—as at so many schools—went from quality (library) to kitsch (Leavey Center).

between classes. But the spanking new unions or student centers at universities today are also built for more pragmatic purposes. Even the prestige schools must compete for fewer and fewer students, and such terms as "yield" have entered the college administration vernacular. Yield is the percentage of accepted students who actually decide to attend; it ranges from 73 percent (yes, some admitted students turn Harvard down) to less than 50 percent.

Another new collegiate concept is this: Keep them happy and keep them here. How do administrations accomplish this? Many recognize that, given two institutions with equivalent academic reputations, a prospect will (statistically) choose the one with a winning football team. So one way to attract and hold students is to provide elaborate athletic complexes. Swimming pools are now "natoriums"; stadiums are all-weather "astrodomes."

Another come-on is the high-tech contemporary computer center, where students are now spending more and more time. Mary Patterson McPherson, president of Bryn Mawr College in Pennsylvania, says that the computer center "is where today's student works, lives, and even socializes. For Bryn Mawr, this creates healthy tensions—putting things together in new combinations." One more symptom of the new emphasis on getting and keeping students is the increased proportion of viewbook content dedicated to nonacademic activities—viewbooks being the promotional picture books that colleges use to attract prospective students.

And the most visible perk on any campus is the union or student center—so visible that donors (whose names become instant campus icons) are almost always available to build or expand them. These student

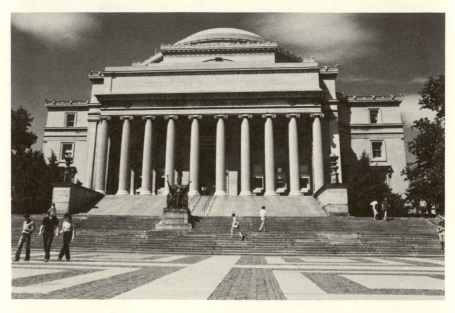

The great brick plaza that is College Walk at Columbia University in New York City creates a welcome urban opening in front of Low Memorial Library. This is one of few and is probably the best of the Beaux Arts structures in campusdom. Daniel Chester French's "Alma Mater" performs the same spatial function as did his sculpture "The Republic" at the Chicago Columbian Exposition. Fountains, urns, flagpoles, and candelabra provide the fancy costumery demanded by the style. (Fred Knubel, Columbia University)

magnets contain eateries, bookstores, galleries, bowling alleys, poolrooms, music listening rooms, meeting rooms, space for dances, student-organization offices, theaters, and video games.

Student unions give their architects more free rein than any other campus building. While their program is extensive and complicated, there is no set plan or style, and some interesting structures have resulted. At Duke, for example—that supremely disciplined Gothic–on–Beaux Art campus—the union is a stone box, its materials matching the rest of the buildings. But there is nothing Gothic about the interior. Here is a huge open space with a coffered ceiling from which everything hangs: stairs, sitting areas, catwalks—a veritable Piranesi prison scene. It was designed by Caudill Rowlett Scott.

A different contemporary approach is taken at the sprawling University of Texas union at Austin. Generous as a Texas ranch, it leads from one food outlet to another as it works its way to outside tables (where it is necessary to talk above the ceaseless chatter of songbirds). The union anchors one corner of the campus; and unfortunately, in this some accessibility had to be sacrificed. At the University of California, San Diego, the $18.5 million Price Center was designed by Douglas Austin of La Jolla (and other project architects) to be the living room of the campus. On its five-acre site are two structures with all the usual amenities, plus a cascading waterfall beside a pedestrian mall for outdoor activities. It is unusual for such a large, new complex to fit so well into the central core of a campus.

In 1873, architect William Potter designed the Chancellor Green Library at Princeton, which is now the student center. Its iron balconies and stained glass provide much character. But the main feature is its apse, whose shape and texture make for one of the most interesting rooms of any union.

Luxuriant older unions with panelled wainscoting, carpeting, and over-stuffed furniture (more like in-town clubs) can be found at Illinois (a large, comfortable Georgian building playing its part at the head of the quad), Iowa State, Indiana at Bloomington, and Wisconsin–Madison.

In fact, when it comes to hallowed places, there is nothing quite like Wisconsin's majestic Italian Renaissance–style Memorial Union, built in 1928. Though the building is outfitted with all the requisite accoutrements—lounges, galleries, great hall, dining rooms, craft shop, bowling alleys, and theater—its finest inside feature is certainly the rathskellar. Rathskellars exist on many campuses, but here at last is an authentic beer hall with brick vaulted ceilings, pillars, arches, and a view of Lake Mendota. In such cerebrally stimulating surroundings as this, philosophical conversations begin in the morning around the great wooden tables and continue on through the evening; chairs abandoned by class-bound students quickly fill with new solons. To put the success of a well-sited, well-designed, well-landscaped work into quantitative terms, take note that 18,000 people enter this building every day.

Some of the best contemporary unions have been worked into traditional

Iowa State University's picturesque Memorial Union on Lake LaVerne is a combination of Italian Tuscan and Lombardy styles. In its siting, design (even its slightly pompous north facade), and landscaping, it deserves recognition as one of the finest works of campus architecture. (ISU Photo Service)

buildings. One example is the rusticated interior of Baxter Hall, which forms part of the squad at Williams College in Williamstown, Massachusetts. Union College in Schenectady, New York, has architecturally opened up what is now its student center building and made a nice indoor-outdoor space.

And Swarthmore's exquisite granite-and-limestone Clothier Hall—a 1920s paradigm of Collegiate Gothic—has been chopped, sliced, and truncated to make the new Tarble Student Center. In this instance, the results are mixed. The building continues to perform a spatial function, sitting at the apex of a triangle on whose sides are situated the library, dining hall, and administration buildings. Inside Tarble, one finds that the soaring verticality of old Clothier is gone, but the new second-story mezzanine—an

all-campus space—encompasses the original steep ceiling with molded hammer beams and trefoil windows. What is now the first floor contains the usual union amenities, but unfortunately it is so stylistically disguised that even the original interior walls are hidden by depressing inside corridors.

The University of Vermont's Billings Campus Center, which used to be the library, was designed by H. H. Richardson in 1885 and shows all the vigor, sureness, and strength that made Richardson the dominant architect of his time. Typically asymmetrical—though not out of balance—it uses Richardson's trademarks of rusticated random ashlar stone, strong window moldings, and a grand low arch. (It was Alberti who said, "The arch is nothing but a beam bent.") The Billings Center is a grab bag of towers, turrets, drums, and loopholes. This inventory of architectural elements was copied by many other designers, but never with the same lively results. While it functions spatially to fill out the eclectic campus green, Billings should be seen inside to be appreciated fully. The soaring central hall is dominated by a huge fireplace, and the round room has hammer beams supporting the high ribbed roof.

In 1986, this building was linked with the Ira Allen Chapel next door "to unite an overused building with an underused one." Rather than complement Billings, however, this McKim, Mead and White structure in the Georgian style, with its outlandishly high steeple, competes with it—an unfortunate juxtaposition. In fact, the chapel's only redeeming quality may be as an historic symbol of religious freedom: The University of Vermont was the first institution of higher learning "not to give preference to any religious sect," thus manifesting an unusual degree of enlightenment for eighteenth-century New England.

The interior of the Dobbs University Center at Emory in Atlanta provides one of architecture's most unique symbiotic experiences. Adding on to Henry Hornbostel's perfect Tuscan facade from the early twentieth century, the modern architect John Portman attached a Miami Beach–like bauble. It is a four-story eatery, an amphitheater of catwalks that confronts Hornbostel's now enclosed exterior. This impeccably crafted high wall of six different marbles looks almost artificial now, in part because the colors are unbleached and the surfaces grime-free—qualities that the eye does not expect of an old facade. The effect is of an unreal stage setting that evokes Vincenzo Scamozzi's extraordinary permanent props in the Olympic Theater at Vicenza of the late Renaissance. And—just to give one more dimension to the friendly disorientation of the place—the hard marble surfaces amplify noise, making mealtimes sound like a student feeding frenzy.

Two contemporary unions that are not unlike each other in their horizontal thrust are those at Massachusetts Institute of Technology in Cambridge and Louisiana State University in Baton Rouge. Edward Catalano designed MIT's precisely scaled building, which acts as a cultural connection between the Beaux Arts older campus and Eero Saarinen's twentieth-century chapel and auditorium. LSU's student union, designed by John Des-

Louisiana State University in Baton Rouge has always taken pride in its campus plantings. Here is a well-thought-out grouping in front of the union building.

mond of Hammond, Louisiana, stands foursquare at the end of the parade ground that is used by the school's 26,000 students as a playing field. The building features a 24-foot grid of concrete columns, rising to a suggestion of capitals as they flow into four-sided flared caps that support the ample roof. Its glazed front wall and floating floor mark this building as different from others on campus, but its cornice height is the same as its neighbors. The union's central atrium, which is carved out of the main double stairs, provides one of the most attractive spaces of any student interior.

Dorms, Suites, and Shoeboxes

As collegiate life developed in the early universities of Europe, Britain and the Continent differed when it came to providing on-campus living quarters. Britain did; continental Europe did not. Thus, college students in Italy and Germany had to find their own quarters if they were to attend the great universities, while students at Oxford, Cambridge, and other English (but not Scottish) universities dwelled in marble halls or some reasonable facsimile thereof. From almost the first, then—following the British tradition—the American colonies were determined to keep their students on

campus after classes, and originally this meant housing them in the same classroom building.

Whatever the arrangement, building and maintaining on-campus living quarters proved to be a major financial burden, and it continues to be so today. But it has always been a first priority anyhow, in the interest of creating a genuinely collegial atmosphere. The ambience achieved was not always orderly; for example, South Carolina College, now the University of South Carolina, found that it had to design separate entries to eliminate corridors where students could cut up. In any case, as universities grew more impersonal, there came a movement to break down the large academic organization into units of students living, working, and socializing together. Thus was born the residential college in the United States. The concept originated, however, at Oxford and Cambridge.

At Yale, the Harkness Memorial Quadrangle by James Rogers was remodeled in 1930 to work the first two residential colleges into the campus. Harvard built its version along the Charles River, mostly designed by Coolidge, Shepley, Bulfinch, and Abbot in a Georgian allusion to the colonial Yard. The college areas were large quads both closed and partly open, with lavish interior public spaces fit for students who would arrive with their manservants. The houses were named for old and distinguished Massachusetts families: Lowell, Quincy, Leverett, Eliot. Very upper crust and of their time, these reclusive halls are the architectural expression of the residential college movement.

When it comes to integrating dorms into the overall campus plan, Princeton did the best job at John D. Rockefeller III College, where Charles Klauder and others designed some of the finest English Gothic halls in the United States. (Klauder built 30 Gothic buildings at Princeton before he went to Boulder, Colorado, and talked the trustees there out of the Gothic style.) Princeton has semiclosed quads of the Oxbridge variety, with flat Tudor arches leading from one to another. These are enlivened by ribbed ceilings and carved faunal brackets. In the middle is Holder Tower, which is modeled after Canterbury Cathedral. (Towers have been an ageless symbol of learning.) Collegiate Gothic became popular as a move back to craftsmanship; the work of the human hand was a late-nineteenth-century need. Though not exactly a genuine neo-Luddite movement, this aesthetic trend was a reaction to the machine age nonetheless.

In a different stylistic vein, Leo Butler College below the Prospect Gardens at Princeton is a residential college that intersperses brick contemporary with the stone Gothic buildings—not an immiscible solution, if done properly. Architect Hugh Stubbins was one of the designers of these stylistically hedged structures. When modern buildings are made to exhibit ancient allusions, care must be taken to avoid caricaturizing. Some of these buildings at Leo Butler are on the edge.

The California system has its own version of the residential college, par-

ticularly at Santa Cruz where buses circumnavigate the mountainside making the connection between class and dorm. San Diego, on the other hand, has a compacted interpretation of the residential college; transportation there is by foot.

Before the advent of the residential college (which, in any case, affects only a small number of schools), dormitories were usually placed outside the campus core. First placement priority was given to administration, library, and classroom buildings. At large colleges, "outside" can be a long way. University of Wisconsin–Madison students who live at the Adams-Tripp dormitories must climb the length of Observatory Hill, and there are residence halls still further away than that. To get from dorm to classroom at Indiana University at Bloomington, students must first negotiate the hill past the library, walk down through Fine Arts Plaza, cross the narrow Jordan River, and then walk forest paths to class.

Exceptions can be found where dormitory buildings have been maintained at the very heart of campus. Connecticut College in New London has living quarters on the central quad, while its schoolroom buildings are outside. Harvard lodges its freshmen right in the Yard; Brown does the same.

Frederick Law Olmsted's preference in college planning was to see a group of cottages spread throughout a parklike scape. Smith College attempted to follow that model. But the nearest most campuses have come to this ideal is the arrangement of their fraternity and sorority houses. Whether they like the Greeks or not, administrations must admit that these mostly large private homes have relieved some of the pressure of providing on-campus housing. At the University of Wisconsin–Madison, many of the houses are beautifully sited right on Lake Mendota—an agreeable approach to college living if ever there was one.

Interesting new campus residential work can be found at the University of Massachusetts–Amherst where Hugh Stubbins has designed a high-density complex in the southwest section, providing vertical interest with berms and small courtyards. A distinctive feature of this compound is its helpful abundance of readable signs identifying which of the many buildings is which. And on the newly built greens at Connecticut's University of Hartford, modern living facilities have been built to old New England specifications, using traditional clapboards and steep roofs.

At Duke University in Durham, North Carolina, the architectural firm of Rogers Associates has fashioned a postmodern dormitory with clever allusions to the Gothic campus surrounding it. A simple tracery is suggested by the close placement of panes of glass in the apex of the gable.

Smaller colleges usually manage to offer dorms near the campus center. At Vassar, for example, traditional red brick buildings with pavilions, sandstone belt courses, and offset gables almost completely enclose the cozy living quad just to the north of the main schoolhouses.

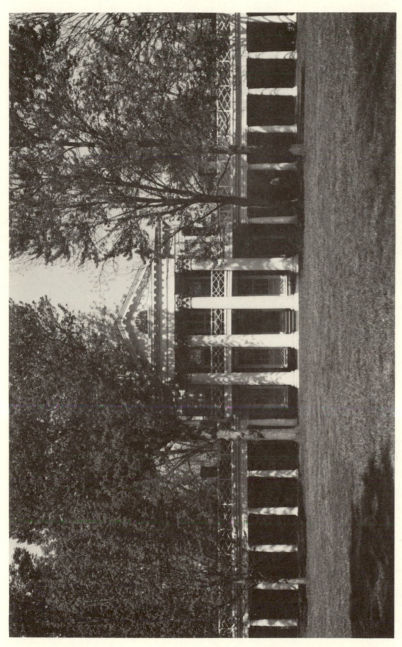

Pavillion III on the University of Virginia Lawn—the most elaborately decorated of the ten constructed—shows a "Chinese railing." Though Jefferson chose classical Roman architecture, he used a modest scale "better suited to our plainer style." And he eschewed imported Italian marble for his columns in favor of brick and stucco. (University of Virginia)

The 1892 Pembroke Hall at Bryn Mawr sits at the core of the campus, with academic buildings all around it. Architects Cope and Stewardson designed Pembroke in the English academic style of the late Middle Ages because, as Stewardson wrote, "The more the mass of people know historic styles, the less will be the demand for the non-descript and commonplace." Stewardson showed the masons how he wanted them to lay stone for Pembroke, thus projecting a Ruskinian image of the architect building with his own hands. This image was most consistently promoted by William Morris and his arts and crafts movement, which advocated that design and construction should be performed by the same workers.

Tiny little Antioch University in Yellow Springs, Ohio, recently redefined a near corner of its campus quad with new dormitories by the firm Schooley, Caldwell Associates of Columbus. This simple and creative student housing cum gathering place won the American Institute of Architects Honor Award in 1989.

As to their relative lavishness, campus dorms range all the way from what University of Vermont students call "shoeboxes" to the Naval Academy Cadet Quarters at Annapolis, Maryland, with their grand French Baroque curved stairways, curved balconies, and curved cornices.

Chapels

On the whole, religious buildings have been more consistently well designed than any other type of building on the campus (no doubt due to divine intervention). Although time has passed them by, chapels still play an important aesthetic role, particularly on Beaux Arts campuses where a tall focal point is a requisite of the style. With the exception of the ecumenical chapel at the modern Air Force Academy in Colorado Springs (built on a Beaux Arts plan) and the small exquisite chapel at the Rochester Institute of Technology, new campuses rarely include them in their building requirements. Thus, in terms of their spatial function as well as intrinsic beauty, we must consider more traditional renderings of this structural form.

Religion was often the spirit that powered the making of a college. Accordingly, the chapel was part and parcel of the sectarian campus and held center stage. Not only was it placed in the core, but it was usually the highest structure as well. Medieval (and early scholastic) thought rarely strayed far from the contemplation of God; it was the decorated, soaring medieval Gothic church, then—rather than the plain and heavy Romanesque—that captured the imagination of campus builders in the United States. Thus Gothic became the preferred style of many of the best chapels.

"I want the central building to be a church," wrote James Duke in 1923, "because such an edifice would be bound to have a profound influence on the spiritual life of the young men and women who come here." In contrast to most other campus churches, though, the United Methodist–related

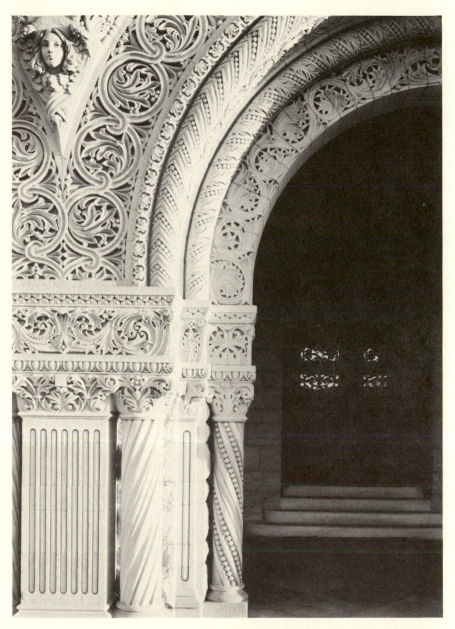

An army of stonecutters built Stanford University's core with mostly low columns capped with simple, carved capitals. Detailing of the memorial church, however, displays perforations, gargoyles, ribbing, egg-and-dart forms, acanthus leaves, volutes, and much more. (Stanford News Service)

Duke University Chapel is not based on earlier cathedrals. Duke's chapel is English Gothic by dint of its great length, square towers, complex vaulting, short crossribs, low nave, and paucity of sculpture. But its stained-glass windows are French. It functions as the Beaux Arts punctuation of a formal axial campus. Its verticality is emphasized by its narrowness, elongated windows, and encrusted spires. To build the chapel, architect Horace Trumbauer of Philadelphia chose stone from the Duke quarry near Hillsborough, North Carolina. Trumbauer's work was certainly efficacious, once inspiring the English novelist Aldous Huxley to say, "It is the most successful essay in English Gothic that I know." Duke's chapel continues to be used for its original purposes: meditation, worship, and organ recitals.

Since campuses have more to do with urban space and architectural facades than interior design, I have not been taking readers inside many of the buildings. But the University Chapel at Princeton—designed by Ralph Adams Cram in 1928—must be entered. Built of Indiana limestone, it is the third largest university chapel in the world (after the chapels at Valparaiso University in Indiana and King's College in Cambridge, England). The wide nave of University Chapel has narrow side aisles and a short transept, forming a Latin cross. Its three complete stories consisting of arcade, triforium, and clerestory are true to the stylistic tradition.

The chancel's oak paneling was carved from Sherwood Forest trees in England; the pews were made from wood originally intended for Civil War gun carriages; the sixteenth-century pulpit was brought from France. In every bay, red and blue stained-glass windows cast a soft pinkish hue that permeates the chapel. They depict scenes from literature—Milton's *Paradise Lost*, Bunyan's *Pilgrim's Progress*, Dante's *Divine Comedy*, Malory's *La Morte d'Arthur*. Add multifoiled tracery, and this chapel has become a Gothic fantasy.

Notable Gothic chapels can also be found at the University of Chicago (one of Bertram Goodhue's last works), Washington University, Vassar (with a mixture of Romanesque), and many others.

Some schools adopted the Georgian style for their chapels—Maryland and Harvard, for example. While the 1932 Memorial Church in the Harvard Yard carries a James Gibbs–like Georgian steeple, it is otherwise a charming mongrel with portly Doric columns showing Greek entasis and an interior vault decorated with Federal-period patera. The inside is also blessed with a wood-carved medieval reredos and pulpit. Memorial Church is a good example of the richness of overlaying styles that characterizes the New World's period buildings. America is no place for purists.

Even the Romanesque—though uncommon—was not completely ignored. We find it, for example, in the chapel at Stanford University. (The 1989 earthquake did almost as much damage to it as the one in 1906.) And the Finney Chapel at Oberlin plays on the Romanesque style of twelfth-century France.

Three modern chapels—Protestant, Catholic, and Jewish—were built by Harrison and Abramovitz in 1955 at Brandeis University in Waltham,

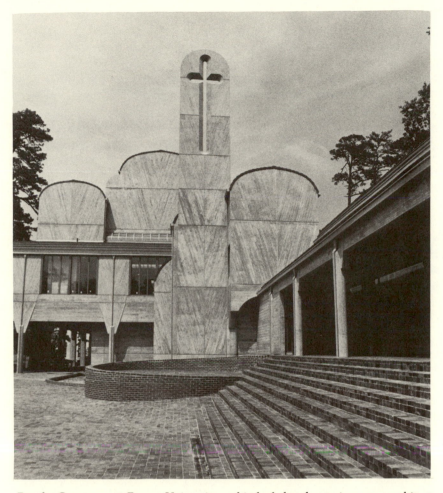

Brooks Commons at Emory University, a kind of church parvis, serves architect Paul Rudolph's Cannon Chapel. This paved space sets off the fine contemporary building and permits it to cast its own shadow. (Emory University Photography)

Massachusetts. Molded into wedges and truncated ellipses, they are connected by walkways around a reflecting pool and together make up a single work of art. In contrast to most of Brandeis's overbuilt campus, the area around its three chapels is protected against further construction.

Economic reality and the new preservation ethos have recently combined to save many obsolete chapels from demolition. This is just in the nick of time; at mid-twentieth century, there were some 400 college chapels in need of recycling. (Notice that this does not include the University of Virginia: Thomas Jefferson wanted a secular campus and thus planned for no religious buildings.) Alternate uses have mercifully been found for the underutilized campus chapels, including as theaters and student centers.

Museums: The Icing on the Cake

The academy can survive without exhibit spaces and display cases. But as art departments collect paintings, archeology departments receive specimens, and development departments bring in chattel (among other donations), a university begins to build up collections of educational value and and is obligated to put them on view and use them as teaching tools. What makes museums different from other places of learning is the accessibility of the real thing. The resulting structures have benefitted campuses with some interesting urban spaces and architecture. I cite only those that possess both.

Natural history has bred some noteworthy buildings, both traditional and contemporary. And in most cases, their placement has enhanced the campuses. One of campusdom's supreme character buildings, Dyche Hall at the University of Kansas in Lawrence, takes its place along Jayhawk Boulevard to keep the spatial momentum flowing. Its romanesque exterior is covered with natural history iconography that reflects the dioramas inside (dioramas that were shown at the 1893 World's Columbian Exposition in Chicago). Among the plant and animal exhibits stands a stuffed U.S. Cavalry horse named Comanche, the only non-Indian survivor of the battle at the Little Big Horn. Not surprisingly, the museum of natural history in Dyche Hall is one of the most popular tourist attractions in Kansas.

A contemporary natural history museum articulates the corner of Newell Drive and Museum Road at the University of Florida in Gainesville. A low-slung building with battered walls, it is modeled after Indian earth mounds and provides human scale to this flat campus with monumental structures. In fact, this is the Florida State Museum of Natural History on this state university campus—a logical amalgam of governmental facilities. After passing under the coffered ceiling of the entrance, one may choose to visit a 500-year-old forest, a North Florida cave, a recreated fossil dig, or even the "Bonompak" room in a Mayan palace. Therefore, the museum—uniquely designed by architect William Morgan—enhances campus aesthetics on the outside, and offers education and research on natural and social history inside.

The museum at the University of Alaska in Fairbanks is one of its better modern structures. It stands with assured dignity on one tier of this multi-level campus. Though small, the museum leads the visitor through geographic sequences with imagination and clarity—qualities achieved by a healthy collaboration of architect and curator.

Though some art galleries have been installed in existing campus buildings, most are newly created ones and represent the latest vintage of this form at the time of their creation. In certain cases, the building is of equal aesthetic interest to its content. One example is the Hood Museum of Art on the green at Dartmouth, designed by Centerbook Architects of Essex, Connecticut. "Its calm yet assertive elbowing-in between the highly unlikely

partners of Richardsonian Wilson Hall and Harrisonian Hopkins Center is masterful. Its several-colored brick masonry adds to the museum's informal gabled forms reminiscent of traditional New England architecture." This was the accurate assessment made by the Brick Institute of America's 1989 award jury.

At Smith College, the modern fine arts center of reinforced concrete slabs, brick, and glass by architects Edward Galanyk and Brian Hunt is not design-integrated with the other campus buildings. But it does perform a useful function in defining the library's front yard. And it provides a walk-through from the core to the north side of campus where many activities take place. This device is often used in Collegiate Gothic style (usually with a gentle Tudor arch), and it adds a sweet nostalgic touch to Smith. The art museum roofed sculpture courtyard connecting the Tryon and Hillyer buildings provides appropriate spatial relief in a dense grouping. (For a small college museum, this one possesses 18,000 pieces of surprisingly top quality—especially its nineteenth- and twentieth-century French and American paintings.)

Inserting modern buildings into a traditional campus does not always make their designers popular people. There was plenty of controversy when I. M. Pei's art museum went up on Fine Arts Plaza at Indiana University at Bloomington. It was condemned as incongrouous, but its scale, siting, materials, and design excellence do no harm to the fine aesthetic tradition of the campus. What is more, the museum is a stunning, crisp building of glass and concrete (artificially colored to match its limestone counterparts). Its soaring height capped by a glazed space frame is reminiscent of the architect's East Wing of the National Gallery in Washington, D.C.

Among I. M. Pei's other campus buildings is the art museum at Cornell, a vertical structure of original form with intermingling solids and voids. It stands on a bluff overlooking beautiful Cayuga Lake on an otherwise unremarkable campus that refused Frederick Law Olmsted's planning advice and suffered the consequences.

The Elvehjem Museum of Art at the University of Wisconsin–Madison is a blocky building around a center atrium—a kind of square Guggenheim. Designed by Harry Weese (as was the humanities building next door), it is well scaled and spacious, being one of the largest college museums in the country. By closing off the narrow space behind the humanities building, it creates an urban area that flows into busy Library Mall.

A. Quincy Jones's Mandeville Center for the Arts at the University of California, San Diego, speaks of supreme architectonic volumes and is enhanced by an appropriate variety of materials. At Wesleyan University, Kevin Roche's Center for the Arts—a campus within a campus—defines its northern edge with severe Indiana limestone boxes. The subtle proportions of these crisp white forms make it work, but the unfortunate absence of weather protection (such as roof overhangs) leaves the walls now unattractively stained.

At Wake Forest University in Winston-Salem, North Carolina, the fine arts center's interior keeps the promise of its excellent brick massing; unlandscaped, it grows out of the grass. Florida State University's fine arts building is creative and sure. And the modern fine arts center at the University of Arkansas in Fayetteville, designed by native Edward Stone, defines the entire south side of the central plaza.

In 1950, Yale's traditional architectural shroud came undraped. The school's modern rebirth was the work of A. Whitney Griswold, its president from 1950 to 1963, who somehow persuaded the trustees that the time had come for a change. The first manifestation of this came in the form of Louis Kahn's art gallery. In an intensive urban setting, the gallery completes the corner of Yale's Chapel Street block and thereby performs a spatial service within the campus. On the exterior of the building, Kahn laid up a four-story solid brick front divided by sensitively scaled belt courses. The first visual effect on the interior is the pioneering tetrahedral ceiling. This is a cast geometric form that provides a patterned cap over the entire story while allowing recessed space for heating ducts and lighting. As a structural element, it permits a flexible arrangement of nonbearing movable exhibition partitions that need not reach the ceiling.

Gathering Places: Performing Centers, Auditoriums, and Stadiums

Setting monstrous structures like theaters and field houses down onto a campus without doing spatial damage is quite a challenge to the planner and architect. The football stadium is the most monstrous of all, and yet some 100 of them were built between 1900 and 1930. The solution in some cases was to build the stadium away from the campus core, as at Harvard's Soldier's Field. Designed by Charles McKim, this was the largest reinforced concrete structure in the land at the time; it was placed all the way across the Charles River, in Boston. At Stanford University, the stadium is on the edge of campus—quite a distance, in fact, from the schoolrooms. Stanford took the trouble to use matching materials, so at least the stadium does not reach out of its bounds and aesthetically tackle the campus observer. The Yale and Brown stadiums, too, are away from the main drag.

This is not the case, however, in two of the most dramatic stadium profiles: Arizona State in Tempe, where Sun Devil Stadium's strong profile continuously looms across the line of sight; and the University of South Carolina, whose stadium's claw-like stands swipe at the sky. And at Michigan State, football did not give an inch in the dominant placement of its stadium—even to the detriment of the campus. For, after all, except when the movement and color of the Saturday afternoon crowd gives it life, the area around a stadium is steeped in gloom.

Some campuses have attacked the problem of the stadium's mass, head on. SUNY at Buffalo, for instance, has bermed its stadium; one must even

Momentary shelters like the Camp Randall Arch are a class way to articulate a change in campus ambience. The great stone-faced mass introduces the University of Wisconsin's football stadium environment and does it with a Romanesque flourish. Gladiators prepare. (University of Wisconsin-Madison, News and Information Service)

look twice to find it. And the University of Colorado has managed to integrate its stadium into the style of the campus. One of the best-designed stadiums in college sports can be seen at the University of North Carolina in Chapel Hill. Kenan Stadium is set unobtrusively in a bowl (like that at the University of Georgia) and surrounded by pines. Kenan is a beautifully designed reinforced concrete work whose structural arms are carefully proportioned and whose stands are nicely rounded and tilted.

The problem of the oversized stadium solves itelf when the rest of the campus is also large scale. The Beaux Arts grandeur of Cass Gilbert's University of Minnesota at Minneapolis–St. Paul is one such example. (By the way, should you venture beyond the U.S. border, you will find the best solution of all at McGill University in Montreal, where the stadium is terraced into a hillside.)

Almost as imposing as stadiums are the covered field houses and auditoriums that are built for sports such as basketball and ice hockey. As these events become popular, and as administrations compete for scholars, large sports arenas have sprouted throughout the land. Enclosing great volumes of space without creating a visual obstruction has been one of architecture's most enduring goals. The Romans had their baths and their Pantheon, and Brunelleschi built his cathedral dome in Florence. In modern times, Pier Luigi Nervi erected his huge exposition hall of ferro cement in Turin. And in the United States, the campus has been a veritable spawning ground for gigantic structures.

At its south campus, for example, Iowa State University in Ames has collected three remarkable buildings of this ilk: C. Y. Stephens Auditorium,

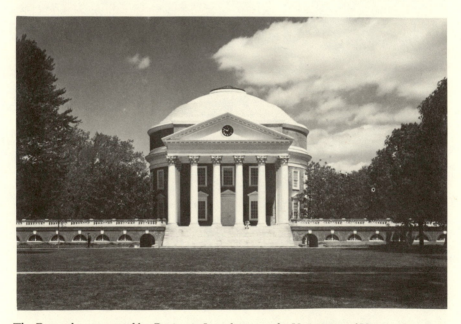

The Rotunda, suggested by Benjamin Latrobe, caps the University of Virginia Lawn. It has experienced a fire, additions, rebuilding and finally, restoration to its original interior. Modern improvements have been made: the dome is now topped with plexiglass, as the original glass and wood leaked. (University of Virginia)

a fine concert hall; J. W. Fisher Theater, where no visitor is more than 13 rows from the stage; and the James H. Hilton Coliseum, for basketball. These are all striking contemporary designs for open spectator space.

Both the field house at the University of Iowa at Iowa City and the assembly hall at the University of Illinois at Champaign–Urbana are built partially into the ground; the grade-level entrance leads to a middle level inside. Iowa then made a steel superstructure and hung the seats from it: structure as space maker. Illinois placed a thin rounded carapace over a wide, scooped-out shell to make one big unimpeded sports assembly hall (where a turtle's fleshy parts would normally be): structure as form giver.

But Illinois did something else besides. Eschewing anything as banal as creating one theater for various types of performances, it built four specialized halls—a large orchestra hall, a music theater, a drama theater, and a small experimental stage—plus an amphitheater, all on one site. Architect Max Abramovitz designed separate buildings, mostly of red brick, that together make their own urban space. The Krannert Center for the Performing Arts is set on two podiums—the first accessed by stairs from the street; the second by means of steps from the amphitheater level, which is used for strolling between acts. All four theaters are connected by a lower lobby. Krannert is a well-conceived festive place with a sense of occasion—a model solution for this late-blooming campus function.

Toward the end of his life, Frank Lloyd Wright built the Gammage Center for the Performing Arts at Arizona State University. Gammage Center is a riot of controlled roundness and circular detailing that reflects Wright's commitment to plasticity—the expressive flow of continuous surface (in preference to traditional cut-and-butt joinery). However, the interior decoration—the selection of materials and colors—was left to Wright's wife Olgivanna. Her somber choices deny the effulgent luster of the architecture.

Of course, for more limited purposes such as campus meetings and performances, auditorium buildings have existed for a long time. One of the richest architecturally is William Potter's 1893 Alexander Hall at Princeton. This is a Romanesque structure of gray rusticated stone and dark trim—the reverse of most other Princeton buildings. Its towers, turrets, and truncated columns supporting great arches make this a splendid character building. The product of less high-tech structural technology than today's, its interior space is riddled with obstructive supports.

Another type of campus gathering place is the outdoor amphitheater. Though often located on a gentle hillside with a view of the woods beyond (e.g., Mount Holyoke and Swarthmore), amphitheaters show up in urban environments as well. The amphitheater in the courtyard of Hellems Arts and Sciences Building at the University of Colorado features plays by Shakespeare. The Greek Theater at Berkeley is modeled after the one in

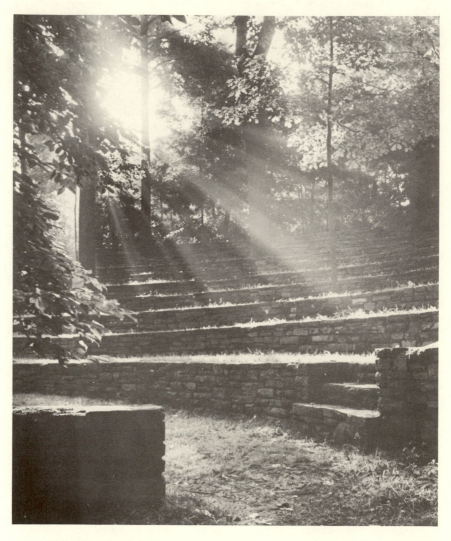

Amphitheaters are popular on campus as gathering places and fair weather performing centers. Scott Outdoor Auditorium at Swarthmore College is nicely worked into a bosky hillside.

The Gettell Amphitheater at Mount Holyoke illustrates the fine art of extending the campus without the usual vulgarity. In addition to completing the amphitheater, the covered walk serves the vital spatial function of stopping the eye to the east of the main quad.

Epidaurus, Greece. And, in the shadow of the world's tallest building, the amphitheater at the Chicago campus of the University of Illinois is mainly for sunning oneself, lolling between classes, and (as mentioned earlier) walking down to the lecture halls below.

3

The Urban Campus

The American campus is a world in itself, a temporary paradise, a
gracious stage of life.

Le Corbusier

What exactly is an urban campus? Is it a compact group of buildings in the
country or a spread-out campus in the city? Which category would the
University of Washington in Seattle fall into, with a marvelous urban red
square sitting right next door to its pastoral quad? Which is the University
of Chicago, with its green core set in the middle of built-up Chicago? And
what about Purdue University in Lafayette, Indiana—with much acreage
but organized in a citylike grid?

For the sake of discussion, let us establish that an urban campus is a
compound of densely grouped structures that results from either free
planning choices or from the exigencies of a predetermined street grid. This
interpretation would eliminate Los Angeles schools such as USC and
UCLA, even though their urban credentials are otherwise impeccable.
Directions to the University of Southern California (USC) make its citifica-
tion hard to dispute: "from the Santa Monica Freeway south, from Harbor
Freeway west, from the airport, the San Diego Freeway north." Yet the
school is an unrestrained sprawling complex that ranges around a campy
statue that the students call "Tommy Trojan." (For reasons that are hard to

fathom, the Hollywood film companies use these buildings as a background for Ivy League movies.) While both USC and UCLA are Northern Italian–derived campuses and both have extensive gridlike plans, their loosely designed layouts sprinkled with greens eliminate them from the urban category.

Planning for reduced spacing requires more discipline; how planners deal with this situation separates the pros from the not-so-pros. Columbia University in New York hired McKim, Mead and White to lay out a Beaux Arts campus in the restricted four blocks between 116th and 120th Streets. Portland State University in Oregon went with the flow and managed to fit its campus directly into the surrounding street web. Its campus is one long pedestrian mall.

South of the Chicago Loop, architect Henry Ives Cobb designed a hierarchical group of campus quads in the Gothic Revival mode just before the turn of the century. Taken by itself, the core of the University of Chicago represents perfection both in spatial experience and in pure archeology. Cobb was probably influenced by reports of Stanford's closed quad. (John D. Rockefeller's endowment for Chicago implied no personal involvement in its design.) Though the Beaux Arts style of the Columbian Exposition next door in Jackson Park must have impacted somewhat on Cobb's design, the University of Chicago is not strictly an axial campus.

Step across the street from the tall modern Regenstein Library. First you will pass through double gates between which are small landscaped quads with a bridged pool, and then burst out into a large space with the administration building on the right and a line of shrubs enclosing the otherwise open east side of the compound. Continue to the south where three medium-sized quads are a welcome sight to those who seek agreeable urban spaces. Arches usher students from one to another.

Inside the buildings, one is reminded everywhere of the richness of Gothic detailing: in the Union, for instance, with carved wainscoting, seals on the windows and walls, stone tracery, drops, cornices, high wooded ceilings with hammer beams. The Chicago campus is a Cantabrigian experience—a throwback in time to medieval Europe and the first moderr. inquiring minds, the scientific method, the Venerable Bede. Thus, faculty members dress up in thirteenth-century robes for graduation. There is security in the trappings of pure scholarship.

But unfortunately the core cannot be taken by itself. Even if these icons of the past are accepted as appropriate material for designing a college campus in the modern era, we find that the University of Chicago's plan was not consistently carried forward. It succumbed, in fact, to the boring layout of downtown streets and then stashed some fine buildings where no urban spaces could possibly be created. Thus, Eero Saarinen's Law quadrangle across the dreary wide Midway on East 60th Street related in no way to the

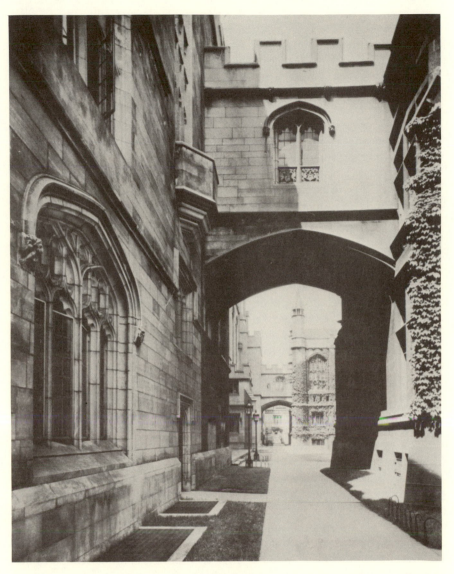

Architect Henry Ives Cobb manipulated space in the best tradition at the University of Chicago. Using rich, medieval paraphernalia, he created an eye-pulling enfilade through the Harper Library bridges. Students enjoy the diverse pleasures of moving along narrow walkways to open areas, then back again to enclosed passages. (University of Chicago Archives)

original campus. Frank Lloyd Wright's Robie House—now owned by the university—sits a block east of the Gothic core in its own almost suburban surroundings. More school activities now take place outside the original quad than inside. It is a reenactment of what has happened at so many other campuses: a fine beginning followed by a disappointing denouement.

Boston's urban campuses attacked their space problems with varying degrees of success. Boston University hunkered down between Storrow Drive and Commonwealth Avenue and then responded to the limits of its mile-long linear site by shooting skyward (e.g., the law school) and by the creative planning of well-landscaped structures, fences, hedges, and fountains. This agreeable architectural scenery masks the nearby stream of traffic on the north and south.

Northeastern University attempted to tie its various structures together with an epidemic of white- and gray-speckled brick laid in double-stretcher Flemish bond. Though the buildings vary in design, there is so much tight mass on this campus that the continuity of brickwork turns out to be too much of a good thing. And the open spaces—like the small plaza in front of the library—are underscaled, producing a dungeon effect. There *is*, however, the Ell Student Center, which does manage to redeem Northeastern somewhat. A vast interior crucible of Gothic height and modern accoutrements, it features sunken lounges, ramps, hanging stories, floating banks of lights, and flying beams. But there is no free lunch in campusdom: The very height that gives grandeur to this space also makes temperature control difficult, especially without air conditioning. As mentioned in Chapter 2, Clark University's Goddard Library faces the same problem.

The Harbor campus of the University of Massachusetts–Boston, on the other hand, was designed as a modern whole, and the results show the professional guiding hands of Sasaki, Dawson, DeMay with Pietro Belluschi. Because the campus as seen from Route 93 looks like a fortification, it is necessary to enter the grounds to appreciate what these architects created from what was once a garbage dump.

Indeed, this dump had been collecting garbage for 40 years. It had to be graded up against a mile-long dike, and then concrete pilings 80 feet long driven into the harbor floor. These pilings now support a fine group of landscaped brick structures amid stately groves on an open plaza. All the buildings are connected by handsome trussed sky bridges. On a rainy day, the movement of students through these transparent conduits animates the campus. (The strong vertical elements that penetrate some of the rooftops are aerating vents from the old dump below; they prevent the buildup of methane gas.)

The Harbor campus library with its high coffered ceilings and comely brick interiors was designed by Harry Weese. It is the masterpiece of the school. But there is a dark side to this campus, as some observant students

Bordered by the Hudson River, Riverside Church, and Grant's Tomb on the west, Columbia University—by dint of Charles McKim's careful planning—maintains its urban dignity. (Columbia University)

have pointed out. They say that the mid-1960s, when this campus was conceived, spawned nervous bureaucrats who were more concerned with controlling students than educating them. This is why they chose an isolated peninsula as the site and why they built an impenetrable campus—one that can be defended, quite literally, from the ramparts.

Moving inland and a bit south, we come upon Trinity College, ten minutes from downtown Hartford, Connecticut. It is a compact Gothic institution famous for its 1878 "Long Walk." This line of buildings was originally to be one side of four linear quads. Practicality and budget restraints made this further work impossible, and so the long row remains. It was designed by British architect William Burges and may be the earliest instance of the Collegiate Gothic style in the United States. In any case, these rich brown multifoiled structures were copied in campus designs for decades afterward, perhaps because they were a reminder of the medieval origins of the learning institution.

Five of the Ivy League's eight campuses are set in urban environments—a function of their early founding. The University of Pennsylvania is one of them (along with Yale, Harvard, Columbia, and Brown). The core of the Pennsylvania campus rests on a site of two by three city blocks in Philadelphia. This tight space requires careful planning, much like that of Columbia University in New York City. Instead of Columbia's Beaux Arts approach, however, Pennsylvania chose to create a quadrangle that dissolves into streetlike walks.

Blanche Levy Park is the center of visual activity, and a fine urban space it is. Surrounded by Romanesque and Gothic structures of great character, this open forum is highlighted by a statue of the school's founder, Benjamin Franklin. The quad unexpectedly climbs a hill before it spills out onto Locust Walk, one of the nicest urban ways at any college. Here the eye can enjoy a movable feast of medieval and classic details: tracery, hooded windows, and pergolas. One bench along this promenade is occupied by the figure of a man in colonial dress, complete with breeches. He is reading the *Pennsylvania Gazette* dated to commemorate the calling of the Federal Constitutional Convention of May 1787. In fact, this is a full-bodied bronze statue of, again, Benjamin Franklin—the "wisest American."

Actually, there is much going on outside the six square blocks of the university proper. There are medical buildings, Franklin Field, and—architecturally most interesting—the residence halls designed by Cope and Stewardson in 1895. The two architects created this enormous complex in combination Gothic-Romanesque style with details from Elizabethan and Jacobean times. It is a showy mix of grouped vertical and bayed windows with stone mullions and transoms, steep gables, segmentally curved caps, tall grouped chimneys set diagonally to each other, round arches, and decorative flat scrolls or strapwork.

The "Long Walk" at Hartford, Connecticut's Trinity College is all that was built of London architect William Burges's rich Collegiate Gothic quadrangles. Delineated outside spaces were eventually created by other structures following a different plan. But the Long Walk's solid (and original) Collegiate Gothic costumery both inside and out lends this campus a special cachet.

This is a closed dorm with heavy security as befits urban living quarters. IDs are needed to enter the gate, and then keys to open each front door. Still, the open quads and triangles created by this extensive structure provide a serene respite for the eye and make fine fields for throwing frisbees.

Yale—though urban—can hardly be called a campus. It is a series of unrelated scholastic entities, each with its own style: Ezra Stiles College, medieval Italian; Sterling Law, Gothic; Woolsey's rounded colonnade, imperial; Davenport, Georgian (except Gothic on the outside to match structures across York Street); the Beinecke Library, the art and architecture building, and the art museums, all modern.

Although Yale has had a number of incarnations since its founding in 1717, its dominant face today is the 1920s work of the New York architect James Gamble Rogers. He saturated the Yale campus with his own brand of picturesque Collegiate Gothic, which includes the whole repertory of Gothic mutations throughout the past 600 years. Rogers designed the law school, the main library, the Center of Graduate Studies, and residences like Harkness Memorial Quadrangle. The splendid space of Harkness divides into Saybrook and Branford Colleges. An elegant composition, well-scaled and detailed, it eschewed the religious Gothic of the nineteenth century. Punctuating this architectural ensemble is Rogers's 200-foot Harkness Tower, Yale's famous symbol.

The old campus is another noteworthy space at Yale and is entered from the New Haven town green through Phelps Gate. This much larger area is formed by mostly Gothic Revival structures built in the 1870s. Exceptions are Dwight Chapel, 1846, and the Georgian-style Connecticut Hall, 1753 (Yale's only extant building from when this quad was originally organized). Standing opposite Connecticut Hall is a 1925 imitative twin, McClellan Hall; such a contrived and unimaginative placement attracts its deserved share of catcalls: "For God, for country, and for symmetry."

Though their compact planning identifies them as urban campuses, not all the colleges in this category are in big cities. Well into the countryside outside of the city of Rochester in Upstate New York stands the Rochester Institute of Technology. Its planners chose to urbanize this fine campus in spite of the generous space available. Other urban campuses directly integrate their architecture with their cities and towns. Bates College in Lewiston, Maine, manages to do this while still maintaining a parklike character.

Recent planners at the University of Missouri have accepted the town of Columbia's streetscape and have done the best they could with it—not without success, either. Closing the street to traffic, they bricked the space between the fine arts building, the bookstore, and the library, built descending terraces, and called it Lowery Plaza. Then they landscaped the closed Ninth Street extension and provided an attractive, unimpeded way to get to class. Along this new walkway, McCoy and Hutchinson of Kansas

City constructed the law school—one of campusdom's few postmodern buildings that work. It is made of brick and glass with concrete trim and columns that recall the free-standing remains of the old quad. The east side of the law school is particularly handsome, with its fanciful brick and concrete walk.

Missouri's other successful space is the quad, which predated the streets and is surrounded by fine medieval and Renaissance Revival buildings. At the center of focus here are the six remaining Ionic columns that surrounded the portico of Missouri's burned 1892 administration building. Most of Missouri's more contemporary structures do not distinguish themselves—particularly, Brady Commons and the (not so) fine arts building.

Streetscape problems such as at Missouri and Boston University are not the only challenges facing the planners of city campuses. Urban topography is another. The College of the Holy Cross in Worcester, Massachusetts, illustrates the pros and cons of working with a hilly compound—the aesthetic advantage of vertical separation versus the angst of opposing gravity. So does Georgetown University in Washington, D.C. Positioned high on a hill overlooking the Potomac River, this should have been a romantic campus. "A more beautiful situation than this . . . could not be imagined," wrote William Gaston, Georgetown's first student. And its Healy Building, a multisteepled medieval character, would seem to be the appropriate centerpiece. (It is named for Father Patrick Healy, who was the first black university president in the United States.)

Misty pictures of the Potomac River beneath the Healy Building's antique profile suggest a perfect Pre-Raphaelite composition. But its east side is simply uncontained space, leaving a narrow void in the overall design. On close inspection the building does indeed live up to its distant silhouette—with pavilioned stone walls, round-headed windows, and dominating spires.

The modern work to the north follows the saddleback terrain with red brick walkways and plazas (another red square, along with those at the University of Washington in Seattle and the Evergreen State College at Olympia, Washington). Here sits the Leavey Student Activity Center, a recent brick building that is large in size but not in concept. Here also is the two-story resource center on the seventh floor of the intercultural center building. The lofty ceiling created by Metcalf and Associates displays a square-in-square design, reflecting the Middle Eastern motifs throughout the building. On the south side of the Healy Building is John Carl Warnecke's fine library building made of brute concrete.

Georgetown has tried to address its cramped and hilly circumstances with imagination and taste. But in the end, moving around this campus means going either up or down—which is sure to develop strong leg calves and may account for Georgetown's excellent athletic teams.

Not all urban campuses are "planned" after the fact—that is, stuck with

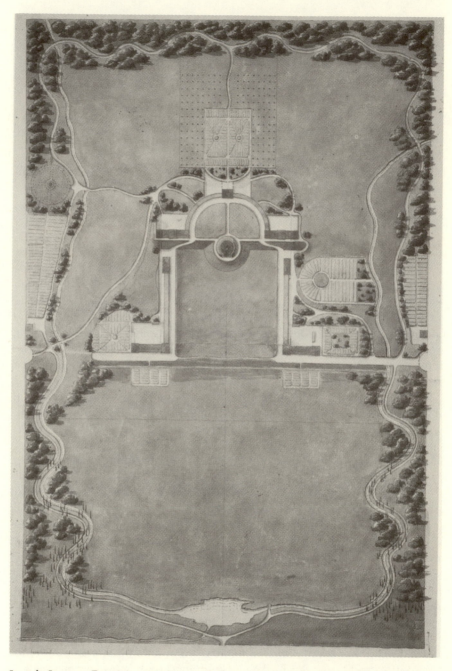

Joseph Jacques Ramée's 1813 Union College was probably the United States' first cohesive campus, four years before Jefferson's University of Virginia. Its parabola (pergola) focuses on a central point (Nott Memorial) with structural legs extending toward the west. This concept—nicely landscaped—produces a graceful set of spatial relationships. (Courtesy of Union College)

whatever city space is left over. In 1813, Union College in Schenectady, New York, was designed by Joseph Jacques Ramée, an itinerant French architect. It was the first professionally planned coherent campus in the United States. Now, some 176 years later—although the arcade is shrunken and the centerpiece expanded—the campus is surprisingly close to the original plan. Ramée's concept was finally completed only in 1967 with the construction of the humanities and social science buildings.

The main elements of the tightly knit Union concept were a curving arcade and two side structures connected by it, with the whole surrounding a high, domed, classical roundhouse—a kind of Pantheon. By the time this

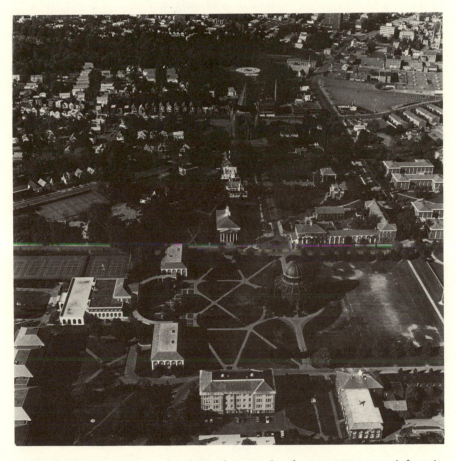

Union College's architecture has been changing for the past 150 years. A favorite theme is the Palladian technique of placing a second-floor order of pilasters on a first-floor masonry base. This can be seen at Schaffer Library and South Hall. A remarkable faithfulness to Ramée's original site plan can be seen in the recent aerial photograph. (Phil Haggerty, Courtesy of Union College)

centerpiece called Nott Memorial was completed in 1875, it had become a 16-sided structure in High Victorian Italianate Gothic. Designed by Edward Potter, the building took a half-century to complete. In any case, Ramée had turned the European monastic quadrangle inside out and created an inviting open plan. Art historian Louis Reau classed Ramée's Union campus right alongside L'Enfant's plan for Washington, D.C.

Speaking of which, for a campus right in the middle of the District of Columbia, Gallaudet College has quite a large site. But, especially for a campus that asked Frederick Law Olmsted's advice, it is a disappointment. Gallaudet is dominated by the medieval College Hall, which meanders along with no mind of its own—at the mercy of later additions. The hall does have its share of towers and tracery, however, and its character makes up for the blandness of the uneven modern buildings that followed. This campus has leapfrogged over all the styles between medieval and modern. With the exception of the well-landscaped secondary education training facility, its buildings do nothing to create satisfactory urban spaces.

4

Contemporary:
The Whole-Cloth
Campus

The Brown Decades ended: their creators and originators were
neglected. . . . Their monuments alone defied time.

Lewis Mumford

Even when extensive plans were developed right from the start, early
campuses rarely went beyond constructing one building at first—Nassau
Hall at Princeton and Old Main at Colorado, for instance. Stanford and
Virginia were exceptions to this almost universal pattern. In recent
decades, however, the story has changed. By the time a new campus is
needed, the heavy demand for it requires that large segments must be con-
structed all at once. Thus we are seeing the sudden appearance of almost
entire new campuses out of fine-quality whole cloth. It has been a rare oppor-
tunity for architects to practice advanced theories of planning and design.

Like forces of change leaning into the winds of time, contemporary work
often places original architecture on conventional layouts. One of the
juiciest commissions of all time went to the Chicago office of Skidmore,
Owings and Merrill in the 1950s. They were to design—and the federal gov-
ernment was to build—the enormous United States Air Force Academy at
Colorado Springs. Using a stunning site snug against the Front Range of the
Rockies, architect Walter Netsch produced Miesian structures on an axial
plan. The tesselated parade grounds provide gigantic spaces that have been

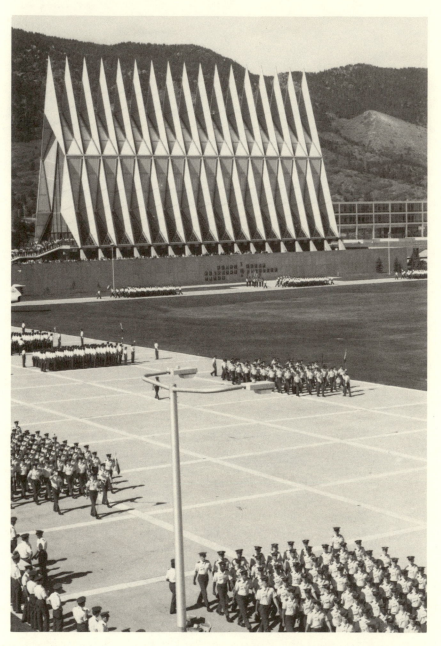

The chapel at the United States Air Force Academy makes a vertical foil for the colossal spread of the parade grounds. (Photo courtesy of United States Air Force Academy)

quite adequately enclosed by low, disciplined, generously glazed, but architectonically unrelieved buildings. Vandenburg Hall is a quarter of a mile long. The Beaux Arts whole is completed by one tall focus: the ecumenical chapel. This aluminum jewel of 17 folded spires is the campus signature. Lawrence Halprin's landscape plan is lean and just right.

With all the talent that produced this work, it had to be a masterpiece. Why then does my heart go out to the young men and women who labor in these academic vineyards? It is because the overly ordered, austere atmosphere created here by adherence to the strict rules laid down by the Bauhaus School in Germany in the 1920s has a deadening effect on the flowering of aesthetic dreams. Desirable continuity is achieved by sameness; order provided by monotony. Thus we have a cookie-cutter campus where a few modules are placed along side, on top of, and opposite each other to make a glib entity that would undoubtedly have gotten an A grade in advanced architecture class. The academy is a monumental statement of refinement in which there is virtually no warm or homey place for people to gather.

Certain interesting modern experiments have tried single-building schemes (a hark back to our original campuses) and linear plans. Single megastructure campuses do not create urban space, however—Richard Maier's Hartford Seminary, for example. And neither do those that are planned along a gallery under one roof—a sort of educational shopping mall. This is true even of some very fine contemporary gallery-style work like Governors State University at University Park, Illinois—planned by Caudill Rowlett Scott—or the Art Center College of Design in Pasadena, California, which has a small campus designed by Craig Elwood in 1975. The latter is another Skidmore, Owings and Merrill version of Miesian architecture, with crisp black steel and glass featuring diagonal wind bracing. Essentially a bridge across a ravine, its single long structure leaves little room for developing a sense of urban spaces. Stockton State College at Pomona, New Jersey—by Geddes, Brecher, Qualls, Cunningham—also has a circulation gallery that curves along the site's contours. But linear is not the wave of the future. These campuses are shallow and require people to double back at almost every move.

One linear plan that does have urban spaces is Kresge College, one of the eight campuses at the University of California, Santa Cruz. This school follows the spine of the foothills overlooking Monterey Bay. A flagellate path winds through the redwood forest (the height of the campus structures being no more than two-thirds that of the trees) from the college entrance "gate" (with medieval reference intended) to the small isolated plaza that terminates this transmogrified Italian hill town. Kresge's living quarters mix with its classrooms and open onto the "street" Tuscan style, with just a hint of Spanish mission.

Kresge College is one of the darlings of architectural camp followers. Visitors come from around the world to view Charles Moore's new concept.

What they see demands nothing less than a karmic adjustment from the skilled observer, for conventional architecture is denied here. Mass is denied; volumes and voids are denied; flat white walls make an unrelieved campus with no detailing; false fronts and rectangular cutouts create the illusion of a cardboard campus; the streetwide plan and tiny plazas induce claustrophobia.

There is a privacy problem at Kresge as well, since the schoolrooms and bedrooms are intermingled. The corniceless roofs allow water to run down the walls, causing rot. And since there is no escape at the end, every move a student makes requires a doubling back. This interesting experiment in campus design is the result of the University of California's admirable determination to try new forms. But good design is not served if it becomes a willful search for mere novelty. If not allowed to be precious, whimsy can be useful in lightening up a serious statement; as the main claim to fame, however, whimsy is not enough.

Santa Cruz is an example of the University of California's growth by college module—a big idea only possible in a big state. Another contemporary U.Cal. campus is at Irvine. Laid out by William Pereira in the 1960s, the campus surrounds a 21-acre wooded center. While visionary, this design effectively prevents the formation of any urban space relationships (something like U.Mass.–Amherst, which is described in Chapter 5).

The heart of the Irvine campus is a series of concentric rings—the inner with undergraduate facilities; the outer for grads and research. The ring-within-a-ring metaphor was intended to express a student's self-absorption during the first years of study and then growth out into the wider circle of the world beyond the campus.

Pereira built the library and student union buildings, as well. They have been criticized as being obsolete modern, a group of "cheese graters." But given the chaotic sprawl that is the Irvine campus, the eye cries out for some order. Pereira's recurring incarnation in the architecture provides that; for me, it is a welcome sight.

In pursuit of still further novelty, Irvine has more recently employed well-known postmodern designers, and they have plied their unsettling trade relentlessly. Frank Gehry—violating the rules of architectural grammar—has provided an engineering building with bulging walls of galvanized steel, in the deconstructivist mode. (This movement of despair believes in random images like the tumbled stones of a bombed city; its watchwords are "fragmentation," "suspension," and "diagonality.") Robert Venturi came up with a barn-shaped structure for the graduate school of management, with reminiscences of the basilica form. ("Inclusivism" is the name of his game.) Eric Moss retaliated with the central heating office, whose main feature is unplumb columns made of terra-cotta pipe. And Charles Moore has given us a lighthearted Italian stage setting in his extension and alumni houses.

The jury is still out on the timelessness of postmodern architecture. Actually, there is an interesting opportunity to compare it with more conventional modern in the fine arts school compound at Irvine. Here an excellent group of buildings was erected in the 1960s by Pereira, who is said to have taken a more personal interest in it than he did with his other campus buildings. It displays a deft use of sculptured concrete forms, with horizontal volumes intersecting vertical planes. Ceilings are coffered and space meanders surprisingly here and there, under and over. Dynamic areas between the structures are created by their skillful placement.

When it came time for an addition to this compound, William Stern's New York office got the job. Now in the compound there is a pinkish structure that, in true postmodern form, stands off by itself, reminiscing—with its barn form (colonial), its shallow round windows (roman), and its acroterion-topped roof (Greek). It has no relation to the rest of the compound, and no urban space is created by its presence. Perhaps this stepchild will eventually be connected to the rest of its family by means of other buildings, walls, or landscaping. Even if it is, it will probably never look like it belongs with the earlier modern buildings. To me, it seems to represent a typically contemptuous postmodern demand that any structure, no matter how well designed, must reference the past, no matter how inappropriate.

Irvine's postmodern buildings are generally small and isolated. So far, they have not succeeded in destabilizing the campus. Its enlightened chancellor, Jack Peltason, supports their presence as a matter of principle, saying, "I don't have to like it."

The most successful modern University of California campus is that at San Diego. Once again, William Pereira provided the beginning: the centrally located (both geographically and scholastically) library, built in 1970. It is a multisided upside-down wedding cake form—almost a flying saucer. The architect described it thus: "The building conveys the idea that powerful and permanent hands are holding aloft knowledge itself."

Originally designed with steel cantilevering, the library's proposed cost sent Pereira back to the drawing board. He changed the structural system to one with massive cast-in-place concrete sloped beam columns on each of the four sides. The attractive results are now visually well documented; the building is an attention-getting main element for the campus. (Inside, however, overly partitioned and with low ceilings, it is a letdown.)

This school, too, has hatched several sequential campuses surrounding the library. Less effort has been made to separate them, however, making the whole more collegial than at Irvine or Santa Cruz. Three of the campuses segue nicely into one another: Ravelle, Muir, and Third Campus (with a name like that, can a donor be far behind?). The few urban spaces at Ravelle—the original campus—were thought to be too large; the Muir campus, accordingly, has more and smaller areas.

When sculpture is heroic in size, it performs more than a decorative function. "The Sun God" by Niki de Saint Phalle—while unable to prevent sky fluids from falling to earth—does create fluid space on the University of California, San Diego, campus. The school's Stuart Collection (of artworks) gives this place an extra visual dimension. (Alan Decker)

Robert Mosher's design for Muir campus makes it probably the best one visually. It consists of upthrusting, peened concrete. Building stories are delineated on the exterior by concrete-form outlines. (Belt courses would have been the traditional method.) Repeated clusters of casement windows create a leitmotif for the campus, which is a coordinated group of structures that builds up to Tioga Hall. Open skywalks connect the buildings with each

other, while shrubs and climbing ivy soften the concrete surfaces. Muir is an assertive, pre-postmodern campus that depends architecturally on massing and form. One theory has it that its vertical graining is meant to compensate for the trees that were removed for construction. This may seem a fitting apologia in a campus named for naturalist John Muir, but the story is surely apocryphal, for the name was chosen after the work was completed.

San Diego has many sculptures on the grounds—a happy side effect of its active endowment program. The most unique must certainly be three recondite trees in the eucalyptus grove near the library. Terry Allen has encased the trees in lead and wired them for sound. Students enjoy the eerie experience of hearing incessant nondirectional mumbling emanating from somewhere in the grove.

Many of the buildings on campus were designed by local architects from San Diego and La Jolla, who tended to be more interested in harmony than in the making of monuments. This has been for the better: Though the various campuses at San Diego meld into one another, they avoid a feeling of sprawl and visual cacophony by means of solid contemporary design throughout. (However, one music professor with a documented IQ of 186 did admit that he gets lost whenever he leaves his building.)

A truly contemporary campus is one that meets the needs of its program in a one-of-kind way. Similarity is rare, because no two programs and no two sites are alike. Thus we have the inner-city University of Illinois at Chicago campus (UIC, formerly Circle Campus), which developed unlike any other well-designed contemporary work—Southeastern Massachusetts, or the Evergreen campus in Olympia, Washington, for instance.

Although the University of Illinois at Chicago was designed by the same firm as was the Air Force Academy in Colorado Springs—the Chicago office of Skidmore, Owings and Merrill—the UIC campus is aesthetically quite different. There under the shadow of the Sears Tower is a sculptural tour de force of a campus, its central space consisting of a raised platform with a depressed amphitheater for sitting but also for walking down to the lecture halls that surround it a floor below. As discussed in Chapter 2, this lecture hall arrangement reflects a unique design program that calls for grouping facilities by function rather than discipline. Meanwhile back aboveground are three smaller raised amphitheaters where students sit on the bleacherlike sides. This juxtaposition of positive and negative space is a genuine inspiration.

The central area is bracketed by the library and the union buildings—both assertive modern designs, but with disappointing interiors. Raised granite walkways course in spatial grandeur through much of the campus to the north and under the engineering lab to the south. But perhaps the finest compliment one can pay to this modern work is to acknowledge that neither text nor photograph can ever do it full justice. After all, what happened here is nothing short of miraculous: Architectural alchemists turned a slum into stylistic gold. As they say, you had to be there. Unfortunately, practi-

Searching for an outdoor gathering place on an urban campus, planners found a creative answer: the amphitheater steps. The University of Illinois at Chicago student union, and also the Sears Tower, are in the background. (University of Illinois at Chicago, the University Library, University Archives)

cal considerations like ice on the walkways mitigate the popularity of the campus among its students, who often wind up moving through the gloomy underpaths.

It would probably be hard to argue—or to convince anyone, anyway—that our first college campus, Harvard, was the genesis of our first modern campus, the Illinois Institute of Technology (IIT). Yet each depends

Elevated walkways are the signature of the University of Illinois at Chicago. (There is talk of enclosing these walkways for easier winter use.) This one leads to University Hall with Stevenson Hall, the library, and the science and engineering office building from left to right. (University of Illinois at Chicago, the University Library, University Archives)

for its spatial effect on the same technique: the offsetting of vertical planes (buildings) so that the areas between are varied and dynamic. In fact, IIT—designed by Ludwig Mies van der Rohe—is an exploded version of its architect's famous 1929 German pavilion at the Barcelona Fair. This seminal glass-enclosed structure, which has since been replicated as a permanent building in Barcelona, contained free-standing interior walls that caused space to slip and slide around them. The effect was as much a revelation at IIT 35 years later.

Mies left Germany after Hitler closed down the Bauhaus School. Eventually he made his way to the United States and was hired to teach at and develop a new campus for IIT. There Mies promptly set about reforming the Beaux Arts instant approach to design in favor of teaching structure and the nature of materials. Frank Lloyd Wright was the only other master who taught these subjects before going on to the study of design. On top of his broadened approach to technique, Mies flew in the face of the new assumption that buildings needed to be specialized. Instead, he opted for the classic concept of flexibility through universal solutions. According to this philosophy, buildings need never become obsolete.

The structural scheme that Mies used for IIT consisted of a steel frame whose flanges would support either glass or brick insertions. (If steel had existed in the ancient order, we would never have had classical architecture, according to Frank Lloyd Wright.) His carefully modulated proportions use a 24-foot module. (The scheme of 24 wide, 24 deep, and 12 high has always been considered a pleasing proportion. Ictinus used the 24 module for the Parthenon; so did Joseph Paxton for the Crystal Palace and—in our own sphere of interest—Mathes Bergman for his Louisiana State student union.) It is not the originality of this system that is important, but the refinement that Mies applied to it. He would study the structures' relationships for days, with an assistant moving model wall components a little this way and a little that to create his notion of perfection.

Crown Hall is the best-known Mies building on the IIT campus. Its huge plate girders support a hanging roof, thus obviating the need for interior columns. Accordingly, the virtually endless teaching space contains drafting tables as far as the eye can see. And because it is only one story, the clean, crisp steel of Crown Hall has never needed to be muddied with fireproof spray.

After Mies had completed much of the campus, the IIT trustees surprised him—and every member of the attentive architectural world—by opening up building commissions to other designers. Walter Netsch of the Chicago office of Skidmore, Owings and Merrill—very much in the Mies tradition—produced the union derived from Crown that is perhaps the second-best structure on the campus. Its huge interior lobby in front of the theater shows how careful proportioning can make a space pleasant even when large.

It is not true, as is generally alleged, that Mies abhorred landscaping; he

did *not* feel that it complicated the view of his pure buildings. His taste in this art is demonstrated along the west length of Perlstein Hall where an offset pattern of trees softens the hard disciplined lines of the structure.

Although the integrity of the Mies plan has never been lost, the question often arises as to whether a whole campus of such relentless coordination—a campus of perfect proportions and details, a campus of pure refinement—offers the eye enough diversity. If IIT could be leavened by some of Kresge College's whimsy and if Kresge had borrowed a touch of IIT class, both campuses might have been better served.

Still another modern campus like no other is Southeastern Massachusetts University near Fall River. As in the case of the Evergreen College in Washington state, SMU's core has no discernible geometric form; it merely fits its site and its purpose. Reveling in the joys of reinforced concrete, architect Paul Rudolph provided mostly three-story pavilions—partly cantilevered and partly on pilotis—featuring outside hanging stairs, vertical window patterns, and much fixed glass.

A series of gentle terraces winds around the many coordinated structures. Buildings surrounds the core on three sides, with room for expansion to the east, and there is a handsome modern shaft for focus. Outside the core, a ring road keeps vehicles away from the center; outside the ring road are the dorms, the sports center, and the power station. Here is a definitive whole-cloth campus with all the contemporary requisites: creativity, site accommodation, continuity, and strong architectonic elements emphasizing form and volumes.

Not all spanking new campuses are low rise. SUNY at Buffalo has a new urban "spine" that flows between the buildings like a city promenade. This school is experimenting with an on-campus shopping mall in an effort to satisfy the demand for private services at its otherwise isolated, automaniac campus. Right on Lake LaSalle, it will have shops and offices plus kiosks and cart locations for student entrepreneurs. Another example of the high-rise campus is the Rochester Institute of Technology (RIT), which has a clustered, almost downtown look of high modern structures.

SUNY at Purchase, New York, exhibits a close kinship to RIT. Both adopted strong geometric forms for their buildings, both have walls and walks covered with brick, and both have an all-star cast of architects. But they differ markedly in plan. While RIT's tall buildings are grouped together, Purchase has adopted a severe axial layout populated with large low structures on a raised platform. The library building emerges like Neptune from the sea, rending the campus mall in two. Tree plantings emphasize the directional character of the campus. There is more grandeur in the spaces than in the buildings, whose floors go both up and down from the platform level.

Endless covered walkways on the north and south of the campus have canted roofs, and structures are assigned building lots like a subdivision.

Architectural coordinator Lawrence B. Anderson placed the Rochester Institute of Technology's buildings so that varied urban spaces resulted. This successful project brought together three of America's best modern campus architects: Edward Larrabee Barnes, Harry Weese, and Hugh Stubbins. (RIT Communications)

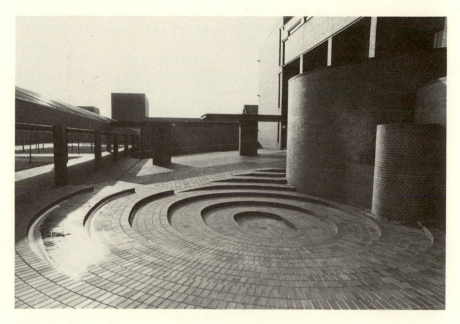

Relentlessly geometric, the sculptural forms of the SUNY at Purchase campus assault the eye. Longitudinal walkways have half gable roofs. (Printed with permission of the State University of New York at Purchase)

The lots are 130 feet wide with 32-foot walkways between. Each architect used the same brownish brick, gray glass, and gray anodized aluminum. Edward Larrabee Barnes provided the overall plan, the performing arts center, and the library; Venturi and Rauch, the humanities and social science building; Philip Johnson and John Burgee, the museum of art; Paul Rudolph, the natural science building; Gunnar Birkerts, the dance instructional facility; and the Architects Collaborative, the visual arts instructional building.

Purchase's relentless formality of plan along with its strong geometric architecture makes a double whammy, and that is probably one whammy too many for the harried eye. RIT's informal plan is a better foil for its pure architectural rectangles and cubes.

The largest collection of Frank Lloyd Wright institutional buildings in one place can be seen at Florida Southern College in Lakeland. Think of it: a college campus dominated by the master! Wright—with characteristic immodesty—called it the only "truly American campus." What actually materialized on the 1922 site were eight buildings that, due to budgetary restraints, were constructed of on-site sand-cast concrete block using mostly student labor. The lack of quality control produced structures that, unfortunately,

have not stood the test of time. Other savings were made by painting some of the fascias green, instead of using the more expensive copper (as was also done at Washington University; see Chapter 5).

The Ann Pfeiffer Chapel—built in 1940, and best known of the Florida Southern buildings—is angular in a Wrightian way and is topped with a roof outrigging (which the students call "God's bicycle rack"). Covered walkways, or esplanades, connect the structures and are fancifully designed; they hug the ground, though, and appear to have been scaled for toddlers. All this having been said, Florida Southern nevertheless offers an example of the great architect's collegial vision. And that, in itself, makes it a treasure.

5

Regionalism

Architecture began in Asia, flourished in Greece and was brought to perfection in Italy.

Leon Battista Alberti

Regionalism affects the planning, styles, methods, and materials that are characteristic of campus groups. It is determined by four basic influences. The first influence—historical period—encompasses both planning and style. Thus, New England and Virginia provided our first campuses and reflected the symbols of Old England in the Georgian style.

Local culture is the second influence. It manifests itself, for instance, in the green enclosed plantation campuses of the South. It is also clearly an influence in the West and Southwest, whose tile roofs reflect the Spanish presence. In the Northwest, campus decoration is characterized by totemic animal symbols, with their flowing lines carved and drawn by the Alaskan and Canadian Indians. The Rocky Mountain states, however, have hardly any cultural influences of their own, and campus designers get little help from local traditions. (Charles Klauder early on, and W. C. Muchow late, proved the exception to this at the University of Colorado, where they used the roof form of mining pitheads.)

The third regional influence consists of materials and methods. Using available clay, New England campuses relied on brick as their common

building material. With vast forests—notably of the Southern yellow pine—the South used much wood in building its campuses. The Midwest, with its emphasis on agriculture and its generous helping of limestone, constructed masonry campuses. Adobe is the material of the Southwest; even nowadays, it is still sentimentally used, although in the form of brown-colored stucco over cement block. Exceptions to this employment of regional materials abound, such as the consistently fine brickwork at the University of South Carolina in Columbia and at Reed College in Portland, Oregon. We are indebted to architect Richard Ritz for calling our attention to the continuity of brick usage at Reed over the years. Campus additions have remained faithful to its tradition of unusually wide joints that require pea gravel to prevent mortar settlement.

Climate and landscape represent the fourth regional influence. Despite the apparently recent "discovery" of solar orientation and other techniques, the fact is that temperature, precipitation, and sun have always been considered by designers. Buildings were oriented to face south in the seventeenth century. And in the early 1800s, students at Jefferson's University of Virginia walked under the protection of colonnades. Campuses continue to use covered walkways as a protection against snow (such as at Skidmore in Saratoga Springs, New York) and sun (at Louisiana State University in Baton Rouge).

Weather influenced the plan of campuses in other ways, as well. Buildings in the South were kept low to withstand hurricanes. And stuccoed brick or block, fairly common in the South and Southwest, is rarely seen in the North, as this finish does not endure well in cold climates.

New England

Because it was the earliest, New England's regionalism is the most pronounced. (New York, New Jersey, and Pennsylvania must be included in this stylistic region.) A sense of antiquity and place characterizes these campuses. They employ medieval and minimalist styles—appropriate for institutions considered to be removed from everyday reality. The buildings on campus are distinctly separated, but show a continuity of style. Sometimes they are laid out around town greens, as at Dartmouth, Amherst, Yale, and Williams.

Williams College in Williamstown, Massachusetts, has a stunning prospect of the ancient, rounded Berkshire Mountains. In 1839, Henry Thoreau wrote that the valley setting was "as good at least as one well-endowed professorship." Although its older buildings have some puritanical authority, the spaces they create are unplanted and a bit too regular. The new Sawyer Library by Harry Weese and Associates integrates well as it straddles two green quads.

Williams College has maintained a parklike ambience with a high percentage of lawns and trees to structures. One result is a weak progression of urban spaces. (Williams College Archives and Special Collections)

The museum of art at Williams is a fine example of the adaptive use of earlier architecture. Charles Moore and Robert Harper redesigned the 1846 brick octagon library by Thomas Tefft, retaining the neoclassical rotunda and providing a three-story entrance atrium. Moore exhibits his usual sense of play with catwalks and multidirectional staircases that are trimmed with

sensuous walnut railings. The Williams campus is not without its problems, though. Like Smith College, it is bisected by a busy highway. In this case, the culprit is Massachusetts Route 2, and it presents a planning problem that cannot be economically solved.

The last of the colonial charters went to Dartmouth College in 1769. In a surprising move for New England, this Hanover, New Hampshire, school's first buildings were made of wood. Later structures were masonry, and together they enclose a large green with, however, a somewhat too commercial character.

Dominating the Dartmouth green is the Georgian-style Baker Library designed by Jens Fredrick Larson and completed in 1928. Its 200-foot bell tower is an Upper Connecticut River Valley landmark. José Clemente Orozco's frescoes painted in the early 1930s are a very good reason to stop and enter this structure. Kitty-corner to the library stands the best traditional building on the green: the wonderfully proportioned and detailed Romanesque Revival–style Rollins Chapel. One peculiar disappointment of the campus layout must be noted, however: Though the college sits right on the Connecticut River, there is very little eye contact with it.

At Durham, the University of New Hampshire exhibits a more Midwestern character than a New England one. Its styles range from excellent Georgian-Federal structures with symmetry, hip roofs, dormers, and plain walls to the Romanesque Revival of Thompson Hall with round granite hooded windows, porte cochere, and turrets. There are also contemporary buildings, most of them poorly done: the library, the union, and the art center. But the lack of organized urban spaces is what tags the University of New Hampshire as non–New England. Instead, the campus follows ridges, drops into white pine dells, disappears, and reappears in a charming pastoral manner. Olmsted would have been happy with this campus.

Mount Holyoke in South Hadley, Massachusetts, typifies and perfects the special early-campus quality. Here abound the revived medieval styles—Romanesque and Gothic—using the red brick and brown stone characteristic of the region. Mount Holyoke handled its expansion needs with far more grace than did Harvard.

Eclectic campuses have their place, but they seem less at home in New England. Thus, Smith College in Northampton, Massachusetts, must be faulted in spite of its fine period specimens, "cottage residences," attractive spaces, and well-botanized walks—beech, tupelo, and so forth. It is a confluence that must have pleased Frederick Law Olmsted, who loved the informal English approach to gardens and whose firm drew plans for Smith in 1892.

But Smith's wide stylistic range is more in keeping with the Midwestern campus mixture than that of monastic New England. Administrators here have allowed Georgian, Greek Revival, and Victorian to shoulder aside the original medieval. They have also promoted the spread of a common

Mount Holyoke is awash with the symbols of New England campusdom: the entry with masonry piers and wrought-iron gate; the turreted, machicolated tower; the rusticated stone facing.

aesthetic disease: the malignant-growth syndrome—in this case, attacking the Neilson Library.

This 1910 building was a work of Palladian perfection. Its Doric portico with modillion blocks supporting the eaves, its gable decorated with dentils and egg-and-dart trim, its two-story, round-headed windows, its complex ironwork and scrolled brick—all are elements that anybody can employ

separately. But only a few—in this case, Lord and Hewlett—can assemble them on a scale and relationship that makes a consummate whole.

Such a work is an organic being from which nothing can be subtracted nor anything added without great pain. In its search for more space, Smith could have gone the underground route like Harvard's Pusey Library, Columbia's Avery Library Extension, or the undergraduate library at Illinois. Or it could have constructed a separate annex behind the library with surface, undergound, or skywalk connectors. (This space has since been taken for other purposes.) Instead, in five separate additions to this building, the administrators managed to destroy a rare architectural piece to satisfy the logistical needs of the moment.

Hampshire College near Amherst is part of the local five-college system, but it has neither quads nor squares to identify it as a New England campus. It does have a pastoral character with hilly backdrops and, when fleshed out, may some day show the way for modern campuses. For now, however, its sound modern brick, concrete, and glass buildings by Justin-Pope Associates offer little in the way of enclosed urban spaces.

Along with Smith, Holyoke, Amherst, and Hampshire Colleges, the University of Massachusetts (just around the corner from Amherst) shares classroom privileges. But this huge university does not fit into the regional New England pattern of human scale, separate antique structures, and cozy wooded dells. Its center is unique, built around a park (like the University of California, Irvine) complete with rolling fields, monuments, and a pond. (Olmsted successfully blocked the original plan of a single large building to contain the whole campus.) The older enclosing buildings are weak delineators, but the fine modern structures are high rises: the university library and the Lincoln Campus Center. These are counterbalanced on the other side of the park by the sweeping, horizontal fine arts center.

The Murray D. Lincoln Campus Center was designed in brute concrete with Marcel Breuer's usual structural revelation. It contains 161 hotel rooms along with other student union conveniences. The room housing the cafeteria has a few shortcomings; for one thing, it demonstrates that deep, natural light wells neither relieve an oppressively low ceiling nor bring in sufficient light. The campus does take a brightly different approach to the perennial problem of parking, though, with a multistory nonintrusive garage connected underground to the Lincoln Campus Center.

Kevin Roche designed the fine arts center across the park. Also brute concrete, its modern form is nevertheless quite different from Lincoln's dense massing. The arts center is an expanded assembly of low angles and planes—a skeleton with see-throughs in many directions.

Of all America's far-flung campuses, perhaps the nearest thing to perfect placemaking is the Harvard Yard in Cambridge, Massachusetts. I refer to the Yard rather than to the campus as a whole because, unlike at Mount

Holyoke, the character of the school has been lost with its physical growth. The Yard itself, though, is a paradigm of New England regionalism and makes an excellent case study.

Verily (make that *veritasly*), it seems to have been created and preserved through diligent planning and control. In fact, a close examination shows just the opposite: The Yard is the result of the longest chain of planning gaffes in the history of American campus making (and Harvard has had the longest time to make them). Harvard's presidents worried little about future land needs; it was, after all, a wilderness out there. Even as late as the last half of the nineteenth century, President Charles Eliot disposed of more land in the Harvard Square area than he acquired. (Eliot's sole concept of design was "to make a building of sound structure to accommodate a useful occupation.")

Eighteenth- and nineteenth-century donors exercised their privilege of choosing architects and sites (usually prominent) for their build-ings—hardly a selection procedure conducive to good campus design. Things went wrong even when great architects were engaged. In 1893 Richard Morris Hunt ignored the rest of the Yard when he designed the original Fogg Art Museum to face the street; it functioned poorly there and was finally demolished in 1973. (The New Fogg is on Quincy Street.) In 1937 President James Conant hired Walter Gropius to be a member of the faculty. This architect was already being apotheosized as the world's leading exponent of the International (Bauhaus) style, but Conant did not give him a building commission for 12 more years.

Today these questionable decisions have come home to roost. The build-ings are not even in themselves specimens; their placement is awkward; the imperial Widener Library jars the Yard's antique continuity; and worst of all, the statement-oriented modern structures that Harvard has built in the past 30 years gallop outside the Yard like brigands ready to attack.

Why, in the face of all this, does the Yard remain one of the most special places in all campusdom? Why is there a spell at work here?

The idea of a yard as a gathering place for students was new in the early 1800s. Most school structures were oriented toward the public roadway, and practical requirements such as privies occupied the backyard. (Some think this is the derivation of the term "Yard"; others believe it was originally a cow yard.) Change came in 1813 with the construction of University Hall; the inside placement and scale of this granite building by Charles Bulfinch determined the way the Yard looks today—the quiet, introspective quadrangles evocative of Cambridge (the quads at Oxford being more tightly closed).

And the old Yard managed to preserve its monastic feeling by benign neglect. It was simply left to its puritanical simplicity. Nobody changed roofs or added bay windows or trendy porticoes; nobody revivalized the

facades (to Greek) when that was fashionable in the nineteenth century; nobody connected the free-standing buildings; hardly anybody fussed with superfluous landscaping like foundation planting or fancy paving of the humble asphalt walks.

Fortunately Harvard has even ignored the generations of planners who were determined to achieve axial symmetry. Redrawing the Yard's plan so buildings would line up and the quads would be square was a constant game. But this Beaux Arts impulse would have impinged on the library or interrupted the view of Memorial Hall. So, gridding was not to be, and the marvelous untidy character of the Yard endures.

An important contribution toward maintaining the yard's solemnity was the conviction on the part of its early architects—Solomon Willard, Charles Bulfinch, Loammi Baldwin, Edward Harris, Robert Peabody, Charles McKim, and Charles Coolidge—that their work should genuinely belong. To this end, prideful monuments were eschewed. For instance, in 1878 H. H. Richardson brought a new style—neo-romanesque—to the Yard with his underappreciated Sever Hall. Yet it was a noninvasive component. Even the latter-day Canaday Hall makes a valiant stab at fitting in with the existing Georgian buildings. It is a modern expression of the old symbols—red brick, pitched roof, and dormers.

From the beginning, Harvard set aside its Yard with an enclosure. The first, in 1638, was a six-foot stockade. Architect Charles McKim began the present memorial fence of wrought iron and masonry in 1901 and took 30 years to complete it. The first and most elaborate opening was the Johnston Gate at the west entrance. (Actually, it existed before the new fence was built.) Panelled brick and limestone pillars are arched by intricate iron tracery brought gracefully down to the wall by scrolled brackets. The gate is of handmade Harvard brick designed to look like the early material. This may be the most elegant collegiate gate in the United States. (Other contenders for the title might include the Sather Gate at Berkeley, the FitzRandolph Gate at Princeton, the Field Memorial Gateway at Mount Holyoke, the north gate at the University of Chicago, the Broadway Gate at Columbia University, the Haygood-Hopkins Memorial Gateway at Emory University, and the Van Wickle Gates at Brown.)

Harvard Yard is what it is by virtue of its time in history, its avoidance of faddism, and the sanity of all those administrations that resisted "bringing it up to date." Sadly, decision makers in the middle of the twentieth century ignored these lessons, and the design devil returned. Granted, its expansion was required, but Harvard produced modern buildings that make no attempt to relate to, and indeed sometimes overbear, the Yard—structures like Gund Hall, William James Hall, the Sackler Museum, Le Corbusier's Carpenter Center, and the science center (ingeniously sited on an apron over Cambridge Street, but a poorly conceived mass nonetheless). These

works display the contemporary architect's frequent indifference to his or her surroundings. As a result, Harvard Yard as an isolated coherent place barely survives. Yet modern buildings *can* belong, as proven at Wellesley, Mount Holyoke, and Smith.

The sense of place and "connectedness" at Brown University in Providence, Rhode Island, is indescribable. To some extent, this has to do with longevity. Brown (1764) is the seventh oldest college in the United States, after Harvard (1636), William and Mary (1693), Yale (1701), Pennsylvania (1740), Columbia (1754), and Princeton (1756).

But Brown is second only to the Harvard Yard in its feeling of timelessness. To this, add its ability to extend its venerable ambience to the surrounding area of College Hill. (Originally there was resistance to the site as being an "inaccessible mountain.") Brown is a montage of old New England images—Adamesque doorways, bracketed eaves, and tree-lined streets with stone parapets supporting picket fences. There is no aesthetic clash of town and gown here. What else would we expect of an old Baptist village where Benevolent Street intersects Benefit Street, where the wealthy live on a street named Power and the students on another named Hope?

Certainly, the ancient quality of this campus is also due to its old-fashioned New England college green with separated structures of great character. There is the Georgian-Federal period relic: University Hall, the first building. Federal-style Hope College was the second, with its hard brick and tighter joints. Greek Revival left us Manning Hall, a copy of the Temple of Artemis Propylaea at Eleusis—an architectural ploy to associate the school with classical education. The Romanesque buildings are superb: Slater Hall, featuring wonderfully patterned brickwork; Sayles Hall, changed from brick to granite after architect Alpheus Morse saw H. H. Richardson's Trinity Church in Boston; Wilson Hall, of ashlar sandstone with brownstone trim; and—just to the north—Lyman Hall, influenced by Richardson's libraries in Massachusetts and Vermont.

Then there is the classical gem of the school: the John Carter Brown Library, with its handsome pronaos. This building proves that even a small structure can aspire to Beaux Arts grandeur. Just off the green is the Victorian Gothic beauty, Robinson Hall, which has a polychromed octagonal dome and lantern. Another Victorian masterpiece is the Italian villa, Corliss-Bracket House, with pedimented windows, balustrades, and wide cornices. The fact that so many of the structures on or near the college green are specimen examples says much about Brown's aesthetic quality.

On the other hand, the use of outside furnishings is not Brown's strong suit. The Soldier's Arch is no more than mediocre. And the much too small-scaled—but excellent—Henry Moore bronze in front of Faunce House would be more appropriate if set in the modest Wriston Quadrangle. By the way, Brown University is named for Nicholas Brown, who gave $5,000 to

Brown University's brick-pier iron-grillage fencing was patterned after Harvard's. The exquisite Van Wickel Gates are opened twice a year: inward for convocation, outward for commencement. (John Forasté/Brown University)

endow a chair—surely one of the cheapest rides in history (after John Harvard, who traded a few books for immortality). Today, it takes at least $1 million to name just one building.

Many nineteenth-century New England schools ambitiously constructed enormous single-building colleges containing administration, classrooms, residences, dining halls, lounges, president and faculty quarters, and other necessities. At the beginning of the twentieth century, most of these behemoths conveniently burned to the ground. About that same time, administrators began to understand the advantages of containing various functions in separate places—as at Wellesley, for example.

One of the few remaining of these great massive schoolhouses is the busy Main Building at Vassar College in Poughkeepsie, New York. Designed by James Renwick, Jr., in 1859 in the style of the seventeenth-century Louvre Palace, this mansard-roofed pile with end wings, pavilions, triple-corner columns, and round-headed windows is evocative of a Victorian age when unmanaged imaginations flourished. For a short time, this was the largest building in the United States. It reflects the romantic tradition of relating structures to their surroundings by color. According to Calvert Vaux, "Every rural building requires four tints." Main Building's red brick walls had dark pearl trim, bluestone string courses, and purple and green roofs.

This structure has been enlivened by the addition of what Vassar calls the "College Center," a kind of union. Built in 1975 by the Boston Firm of Shepley, Bulfinch, Richardson and Abbott, it encloses the rear wing with a Gropius-like skylighted atrium of steel, glass, and brick.

Vassar's two areas of spatial interest reflect the regional characteristics of New England campuses: The pleasantly scaled residential quad is created by separated Georgian structures, some with triple offset gables and all with sandstone trim. More interesting (and more Olmsted-esque) is the larger undefined park loosely enclosed by Main, the president's house, the loggia-clad chapel (containing both La Farge and Tiffany windows), Taylor and Rockefeller Halls, and the marvelous Thompson Library. Its specimen trees give a lift to an otherwise flat plain with white pines, beeches, and the largest sycamore I have ever seen.

Modern contributions that neither add to nor subtract from the urban space at Vassar include Saarinen's Noyes House, a semicircular saw-toothed dorm, and Ferry House—another dorm, by Marcel Breuer, with his typical geometric forms of white-painted brick and natural wood exterior. The Seeley Mudd Chemistry Building of brick and glass block, is a fey post-modern structure that acts as a foil for the more classical New England Building next door. (The chemistry building is one of many on American campuses that have been the beneficiary of Mudd funds. These include Harvard, Yale, Princeon, MIT, Amherst, and Oberlin.)

Bryn Mawr College in Pennsylvania claims that its 1887 Radnor Building by Cope and Stewardson introduced the Collegiate Gothic style to the

United States. Aside from its assured success in Anglophile Philadelphia, this work struck a responsive chord in much of academia, and the young architectural firm was to draw its oriel windows, crenellated towers, and pointed arches for Princeton, the University of Pennsylvania, the University of Missouri, and Washington University in St. Louis.

This late–English Gothic style continued to grace new academy halls through the 1940s. And while it may be true that Bryn Mawr's Collegiate Gothic was most influential, the truth is that English architect William Burges designed the 1878 Seabury and Jarvis Halls in this style at Trinity College in Hartford, Connecticut, nine years earlier. Trinity recalled St. John's College in Cambridge, England.

Bryn Mawr does contain an interesting segue from Victorian Gothic to Collegiate Gothic in its first building, Taylor Hall, which reflected architect Addison Hutton's abhorrence of conspicuous display. Well acquainted with founder Joseph Taylor's Quaker beliefs, Hutton designed a structure in keeping with the "style of a Quaker Lady—her satin bonnet, her silk dress, her kid gloves, her perfect slipper to harmonize with the expression on her face which is both intellectual and holy."

Thus the 1884 Taylor Hall looks down from her high tower resting on a tightly massed pile with pavilions, steep gables, and tall chimneys. But the first was the last at Bryn Mawr: The Quaker-lady approach to campus building was ended when the trustees hired (because of family connections) architects Cope and Stewardson. And these two young men—captivated by a recent visit to Oxford and Cambridge—then introduced their late-English Collegiate Gothic mode. (Thus the Collegiate, that would sweep all before it, came about as a product of nepotism.)

The transition from the polychromed Gothic and Romanesque Revival styles of the High Victorian period to the square towers of Collegiate or Tudor Gothic that blossomed in the early years of the twentieth century can be seen on many campuses of the Northeast. Princeton's marvelous nineteenth-century buildings by William Potter melted into the secular Gothic of Cope and Stewardson. (This latter Gothic was admittedly an easier style to draft.) Landscape architect Calvert Vaux, a partner of Frederick Law Olmstead, laid out an 1882 plan at Bryn Mawr calling for a small central quad. But by 1891 his concept had already been violated, with the construction of Denbigh Hall. After that, the school was committed to Olmsted's surprising concept of boundary-line buildings with interior plantings and open space. This disagreement between the two great landscapers produced a diffident but dignified campus whose most interesting space is that between Pembroke and Taylor. The 1894 Pembroke Hall was a linear Gothic solution for defining the southern campus boundary (at that time), which Vaux had originally suggested accomplishing by plantings. An apt touch is the return wall to the north of Rockefeller Hall, which helps to enclose and articulate an otherwise unrealized sense of definition.

Eventually, Bryn Mawr gave up its "architecture of association" and ventured into the postwar world of contemporary design. Though Louis Kahn always insisted that his Erdman Hall was meant to reference the medieval styles of the campus, his lozenge-sided building does not, in fact, visually integrate into the surrounding work. The best of these modern structures is Canaday Library, which uses the gray stone of the past in a new way. While blending with the older buildings, Canaday offers a different interior experience with its central atrium and a periodical room brightened by glazed walls.

Bryn Mawr's halls are given Welsh names, the most creative of them being Helfarian, which means "place where the gold is chased." Helfarian houses the development office. Bryn Mawr itself means "high hill."

Though following the same development pattern, Swarthmore College near Philadelphia started out in 1864 with the great Parrish Hall, designed in Second Empire—a popular Victorian style in a time of high style. Fifty years later, it built Clothier Hall of granite and limestone as its Collegiate Gothic entry. In the interim, Swarthmore placed its structures carefully to create a number of pleasing spaces; and since then it has avoided the usual campus downfall by building good modern work.

This includes the baronial Sharples Dining Hall by Vincent Kling and the pleasantly sprawling DuPont Science Building—the latter relating better to existing structures, and also well landscaped. Nearby is the hill-hugging Lang Music Building by Mitchell-Giurgola. The McCabe Library, another well-sited building, recalls earlier styles with its stone face and loopholes (slits for medieval bowmen to repel the enemy). Here, in self-conscious whimsy, Swarthmore runs the annual "McCabe Mile," an 18-lap footrace through the downstairs bookstacks.

In addition to taking advantage of its site, Swarthmore remembered the joy of outdoor activities when it included on campus the beautiful Scott Arboretum behind the library as well as the bosky Scott Outdoor Auditorium that is used for commencement (among other things). When it rained during one graduation, the audience—gathered for protection in the fieldhouse—had to wait while the tradition-bound seniors walked into the outdoor theater momentarily with the president. Now commencements are always held outside, rain or shine.

With all the things Swarthmore did right, it does have one spatial flaw. The area on the empty side of Parrish Hall falls away down the hill and—being uncontained—is not space at all, but a void. (The Healey Building's empty side at Georgetown has the same problem, as mentioned in Chapter 3.) This narrow area should be delineated by a row of shrubs, trees, walls, or fences. Carefully done, it would convert nothing into something.

One other of the many small colleges situated along Philadelphia's Main Line railroad that is worthy of comment here is Haverford College— founded in 1833—earlier than Bryn Mawr or Swarthmore, and pre-

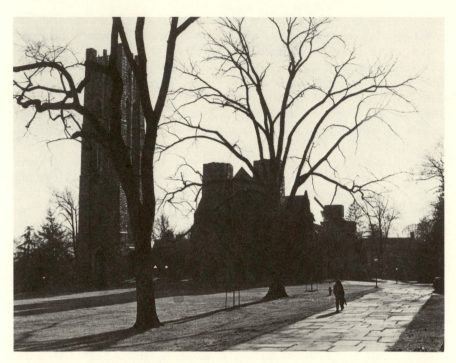

Swarthmore's architectural mix works well because of its high quality, building separation, and the fine walks between them. This Gothic Revival composition, Clothier Hall, contains a new social center manipulated into the rich building shell by Robert Venturi.

Victorian, in fact—Haverford at first housed all its functions in the Georgian-style Founders Hall and then proceeded to enclose a fairly tight and nicely scaled quad with the well-landscaped Gothic-style Magill Library and other structures that followed. This arrangement is not typical of the region but belongs further south where Jeffersonian planning eventually prevailed. Haverford is the male campus to Bryn Mawr's female, and courses are interchangeable: Just take the blue bus. The long, straight road approaching the campus prepares one for more than can possibly be delivered, and thus gives a first impression of amateurism in planning. Swarthmore, Duke, and Rice have the same sort of overdone approach road. And even at Stanford—where a masterpiece awaits at the end of the road—the device is still pretentious.

The South

While many Northeastern colleges were founded by the church—Harvard and Yale by the Congregationalists; Brown, Princeton, and Columbia by the Baptists, Presbyterians, and Anglicans (disestablished

during the Revolutionary War), respectively—the South had to depend on the states to foster its higher education institutions. Thus, most of its great universities are public schools.

From Maryland to Florida, campuses were influenced by the 1817 mall plan at the University of Virginia—a mode that would fit well into the Beaux Arts formality adopted by the United States in the years to come. Like Andrea Palladio 250 years before, however, Thomas Jefferson adhered to Roman rather than Greek forms and, as a rule, to residential scale rather than the institutional palaces of the Beaux Arts. His full-bodied classicism dominated the South while the delicate Federal style was flourishing in most other areas of the Eastern United States.

This classical pattern can be seen at the University of Maryland in College Park with its directional quad interrupted only by McKeldin Library. The raised pedimented porticoes columned in roman orders reflect the sober eighteenth-century neo-classical reaction to the flamboyant Baroque style. Walking down the Maryland quad, one could be in London or Leningrad.

The main administration building at Maryland has three porticoes, with six columns for the central one and four for the lateral subentrances. There are many parts to the huge Maryland campus; it includes a lovely Georgian chapel, some high-rise structures, and a poorly conceived horseshoe-shaped fraternity row. Overall, this campus of red brick Georgian ensembles is imposing. Nevertheless, after climbing so many great outdoor stairways to enter these buildings, one must begin to wonder whether this is really such a suitable style for a friendly American campus.

A more successful example of the rediscovered Jeffersonian mall plan (probably following in the footsteps of Chicago's 1893 Columbian Exposition, which touted formalism) is the "new" Johns Hopkins campus. In 1904, the school moved from its anticollegial, German-influenced campus in the middle of Baltimore to the outskirts, where it held a contest for the best plan. Parker, Thomas, and Rice won and produced a creative version of the cross-axis theme.

The result is a well-scaled quad where Georgian buildings are connected by Tuscan pergolas on the sides and brick arcades with limestone keystones at the corners. A cross axis extends to the south and is stopped by Garland Hall at just the right place to leave a pleasing Georgian-Federal subquad. Still another small quad in the school's planning hierarchy is created north of the Homewood Museum—this one quite closed in, as at the University of Virginia.

The glaring weakness of the Johns Hopkins main quad is the Eisenhower Library at the eastern end—too low to perform its containing function, and poorly conceived in a pretentious style of heavy stripped-down classicism sometimes called Mussolini Modern. The school could strike an aesthetic blow by replacing this structure with a large one or, at the least, building on a second story in a more appropriate style.

Johns Hopkins is a well-planned campus with depth and vertical interest.

The flat main site with hilly sides is well managed by means of outside balcony overlooks. It is a good—though not definitive—example of the Southeastern regional style.

In Williamsburg, Virginia, the College of William and Mary (really a university) spreads out in a large triangle from the original small triangle made by the Wren Building, the Brafferton, and the president's house. The second oldest campus in the United States after Harvard, William and Mary was granted a royal charter in 1693. Its informal grounds of separated but related structures has sunken gardens, ponds, hilly mounds, and nice landscaping.

But William and Mary's notable contribution to campus architecture is the Sir Christopher Wren Building. It is the oldest academic structure in the United States—that is, if you do not count additions, reconstructions, and fires (including one set by federal soldiers in 1862). Did the great Christopher Wren design this 1697 building? Probably not, although evidence that he did comes from the Reverend Hugh Jones in the 1724 publication *The Present State of Virginia:* "The building is beautiful and commodious, being first modelled by Sir Christopher Wren." Wren died in 1723 and could have been the architect, but there is no other real evidence that he was.

The Wren Building is a well-scaled, earth-colored Georgian structure with a narrow pedimented pavilion, dormers, hip roof, and cupola. After many incarnations, it is now back to its original appearance. Among the sources that architectural researchers used to accomplish this was a floor plan made by alumnus Thomas Jefferson in 1772. They also consulted the sketchbook of a Williamsburg belle, whose 1856 drawing noted the windows where her boyfriends lived.

The ultimate Southern campus—the epitome of the plantation college and the seminal learning place in America—is Thomas Jefferson's University of Virginia in Charlottesville. In concept it was a closed double mall with alternating French and English gardens between the building rows. Its decoration, as in all of Jefferson's work, was based on the Tuscan and Roman orders. (Jefferson had little direct familiarity with Greek-derived structures and, in any case, considered that the young country should foster symbols with the grandeur of Rome—to make up for a weak military and an anemic exchequer.) But the form of education that Jefferson established was based on the Greek model of students and teachers living and questioning together. (Faculty wives eventually objected to so many students underfoot.)

Five differently detailed faculty pavilions line each long side of the Lawn, which is oriented north to south. The pavilions are fronted by large columns and connected by smaller columns at the students' rooms. In an example of Jefferson's experimental thinking, the pavilions were roofed with folded tin shingles (which later leaked). Pavilion I used the Doric order from the Baths of Diocletian; Pavilion II, the Ionic order from the Temple of

"The last of my mortal cares" is the way Thomas Jefferson described the University of Virginia. This aerial view shows the Lawn with the two Cabell Halls (designed by Stanford White) in the foreground and the Rotunda to the north. Many classes are held in the Cabell Halls, which were not foreseen by Jefferson. (University of Virginia)

Fortuna Virilis; Pavilion IV, the Doric of Albano, from Chambray. Pavilion VIII, with two columns in antis and two engaged Corinthian columns, was influenced if not designed by Benjamin Latrobe. Though Jefferson was dedicated to the sanctity of order, he was not a prisoner of classical symmetry. Where the land slopes down on the east, he accommodated his plan to the site by increasing the distance between the parallel building rows.

At the north end—the head of the table, so to speak—is the great Rotunda, a reduced version of the Pantheon in Rome. This is connected to the longitudinal building line by arcaded arms surmounted by a balustrade—a perfect assembly of parts, also suggested by Latrobe.

The one-brick-wide walls outlining the yards behind the pavilions were serpentined for stability. Jefferson had used these before, but they became a signature of the university. Straight walls connecting the serpentines needed to be two bricks thick. Jefferson's "academical village" was an "open square of grass and trees which would provide a quiet retirement so friendly to study and lessen the dangers of fire, infection and tumult." The artistically conservative Jefferson had consulted architectural pattern books, and he was the first American to own a copy of Andrea Palladio's *Four Books of Archi-*

tecture. His plan for the University of Virginia was undoubtedly influenced by the Villa Trissino illustration at Plate 43, Book 2 of the *Four Books*.

Jefferson still dominates the University of Virginia both in architecture and tradition. For instance, the term *senior* is not used at Virginia, for "T.J." (as Jefferson is lovingly called in Charlottesville) did not believe that anybody could be a senior in knowledge. Professors are referred to as "Mister," because Jefferson was never a professor. Although Jefferson was considered a gentleman architect—a term patronizingly used to acknowledge his lack of formal training—his drawings, often done in ink, sometimes show a high level of drafting precision.

Certainly, his Virginia campus is universally revered; the American Institute of Architects voted it the proudest achievement in American architecture. Can even the grumpiest critic find something less than perfect here? The Lawn is now only one element in the University of Virginia grounds (the term *campus* is verboten), the rest experiencing a centrifugal, unfocused growth. Part of the reason is that Jefferson's complete design did not allow for expansion through secondary axes or hierarchical quads. He provided a closed Tchaikovsky melody instead of a developable Beethoven theme.

One problem affecting the Lawn itself is that there was never adequate compensation made for the mall's drop-off to the south. Old Cabell Hall and New Cabell Hall, which were not in Jefferson's original plan, are too low to contain the Lawn space visually. And while Jefferson's concept for a double mall has never been exceeded (even by Stanford or Louisiana State), it is imperfectly realized in the scale and details of its classical forms.

Sweet Briar College nestles comfortably among the bosky hills and lawns of the Virginia Piedmont. It is comfortable because Georgian-Federal is the right style for that time, and red brick and creamy limestone are the right materials, for this Virginia countryside. Named for the roses around the original Italianate house (with its famous boxwood circle), the school was designed by Cram and Ferguson. Their simple and logical plan extends arcades in both directions from the refectory with its pediment, balconies, cupola, and blind arches—a poetry of recurring form.

This campus works because of the continuity provided by its recurring classicism, its careful placement of structures, and their physical relationship emphasized by the texture of balustrade-covered arcades. A similarly successful campus of hills, hollies, magnolias, and lawns can be found at Wake Forest University in Winston-Salem, North Carolina. Also Georgian in style, it is constructed of Old Virginia brick and trimmed in granite and limestone.

Like Sweet Briar, the plan of Wake Forest takes into account the eye's need for spatial diversity by placing differently scaled quads at various levels. Wait Chapel with its strong Doric columns surmounted by a staged steeple recalls Harvard's Memorial Church. The modern brick massing and

detail work of the fine arts center grow naturally out of the grass. This building keeps the promise of its excellent exterior by offering handsome inside rooms, particularly the theater.

Nearby is a campus with the same uncanny sense of place as Brown University. Founded in 1772 and built around the old Salem Square, little Salem College is a model of authentic academic preservation. With hooded archways, old bricks, handsome timbers, benches, and lightposts, there is an arcadian timelessness here. Buildings like Home Moravian Church and Single Sisters reflect the once revolutionary Moravian belief that women deserved to be educated as well as men. The commercial town of Winston merged with Salem in 1913.

Three others of the South's best campuses display the Federal-Georgian styles: the University of South Carolina at Columbia; Duke's east campus in Durham, North Carolina; and the University of North Carolina at Chapel Hill. Their separated, low-pitched, hip-roofed buildings illustrate different means for accomplishing the same end: pleasing urban spaces delineated by harmonious structures. America's oldest state college building is the 1779 Old East at the University of North Carolina (UNC) at Chapel Hill. This fine brick structure, which is still used for residence purposes, is duplicated by West Hall; together with South Hall, they make a small quad. This in turn has grown to become a large, loosely enclosed, treed space called McCorkle Place—the oldest and most beautiful of Chapel Hill's many squares. (See below for a further discussion of Chapel Hill.)

The physical and sentimental heart of the University of South Carolina in Columbia—the Horseshoe—is more precisely defined, with close Federal-style structures. They were all either designed or influenced by architect Robert Mills, who built the Washington Monument and added the annex to Virginia's Rotunda. (As a young man, Mills had worked with Jefferson.) His South Carolina buildings—derivative of those at Harvard, Brown, and Dartmouth—were originally painted red for emphasis and to hide mortar joint irregularities. Somehow, the Horseshoe managed to survive even the burning of Columbia by General William Sherman during the Civil War.

The University of South Carolina's Horseshoe is one of very few almost pure Federal quads on any campus—their scarcity partially explained by the brevity of the Federal period, from 1780 to 1820. This style characterized by plain walls, delicate fan transoms, attenuated columns, blind arches, upwardly receding windows, and careful proportions is exquisitely illustrated by the buildings at South Carolina. One planning feature here (but not peculiar to the Horseshoe) is the mirroring of buildings on opposite sides of the quad. Thus, Rutledge and De-Saussure are paired; so are Legare and Harper and Elliot and Pinkney. Though they are not identical to their opposites, the massing and materials—tan brick and stucco—do provide an extra degree of harmoniousness to this already perfect assembly of elements.

President's House 1810

The president's house on the Horseshoe at the University of South Carolina, with its fine botanical touches, is an example of the refined buildings that give this quad its cohesive quality. (Courtesy of the University of South Carolina)

Duke's east campus illustrates the Georgian mode as revived in the 1920s. It recalls the University of Virginia in plan (complete with rotunda), if not in style. Credit for this excellent group is commonly assigned to the Philadelphia architect, Horace Trumbauer. It belongs, however, to the first professional black architect in the United States: Julian Abele. Abele was helped through his formal training at the University of Pennsylvania by Trumbauer, and then apprenticed to his office. Though Abele designed the buildings for Duke University, his name does not even apepar on the plans. Ironically, Trumbauer himself was not a formally trained architect.

UNC at Chapel Hill maintained a sense of well-scaled enclosed spaces throughout the development of the "Noble Grove"—the old campus—with South Hall providing the north closure for Polk Place and performing the same function on the south for McCorkle Place. Part of the harmony in this early quad derives from the use of local stone and clay, which lends a tawny shade to its buildings. This is in the best tradition of Southern architecture. (Duke's west campus, on the other hand—with red, yellow, and gray stone—is less in harmony with its natural setting.)

A smaller, well-landscaped quad is created by Carr and Bynum Halls and the Greek Revival Playmakers Theater designed by Alexander Jackson Davis, who replaced the usual acanthus leaves of the capital with corn and wheat stalks. (It was Davis who coined the term *Collegiate Gothic* in the 1850s.) A nifty little brick-paved mall emerges from three modern structures: the union, the student stores building, and the undergraduate library. There are many other such spaces. And it is this dedication to the finely proportioned green and paved enclosures throughout the campus that sets Chapel Hill apart.

Located between East, West, and South Halls—at exactly the right spot for a visual symbol—is the Old Well. It is the logo, the watering hole, the meeting place of Chapel Hill. The Old Well was built in 1897 at the suggestion of President Edwin Alderman, who described a "sort of sixth cousin of a Greek shrine, or third cousin of the Temple of Vesta." The original $200 version provided by a local lumberyard was replaced in stone in 1954 with designs from Eggers and Higgins. However Greek the first may have been, this one has Roman orders and a Roman dome.

One of Chapel Hill's charms is its 30 miles of brick-paved walks placed since 1947. It was not always thus. Student Thomas Wolfe, whose first novel, *Look Homeward, Angel*, describes life at the University of North Carolina, lamented, "The campus paths were dreary trenches of mud and slime." Wolfe, however, was of two minds:

Of white old well, and of Old South
With bells deep booming tone,
They'll think again of Chapel Hill and—
Thinking—come back home. . . .

While the old quad is a perfect college place, such approbation is not deserved universally by the rest of Chapel Hill's campus. Edson Armi, architectural historian in the UNC art department, says that the "modern-age buildings have committed aesthetic suicide." Marvin Saltzman, professor of art, calls the modern union, student stores building, and under-graduate library "unhumanized buildings." While it is nice to respect Polk and McCorkle Places, he says, the rest has been "McDonaldized."

The University of South Carolina had somewhat the same trouble with its later architecture and even more with its planning. After its Horseshoe was completed, designers lost interest in both urban space and architectural continuity. Duke, on the other hand—eschewing the Georgian repose of its flat eastern site—chose the restlessness of Gothic Revival (with some Eliza-bethan overtones) for its irregular west campus. Again the Trumbauer office (read Abele) drew the plans. While one may question the appropriate-ness of setting a monumental gothic work among the North Carolina pines, there is no doubt about the competence of the plan itself.

This campus is based on disciplined Beaux Arts intersecting axes with a strong central focus (the chapel). Its many-ribbed, traceried, gargoyled buildings offer a severe continuity that almost carries a good thing too far. Though its rich, cloistered structures of multicolored stone laid in random ashlar display many faces of Gothic, the whole has trouble avoiding a sense of monotony. Outside of the elongated cruciform plan, the architect does vary his spaces, though—particularly in creating secondary ones. William Few Quad, for instance, provides a fine visual experience as the eye is drawn through an enfilade of arched openings.

Near the southern slopes of the Blue Ridge Mountains, Clemson University in South Carolina should present an up-to-date face: 70 percent of its buildings have been made since 1950. Still, the most interesting structure on the campus is old Tillman Hall, a Romanesque Revival beauty with brick arches and a handsome modified Italian steeple. The original "Main Building" on the same site was constructed with convict labor in 1892, but it burned down two years later. Fort Hill—John Calhoun's house on the campus—is typical of the early 1800s Southern Colonial style, with two-story classical columns supporting a full entablature under a pediment.

The best urban assembly at Clemson is the library quad, with well-defined space delineated by mediocre structures. A pool under the ramped Cooper Library leads to an outdoor theater—a pleasing concept. The library itself is a modern version of the Southern vernacular and illustrates the complex needs that architects must consider in their working drawings. Besides the usual stacks and reading rooms, it houses LUIS (Library User Information System) for bibliographic records and DORIS (Document Online Retrieval System) for access to periodical indexes.

If Harvard evokes a sense of history, Brown a sense of place, and Penn a sense of character, then Emory exudes a sense of repose. Here in Atlanta's

Druid Hills, an architect has again tapped the green rolling countryside of Italy for his inspiration. Using the low overhanging hipped roofs of the Renaissance, Henry Hornbostel collected six subdued, elegant, and artistically related buildings and integrated them with the natural beauty of the forest pines and magnolias. Designed by Hornbostel and Ivey and Crook, these patchwork marble palaces form a quadrangle that suggests New England planning more than that of the South. But whatever the derivation of their layout, in their harmoniousness and repose they are in a class by themselves.

From the standpoint of planning and design, Emory University has accomplished the unusual feat of integrating its fine sports structures and excellent medical buildings into the whole campus. Furthermore, over the years, Emory has managed to maintain the high architectural standards established from the start. Distinguished modern structures include the chemistry building by Robert and Company, Gambrell Hall Law School by Stevens and Wilkinson, Goodrich C. Wright Hall Computer Center by Hall and Morris, the George W. Woodruff Physical Education Center by John Portman, and the William P. Cannon Chapel by Paul Rudolph. The city of Atlanta contains many other schools, of which the Georgia Tech and Spelman College campuses are the most pleasing.

The University of Florida in Gainesville was conceived as a grid. It then compounded this planning mistake in 1930 with the rearrangement of streets within the campus to coordinate with the city streets bordering it. The original curvilinear roads "made it difficult to locate the needed additional buildings and accommodate vehicular traffic," it was explained. That priorities could be so mixed up at a time when cars were few and after Frederick Law Olmsted, Jr., had offered his own plan for the campus is hard to believe.

Nevertheless, the great central space—Plaza of the Americas—alleviates some of the "cityness," and the placement of certain structures as well as the use of large "blocks" (to use urban terminology) permit students to forget the unimaginative planning of the campus. Ponds, picnic areas, and shady nooks also help. All of the original buildings were Collegiate Gothic in style with tracery, gargoyles, medallions, fan-vaulted ceilings, and the laying of English cross-bond brickwork. The trim of window and door surrounds, water tables, and quoins was first cast in molds of crushed stone and cement, then tooled to simulate cut stone. Steeply pitched, red clay roofs offer a touch of Spanish influence.

For its modern architectural work, the University of Florida has made better choices than most schools. Notable successes include the immense Reitz Union by Moore and May of Gainesville and Barrett, Daffin, and Bishop of Tallahassee, the fine arts complex by Kemp, Bunch and Jackson of Jacksonville, and the Florida Museum of Natural History (see Chapter 2 for a description) by William Morgan.

This ample walkway to Emory University's Woodruff Library provides one solution to bridging a campus declivity. (Emory University Photography)

The University of West Florida (UWF) in Pensacola has the best aesthetic coordination of any college in Florida. Its urban spaces are random and well conceived. Buildings are separated from but related to each other, and there is a botanical leitmotif of moss-draped oak and azaleas in the wooded landscape bordering the Escambia River.

It is the controlled architecture of the whole campus that distinguishes UWF. Severe modern forms were eschewed in favor of one-story (almost

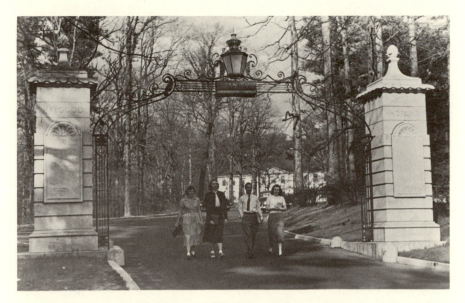

A college entrance like the Haygood-Hopkins Memorial Gateway shown here prepares the eye for a satisfying visual experience. Unfortunately this agreeable assemblage of masonry and iron at Emory University proved too low for large trucks and had to be changed. (Emory Univeristy Photography)

The aesthetically hep University of West Florida allotted a full 1 percent of its construction budget to art. This ceramic pylon is the work of Professor Steve Hayworth. The well-placed sculpture lends a cultural touch to the botanically pleasing campus and creates a spatial vortex for passing students. (University of West Florida photo by Tom Carter)

bungalowlike) and two-story structures with galleries, double columns, and brown shingle roofs. The tendency toward sameness is assuaged by subtle variations in materials, scale, and window treatment. In general, the later structures improve over the earlier ones. Landscaping and outdoor furnishings are exquisite; there are flowering trees, evergreens, shrubs, ground-covers, lawns, and paved walkways. A half-mile boardwalk leads into the bayou where Captain Thunder the alligator patrols.

The Middle West

The fresh new campuses of the Midwest must have warmed the cockles of Frederick Law Olmsted's heart. The great nineteenth-century self-taught landscape architect always opted for the romantic and informal English country garden approach to campus design (except, notably, at Stanford University).

They were founded at a time when making education available to everybody was a new and exciting idea, an anti-elitist move toward democracy, and a populist explosion. James Russell Lowell said, "It was in making education not only common to all but in a sense compulsory to all that the destiny of the free republics of America was practically settled."

In 1858 Senator Justin Smith Morrill tried to pass an act that would grant land to the states for postsecondary education in agriculture and engineering, but he failed because of the prevailing military priorities. On its second try in 1862, the Morrill Act was signed by Abraham Lincoln.

Because of the development stage of the Midwestern states, much of this largess devolved on them. And because of the new democratic inclinations of the time, campuses eschewed the tight, formal plan of the earlier schools (which were established to train teachers, ministers, and lawyers) in favor of egalitarian, nonhierarchic layout. What emerged on these new campuses were numerous eclectic structures in spacious parklike surroundings. It was like transitioning from a standard movie screen to a wide one.

The two prototypes of the new midnineteenth century land-grant approach to campus making are Michigan State University in East Lansing and Indiana University at Bloomington. A look at the difference in the manner these two schools responded to growth requirements tells a lot about how choices are made.

Frederick Law Olmsted said, "The campus of Michigan Agricultural College [now Michigan State University] is probably the best example of the type of landscaping characteristic of the 19th century American University." But when it was time to grow beyond its beautiful botanical center called the Oval, Michigan State crossed the Red Cedar River and dismissed the informal park in favor of a grid system. The advice of Michigan State planners like Adam Oliver, who was responsible for the lovely core, was long forgotten, and the enlarged campus became ordinary. The

connection between the old and new campus segments now reads like a solecism.

When Indiana—on the other hand—crossed its wet-weather stream, the Jordan River, to leave the old Crescent, university president after university president refused to cave in to the pressures for routine development and determinedly preserved its campus in the woods.

Another difference was in the approach of the two universities to post–World War II design. While Michigan State attempted modern architecture with such unenduring devices as colorful spandrels and aluminum trim—thus trivializing the fine medieval revival buildings around the Oval—Indiana was hiring I. M. Pei for its art museum and Eggers and Higgins for its new library.

Indiana's library is a strong cubistic statement of stone that, unlike most libraries, was not placed in the middle of the classroom campus but on its edge near the residential zone. Its long approach relieves the enormity of the building, thus avoiding an otherwise overbearing presence.

Iowa State University (the state science and technology school) in Ames, and the University of Iowa (the state liberal arts school), in Iowa City, show a different kind of contrast. The more conventional and festive Midwestern land-grant campus at Iowa State displays a widely spread, roughly rectangular core with parklike vistas throughout. Because of this separateness and the softening of shrubbery, flower plantings, and trees, its monumental buildings of different styles are not offensive. "Old Botany" is the star of this collection, with its architectural elements of great arched entry, balconies, dormers, and white trim. The landscape composition just north of the union—its plantings, walks, sculpture by Christian Petersen (artist in residence), and crocketed Gothic bell tower—is one of campusdom's treasures.

East of Ames at Iowa City, the University of Iowa marches to a different drummer. From the first, it was established as an urban campus on the west side of the Iowa River, with buildings stashed up and down the city streets. Administration functions proved to be a creative alternate use of the old state capitol. Moreover, the University of Iowa improved as it grew (like Indiana). Moving eastward across the river, Iowa sprouted a group of marvelous new forms. Among them were the human biology building, the health services institute, and the dentistry building (which allegedly is in the shape of a molar). The new field house burrowed into the ground, thus permitting the outer steel frame from which it hangs to be lower and less obtrusive. The law school, too, is an attractive modern structure.

Alas, neither the old campus at the University of Iowa nor the new one—even with its assault on the architectural senses—has dealt with the need for good urban spaces. Iowa State, on the other hand, never lost sight of this essential campus ingredient; its placement of new structures respects the spatial need. For example, the small Hub, a food services mini-union near

the library, is a gem; its roofline and materials canonically reference Morrill Hall next door. It has tastefully tied itself to this structure by landscaping techniques—plantings, walks, and walls—and has provided terraces and outdoor sitting areas.

This recent appearance of small eateries here and there about larger campuses helps provide the 30,000 or so student meals required daily, and without causing a mass ingathering at one spot—thereby avoiding extra walking and long lines. This has been very artistically accomplished at UCLA.

Near the Hub at Iowa State is Parks Library, which exhibits a fine contemporary addition to its traditional library structure. The new part is a glass enclosure that bridges two corners of the old library and provides new bright spaces for reading rooms. A similar solution was done less successfully at the University of Missouri at Columbia (see Chapter 3) and disastrously at Smith College and Michigan State University. Berkeley solved the problem more effectively by building the separate new Moffitt Library, a stunning study in concrete-and-glass horizontalism by John Carl Warnecke.

There are three ways to add structures to a campus. First, the existing buildings or styles can be copied, which in reality is a denial of the historical progress of architecture. Second, what went before can be contemptuously rejected, which is what many postmodern buildings do. Oberlin and the University of California, Irvine, have been mentioned in this regard. Third, contemporary additions can be made that, while different, respect the grace and proportions of existing work.

Putting additions onto buildings—or indeed onto groups of buildings—is a dangerous undertaking, but sometimes it works. At Antioch, the architect Max Mercer placed a handsome modern stairwell on the front of the 1852 Romanesque-style Antioch Hall. And the University of Colorado successfully added a wing to its theater auditorium that reflects the round-headed Romanesque Revival window motif in a modern and urbane manner.

Sometimes additions *almost* work, as witness the doubling of the Illinois student union by the unique solution of replicating the old one—making it the largest in the United States. While successful from a utilitarian standpoint, this knock-off approach exhibits a shortage of creative ideas.

Most of the time, additions do not work. This can be the result of attempting to add to a building that is already complete in itself. Cass Gilbert's elegant Allen Art Museum at Oberlin, for instance—Renaissance in style, but compatible with his earlier Romanesque structures—is a perfect organic work, whose proportions—the arcade set into a loggia, the molded panel walls, the overhanging tile roof with frieze—have all been carefully worked out. Instead of constructing a separate art school, however, the administration appended it to the art museum. Even an appropriate structure would have badly wounded the museum's stylistic integrity. But Robert Venturi's uncompromising and controversial postmodern solution (with his signature checkerboard wall) turns the dagger. Venturi says he

favors energy over compatibility. Why not have both? Instead, additions fail more often than not, because of bad architectural choices—either stylistic clashes or plain inept design.

The University of Illinois at Champaign–Urbana, whose campus is often characterized as colorless, actually has an underrated quadrangle where structures are high enough, separated enough, and ornamented enough to create a perfectly proportioned core element. One of them—the multi-gabled, multitowered, multibalconied English building—was designed by McKim, Mead, and White in 1905.

The mall at Illinois is a fine rectangular composition rich in architectural vocabulary. From the Georgian-style union anchoring the north end of the main quad to the domed Foellinger Auditorium bauble at the south, it is a panoply of materials and styles rationalized by common scale and high quality.

Architect Charles Platt influenced Illinois's development during the 1920s. Platt built, among other things, the Georgian library. Richardson, Severns, and Scheeler placed the library's addition underground. They built two small entry structures and a two-story-deep well to provide light for the

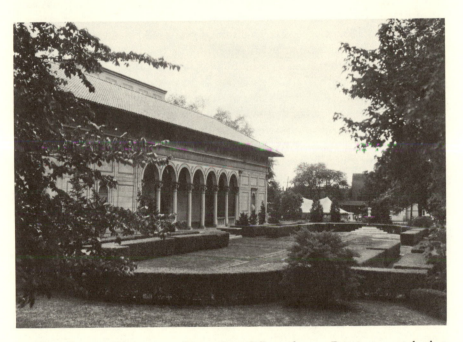

For the Allen Art Museum, architect Cass Gilbert chose a Renaissance style that would mix with his earlier Oberlin work. Formal landscaping sets off a symmetrical and exquisite building. It faces the huge 13-acre Tappan Square, which was reclaimed in the 1920s. Old buildings were removed at that time on the advice of the Olmsteds. (Oberlin College Archives)

underground floors. This leaves intact the second campus quadrangle—a formal space preferable to the rough edges that often accompany growth's centrifugal forces. This is a spatial solution that is being seen more and more on college campuses.

The largest of all donations to a public university—the Beckman Center at Illinois—has received much notoriety. This postmodern building with its dramatic atrium provides an opportunity for healthy comparison with a structure at Indiana University at Bloomington that we discussed in Chapter 2: the University Art Museum by I. M. Pei. Beckman Center has a hard-edged overmarbled interior with calculated classical references—columns and capitals—that here, instead of providing a sense of permanence, give it an evanescent mien. Pei's building—also hard-edged and with an atrium—depends not on decoration for success, but on a more basic architectural imperative: form. While Pei's spaces are thrilling, Beckman's are more like gee whiz.

Not all Midwestern campuses are large. Antioch University in Yellow Springs, Ohio, has only 500 students, for instance. But the school has long attempted the informal, less structured Olmstedian type of planning. Its red brick buildings are almost randomly placed, making for changing vistas as students move through the minimalist (like Reed College) and parklike campus. The 1852 mother hen to all these scattered chicks is Antioch Hall. This towered Romanesque brick pile—one of the first in this style—was inspired by the Smithsonian castle in Washington, D.C.

Oberlin in Ohio has 2,500 students. It hugs the town green like Dartmouth, Williams, Amherst, Yale, and Salem College in North Carolina. Actually, Oberlin surrounds the 13-acre Tappan Square, a park centered around an enchanting double-roofed bandstand. The original college buildings were removed to make this green at the suggestion of the Olmsteds. But Oberlin's best urban space is a newly created quadrangle surrounded by the union, Dascomb Hall, Warner Center, and the library. The New Seeley Mudd Learning Center designed by Warner, Burns, Toan and Lundy is an oversized concrete-and-glass structure with receding floors of the genre first conceived for the Boston City Hall (as discussed in Chapter 2). The other buildings that make up the quadrangle are fine period pieces. One of them—Warner Gym, designed by Norman Patton—was the inspiration for Cass Gilbert's Romanesque-Renaissance buildings at Oberlin, including Finney Chapel (from twelfth-century France), Cox Administration Building, and the Allen Art Museum.

Less typical of the Midwestern region are two small campuses that are strictly quadrangles: Washington University, wedged into the city of St. Louis; and Grinnell College, lost in the Iowa cornfields. Both suffer, planningwise, from a lack of depth in their containing enclosures. They are mostly defined by a single line of buildings on either side of the quad.

This is not immediately apparent at Washington University, whose

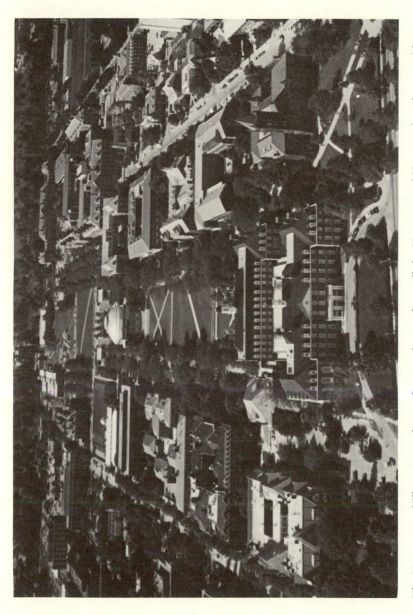

The University of Illinois's rectilinear shape and rotunda recall the University of Virginia, but the resemblance stops there. Foellinger Auditorium's delightful, almost rococo facade takes itself less seriously than Jefferson's Rotunda. But the Illini Mall's separated structures are more substantial than Virginia's closed fragile classicism. The double Georgian-style union can be seen in the foreground.

imposing entrance carries visitors up terraced steps and through the Gothic-style Brookings Quadrangle archway to a modest space (where the modern Beaumont Pavilion has been slyly positioned for commencement ceremonies and such). The next building—an English Renaissance structure, Ridgley Hall—was used for the 1904 World's Fair. It contains Holmes Lounge, one of the grandest rooms on any campus. Of enormous size with richly encrustated detail and a marvelous carved ceiling, the lounge was once the library reading room.

The emergence to the quad itself is a disappointment. It may be wide, but its longitudinal end to the west is weak—contained only by a parking lot. The treed space is almost completely unlandscaped except for one successful garden spot in front of the Graham Chapel (modeled after King's College Chapel in Cambridge), which contains plantings, brick walks, benches, and flowers. All this only whets one's appetite for more. The contemporary Olin Library helps break up the quad with its carefully crafted stone, concrete, and glass; the bonding of its red Missouri granite matches the older buildings. It is a good example of a successful integration of modern and medieval styles.

Two modern building groups give some depth to the plan. The concrete and glass block union is landscaped with brick walks and an amphitheater

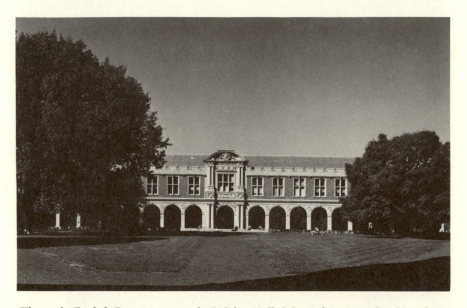

The early English Renaissance–style Ridgley Hall defines the west side of Washington University's Brookings Quadrangle. This perfectly scaled treed space is also embellished with Collegiate Gothic and contemporary accoutrements. All walks in the quad radiate to the elegant Ridgley entrance. (David Kilper, Washington University in St. Louis)

into which the plaza molds. Eliot and Mudd Halls are of brute concrete with holes showing tie-rod placement. They have a truncated gable roof painted green to look like more expensive copper. To the east is McMillan Hall, which was once a women's dormitory as evidenced by the iron fence around it—put there to keep women in and men out.

If Washington University had adhered more closely to Walter Cope's 1899 double-mall plan, its campus would now exhibit more depth and better scale.

Grinnell's north campus Gothic dorms bring to mind the dependable charm and utility of the enclosed arcade. Appropriately called the Loggia, it gives students a covered, red-brick walk as they circulate around the dormitories. Grinnell's fine modern library and union, the Forum, sit comfortably in the Gothic Revival quad.

With all its good planning and medieval styling, this sweet campus never does quite escape its cornfield origins. Corn grows within sight of the quad, and the importance of the railroad to this part of the country is demonstrated by the tracks that run through the campus.

Finally, there is Kenyon College in Gambier, Ohio. Founded by Philander Chase as "a retreat of virtue from the vices of the world," Kenyon was meant to train priests for the Episcopal Church. (New England ministers would not be persuaded to come to the new territory of Indians and bears.)

Kenyon's old green proves that it is possible to make an attractive, parklike ambience without the benefit of special topographical features. By placing structures randomly but carefully among what are now grand mature specimen trees (having grown without competition for the sun) and making paths but no roads, planners provided the feel of an old colonial village. The cemetery on the old green is a quiet meditation spot with a true sense of place. (Author Wallace Stegner said, "No place is a place until things that have happened in it are remembered.")

The original structures on campus are Gothic Revival. In fact, pinnacled and embattled Old Kenyon is alleged to be the first of this style in the United States. Modern architectural attempts have not been wholly successful, but three buildings are excellent. The Olin Library adapted postmodernism skillfully, with well-organized formal elements including two pediments, end gables, and transverse wings—Georgian symmetry. Its window treatment is flat to create a Mondrian-like composition. Along with Missouri's law school and Duke's dormitory (both discussed in Chapter 2), Olin Library is one of the better postmodern structures on any campus.

Kenyon's Bolton Theater is a fine modern sculpture. And Gund Commons is an intriguing cluster of new hipped roofs. Indeed, the structures on this commons hold great visual interest both inside and out. Overall, however, Kenyon's newer campus leaves something to be desired, sitting as it does on either side of a busy road. Although the parklike character is maintained, it does not have the same monastic feel of the old.

The West

A pronounced regionalism characterizes the West and Southwest of the United States. What is loosely called mission style or California mission consists of stucco, brick or stone, roof tiles (usually red), and arches. This kind of decoration is appliquéd on substantial architectural styles with merry abandon. At Stanford University it is used with Romanesque, at Berkeley with Beaux Arts, at Santa Cruz's Porter College with contemporary. Surprisingly, the mission influence peters out to the south: There is actually very little at Santa Cruz and none at all at San Diego.

Mission churches were built up and down the California coast by Franciscan priests during the eighteenth and nineteenth centuries. Their gardens and open courts, tile roofs, arcades, and intricately carved openings contrasting with plain undecorated walls show the Moorish influence on Spain as transplanted to California. (Spain's most perfect expression of this architecture is the fourteenth-century Alhambra in Granada.) In spite of influences by other European countries like Italy, France, and the Netherlands, only Spain ever gave England any real competition when it comes to leaving architectural footprints in America.

Henry Hobson Richardson combined mission elements with capital details from the south of France, gave them presence, and made them his own. Richardson's sense of style had a paramount impact on the design of the Stanford University campus through his influence on the young associates in his firm. Charles Coolidge was one of the inheritors of Richardson's practice. In the short time that Coolidge worked for Leland Stanford, he produced the marvelous Romanesque-mission core of the campus. It would have done the master proud.

UCLA's first architects, Allison and Allison, selected Romanesque over Italy's other architectural styles in order to summon up the "vanished glory of Rome." In a more general sense, they were thinking of Northern Italy because its climate and landscape are similar to Los Angeles. The Lombardy region has little lumber or good stone leaving brick its characteristic material. Accordingly, UCLA's four original buildings were made of brick with stone trim. Lombardy's contribution to the Romanesque was masonry, vaulting, and belfries. All these are seen in UCLA's signature building, Royce Hall. Built in 1929 and modeled after Milan's tenth-century San Ambrogio Church, it has twin towers separated by a peaked loggia. The towers are balanced but differ in detail. Royce's architects took the liberty of adding wings to the church center in order to increase volume without excessive mass. It has been called a "breath of Lombardy in the hills of Westwood."

Modern work at UCLA since the 1940s has played havoc with the campus, except for the molecular biology institute, a well-massed concrete and glass structure with strong vertical thrust and a novel inverted fountain. The four original Romanesque buildings retain their spacious

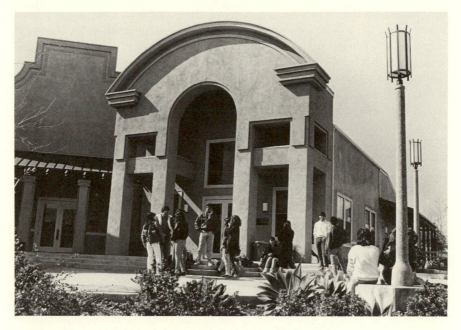

Charles Moore's Northern Italian–derived stage setting for the university extension building at the University of California, Irvine. This simplified stucco Palladian facade does not belong with subtropical plantings.

setting, with grounds ideal for students to gather (in contrast to Berkeley, which is sprawling but unspacious). Royce Hall carries on a constant medieval dialogue with Powell Library across Dickson Plaza.

The Franklin Murphy Sculpture Garden has stone walks, mounded lawns, low walls, sitting areas, flowers, and a grove of small trees molded together into UCLA's best space. There is a handsome pool with a contemporary fountain by George Tsutakawa. Carefully placed in this garden are sculptures by Lachaise, Arp, Lipchitz, Maillol, Rodin's "Walking Man," and Matisse's four reliefs of "Woman Combing Her Hair."

But the garden is aesthetically damned by its backdrop—the mediocre art center building—and this juxtaposition nicely sums up UCLA's present growth problem from the artistic standpoint. Well-conceived grounds with live oaks, sycamore, figs, and eucalyptus are surrounded by poorly designed modern buildings.

Porter College at the University of California, Santa Cruz, on the other hand, shows a modern use of outdoor space and fine landscaping by Thomas Church, with hipped pavilions enclosing the whole. Architect Hugh Stubbins covered all this with tile roofs and white stuccoed walls, thus reminding one and all that it is California. The main plaza has a fine

fountain sculpture, and a redwood grove stops the eye to the west. Walk-ways have a warm pea-gravel finish. Shopping mall–type furnish-ings—raised flower beds and pergolas—have been transferred to the grounds of this campus. (Another fine Santa Cruz campus, Adlai Stevenson College, has adopted a resort signature—an outdoor swimming pool with a view toward the Pacific.)

The Santa Cruz administration felt that Porter College should be the last of its conventional modern campuses. Thus, under a long-range develop-ment plan prepared by John Carl Warnecke in 1963, it hired Charles Moore to design something that would plough new furrows. Santa Cruz provided him with a circuitous mountain spine in a redwood forest. Moore, no stranger to whimsy, gave the university a linear, windy postmodern campus that is now the home of Kresge College (see Chapter 4). It acknowl-edges California mission with its plain white walls and Italian hill-town roots. That is all Moore was willing to give to the mission style, however. The college's roofs are asphalt, and there is no decoration at doors and windows.

Though it seems unlikely, some elements of California mission style did manage to penetrate even the great classical campus of the University of California, Berkeley. "The core of Berkeley campus by John Galen Howard is one of the largest and most complete Beaux Arts ensembles ever to be exe-cuted in permanent materials in the history of American architecture," said art-history writer Loren Partridge in 1978.

Howard's architectural design was not the first choice in the 1899 Phoebe Hearst competition to select a plan for "a city of learning." A design by Emil Benard was first choice, but Benard's grand Roman-like effects were just too costly. Howard emphasized solids, not voids. The Greekness of his concept was encouraged by the self-conscious image of Berkeley as the Athens of the West. (Almost all of the more than 100 submissions to the contest were in Beaux Arts style—a triumph of dogma over imagination.)

Howard ignored contours in his axial plan for this hilly site, but Frederick Law Olmsted, whose picturesque plan had been put aside in 1867, got his way on two items in the end: one axis leads to the Golden Gate Bridge, and Olmsted's parks were eventually incorporated into Howard's plan.

Instead of stucco, Howard used white granite for his walls (until concrete replaced it for budgetary reasons), bronze and wood for trim, and red tile roofs. He recalled mission derivations when he built Sather Tower, a hand-some medieval campanile that suggested the divine origins of knowledge. Since it has classic details, however, Howard must also have thought of it as representing the secular power of truth.

Howard was interested in symbolic statuary. Over the entrance to the Bancroft Library, just west of Sather Tower, he placed a bronze bust of Athena, the Goddess of Wisdom. With her are several serpents (one of her signs) that encoil an open book.

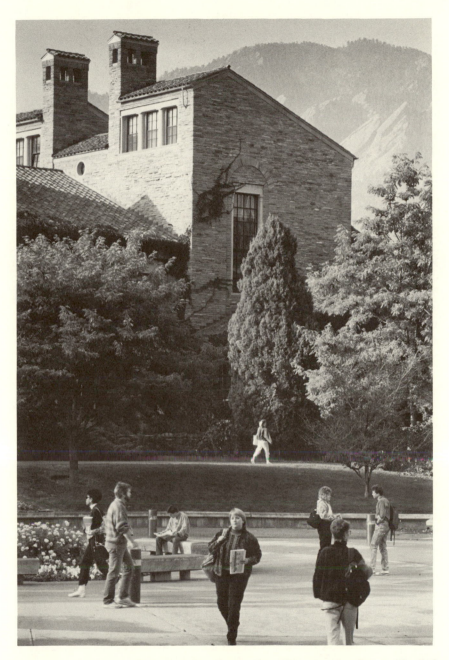

Believing it more appropriate for the Rocky Mountains, architect Charles Klauder traded in his favorite Gothic style for this Italian-influenced mode. The University of Colorado deserves high praise for the quality of its walks, landscaping and outdoor furnishings. (University of Colorado photo by Ken Abbott)

The best of the structures among Berkeley's core group is Bernard May-beck's unpretentious Hearst Mining Building (1907). Its sensitive use of glass and red tile gives it an endearing touch compared to Howard's classical piles. As at Michigan State and UCLA, however, most of Berkeley's architectural choices since World War II have been poor. It was, for example, bad judgment to permit Evans Hall to overbear lovely Mining Circle.

Bertram Goodhue's 1920 plan for the California Institute of Technology in Pasadena is determinedly axial. It is also symmetrical, with arcades on both sides of the main drag. This mission touch is an enrichment of the otherwise Pueblo-style, adobelike inner core. Casement windows have deep reveals with tan stuccoed surrounds. One expects to see primitive people emerging from the roofs of these adobe structures, instead of the Nobel laureates who walk through Caltech's doors.

Bernard Maybeck planned Mills College in Oakland but did not design the Beaux Arts buildings he wanted to see there. His 1919 plan was revised in 1922 by Walter Ratcliff, who also designed one of the best buildings on campus: the spatially exciting art center. Mills College has applied California mission elements—white stucco walls and red tile roof—to both its traditional buildings, such as Julia Morgan's classical library, and modern, such as the Spanish Revival music building also by Walter Ratcliff. The richly carved doors of the music building contrast with expanses of plain wall—a touch of Moorish in California.

In Seattle, the University of Washington shows the happy result of foresight. Administrations started their long-term planning early enough to avoid the common burden of playing aesthetic catch-up for the rest of the school's life. After much debate, a site was chosen "remote from the center of a rapidly growing and expanding city." The location and size of the grounds showed sound thinking, but no planning had yet been done when the first building, Denny Hall, was placed on a knoll overlooking Lake Washington.

In 1909 the Olmsteds laid out the Alaska-Yukon-Pacific Exposition on part of the Seattle school grounds. Its most dramatic feature was the grand view, which included Mount Rainier; the axis allowing for this was retained as part of the university's general plan. A new plan by the firm of Bebb and Gould was prepared and accepted in 1915, and then updated in 1934 after each department of the university had been scrutinized as to needs. Bebb and Gould held to the idea that order is the most important quality of a campus. "A group of structures worthy of housing an institution of learning shall not be a motley jumble of discordant units," wrote architect John Paul Jones of the firm. "Change is inevitable. . . . A long range plan seeks to define the direction of change without restricting it; the plan becomes a dynamic principle rather than a static creed; studies determine location and grouping of buildings to best exploit the natural advantages of the site, conserve views and create new ones between buildings."

University of Washington planners took advantage of their site by lining up the main axis of the campus with Mount Rainier. Drumheller Fountain sets it off in the foreground. (Special Collections and Preservation Division, University of Washington Libraries)

These wise concepts and the work that resulted from them form a veritable text on how to plan and design university grounds. More's the pity that most administrations do not follow this sensible model. For the University of Washington, in all its majesty, is living proof that careful planning works. Its comely urban center paved with brick and its greenswards fanning out according to function are a disciplined and artistic achievement.

Disappointments and Missed Opportunities

The ideal college is Mark Hopkins at one end of a log and a student at the other.

James Garfield

If the best classroom is nature's embrace, then we do not need architecture on campuses. But if we must shelter students while they learn, then we should do it with far more taste than we have in the past. College campuses, alas, do not improve with age. "Time refuses to console them," Lowell noted. As a cultural center, the university should march in the vanguard of aesthetic achievement. If not here, then where?

To understand why some campuses do succeed, it is instructive to determine why others do not. One could say that it is all a matter of choices, or better said, of who chooses: the professional or the amateur. An example of how not to go about choosing is provided in the struggle between Princeton's thirteenth president, Woodrow Wilson, and Dean Andrew Fleming West (whose campus ideal was cloistered seclusion). Wilson wanted the new graduate center to be in the middle of campus. West preferred to locate it a mile away. Though Wilson lost, both were wrong. This was a decision that should have been left to planners.

Colleges with attractive sites often have a reputation for beauty mistakenly based on what could have been. Conceptual failure is one reason for this.

The University of the South in Sewanee, Tennessee, wastes its lovely mountain site with an unfocused plan. And the University of Tennessee in Knoxville does not exploit its fine location on University Hill overlooking the Tennessee River.

The Coast Guard Academy in New London, Connecticut, also must take its place in the parade of missed opportunities. Its attractive hillside site on the wide Thames River cries for modern treatment. Richard Neutra's hanging Lovell House in Los Angeles would have been an ideal guide. Instead, after much unnecessary and expensive earth moving, the Coast Guard occupies a group of flatland-loving Georgian buildings—a veritable model of inappropriateness.

Another service academy that failed to take advantage of its beautiful site is West Point. On a high plateau between the Hudson Valley and the Shawangunk Mountains in New York State, the United States Military Academy built its own version of an acropolis—that is, a fortified height or citadel. Notwithstanding the standards set by Callicrates, however, the army produced no Parthenon. Instead, it constructed a group of stone-faced crenellated Gothic barracks that makes West Point look like a puppet army base. One feels the need to retreat before these towered battlements.

But wait: Standing tall at a bend in the Hudson River is Eisenhower Hall, a modern brick eminence that gazes upstream at the interlocking mountains lining the shore. This nineteenth-century romantic setting of elemental nature— this Thomas Cole in the round—almost redeems the rest of the post campus.

One common design mistake is the grid, an enemy of proper site exploitation. Its orderliness and ease of address are not needed on a campus. Purdue University in Lafayette, Indiana, for example, made a deadly gridlocked city of its campus. Respect for contours is far more important. Roadways at the University of Connecticut in Storrs cut furrows straight through the soft contours of the land, webbing the campus from east to west and north to south. And in its manic building frenzy, U.Conn. has managed to cover the top of beautiful Spring Hill with mediocre structures whose main function is to obliterate the view. One must clamber to the third floor of the library to enjoy a prospect of Connecticut's easterly hills.

Ironically, Homer Babbidge, president of U.Conn. from 1962 to 1972, was sophisticated in the design of campuses and wrote learned articles on the subject. But he never found a way around the state's architectural selection procedures, which are frankly based on the spoils system. The public works administrator, a political appointee, chooses from a list of campaign contributors. When President Babbidge was trying to promote first-rate designers, he could not even get the public works department to return his phone calls.

A site that does not take good advantage of its surroundings represents an inexcusable missed opportunity. Cornell University in Ithaca, New York, should have been a model campus for hillside location and its two dramatic

gorges. Though it is placed "high above Cayuga's waters," the school cannot see the lake except from I. M. Pei's fine arts tower. Instead of following contours, the roads and walkways are straight; they show neither an orientation toward the lake nor any sense of residing on a high hill. And the gorges, far from enhancing scenic delight, have become macabre repositories for suicidal students.

From these examples, it would seem that a complex and demanding project like a college campus cannot, along with all its other requirements, also keep its attractive surroundings in view. The Muses surely must be sacrificed. But not so fast! Williams College in Williamstown, Massachusetts, has done it. With the same requisite inventory of buildings as all the rest, Williams has nevertheless maintained its prospect of the stunning Berkshire Mountains from anywhere on campus.

Architectural failure stands firm as another cause for aesthetic disappointment. One need only look at campus fine arts buildings. Here, if anywhere, design quality should be assured. Alas, poor decisions seem to constitute an almost endemic scourge of art centers; the resulting déclassé work can be seen at Washington University, Indiana, Missouri, UCLA, Illinois, Michigan State, and New Hampshire.

Or consider Amherst College in Massachusetts, a campus with good plantings delineating well-planned spaces on an attractive site, with some fine views of the Holyoke Range—all this located in a charming New England village. What could possibly go wrong? Murphy's Law found a way.

Administration after administration seemed to have an unerring instinct for making bad architectural choices. In so doing, they made Amherst College the last word in missed opportunities. It simply takes more than a mix of brick and limestone to make good design; the quad where the campus started is surrounded by just such mediocre structures. The 1831 South College Building, Amherst's first, is the only one with genuine probity.

Over the years, the college took over three sides of the town green, still with no discernible improvement in architectural quality. And now—with all that has been learned of campus design—the new campus center structure turns out to be a disappointing yellow box with no redeeming touches of grace. The Chinese have an explanation for such consistency in producing unsuccessful architectural work. They would say the administration erred in not hiring a Feng Shui master. (Feng Shui is a 2,000-year-old religious belief that all buildings need a divination to achieve harmonious movement through proper location, siting, and design. Amherst, take note.)

A few hopeful exceptions on the Amherst campus include the west facade of McKim, Mead and White's Fayerweather Hall, with its fine Palladian mien. And some good modern work can be seen in the music building, the Merrill Center, and the Seeley G. Mudd Building.

When Goucher College held a competition in 1938 to design a new campus on 287 rolling acres near Towson, Maryland, it rejected the many axial plans

that ignored the site. The winner was the firm of Moore and Hutchins, who had respected the land's contours. They placed structures loosely around the site in an Olmsted style. As construction proceeded and the design fleshed out, however, it became apparent that the buildings of tan stone and gently sloping red hip roofs—though related to each other— lacked architectural distinction. Their art deco interiors are marred by being constructed in a style that did not endure. The resulting campus is a near-miss.

Another move from downtown, and another disappointment, is the modern brick campus of Skidmore College at Saratoga Springs, New York. By placing the library across the width of the quad, the long space was nicely divided. Projecting windows and covered walks are the campus signature. A whimsical touch of continuity is provided by recurring outdoor light fixtures of many-colored tile. But the dining building at the quad's long end is not massive enough to provide a satisfactory closure. Although the site's hilly fields and woodlands have been respected, the cohesive design should have produced a better contained, more exciting campus.

The University of Maine at Orono has a site that, given some distinguished planning and building design, would have produced a first-rate campus. Sadly, it got neither.

Even if all else is done well, there is always the inclination to squeeze one more structure in. More than one campus has been damaged by this density problem. The University of Kentucky in Lexington is one. Another is Brandeis University in Waltham, Massachusetts, which resides on a small mountain topped by a castle. It has an opportunity to create a beautiful campus, but the administration got greedy. In spite of excellent buildings like the Rabb Graduate Center, the Oln-Sang Center, and the Shiffman Center, Brandeis overbuilt its site and created a hodgepodge. Verticality requires more separation than Brandeis was willing to give.

Finally, there is the campus where everything is planned and executed perfectly, yet it still has a sense of placelessness. In the 1950s and 1960s, Governor Nelson Rockefeller applied his artistic interests to what promised to be an aesthetic coup for the college campus. In response to pent-up demand, the state of New York built a plethora of new campuses and expanded its old teachers colleges. There is now a state university campus within 50 miles of every New York resident. The state's campus construction arm did everything right. It chose the best planners, architects, and builders. Projects came in under budget and on time.

Yet, as we SUNY-hop among New York's 64 campuses, from Buffalo to Binghamton (with its cascading science complex), from Purchase to New Paltz, anticipating a romp, at last, in the Elysian fields of perfect campusdom, a little rain begins to fall on our parade. Something is not right. The problem is that these campuses are cold and all business; they want adequate plantings where wondrous botanical things can happen at every turn. But, alas, they are made all of a piece, with no surprises. Is it impossible to build a new campus where elusive serendipity plays a part?

The discussion in Chapter 7 will show that it is not, witnessed by SUNY at Albany but not by the SUNY system as a whole.

With folded mountains as a backdrop and the tradition of subtropical landscaping (at least since the Japanese arrived in 1886), the University of Hawaii should be an aesthetically rich, botanical campus. But this is not the case. The funky older buildings do not belong there (or anywhere else), and (notwithstanding some fine new structures) they irretrievably damage the whole.

We must similarly dispose of the University of Alaska at its raised site overlooking the city of Fairbanks. With a few exceptions like the museum and the commons, its attempt at a complete modern campus fails both in the planning and architectural departments.

What is agonizing about these aesthetically lost campuses is the fact that it would have cost no more to have done it right. Better planning in the placement of buildings would have made more pleasing urban spaces. The quality of architecture would have been augmented if first-rate designers had been selected, and donors kept at bay. Landscaping, the third pillar on which a good campus rests, requires professionals; the resident grounds-keeper or local garden club are not equipped to design campus plantings.

And professionalism would have avoided some of the most damaging individual structures at otherwise redeemable colleges. A compendium of the biggest disappointments in campusdom would have to include Uris Hall at Columbia University, the Middleton Library at Louisiana State University, most of the contemporary work at UCLA and Michigan State University, the Eisenhower Library at Johns Hopkins, the Venturi addition to the Allen Art Building at Oberlin, the Hoover Tower at Stanford University, additions to the Neilson Library at Smith College, Ballantine Hall at Indiana University at Bloomington, Evans Hall at Berkeley, the University of Wisconsin's Memorial Library, Widener Library in the Harvard Yard, and the Leavey Student Activities Center at Georgetown University.

On the other hand, some truly outstanding campus buildings are wasted in terms of establishing useful urban space. They are physically too far removed to participate and add to the campus environment. Their aesthetic accomplishments should be duly noted.

The 1963 engineering science center at the University of Colorado—by W. C. Muchow of Denver, with landscaping by the Sasaki office in Watertown, Massachusetts—has shed roofs that reference local mining structures, as well as slight allusions to the red sandstone of the rest of the campus. It is a fantasy of volumes and voids, open courtyards and solid board-formed concrete, coffered ceilings and towers. There is an interlocking of space among the building elements of the ten-acre compound, with pools and fountains enlivening this engineering tour de force.

Architect Mario Ciampi's 1968 university art museum rests uneasily across the street from the Berkeley campus, thus contributing nothing to its urban space. The museum is a windowless concrete structure that dares you

to enter. Worth even a double dare, its unexpected interior is an angular chambered nautilus that winds around a central entry court; it has sky-lighted interconnecting gallery ramps and tiered cantilevered projections. Anyone (like myself) who complains that architects do not manipulate space enough should see this rambunctious, impertinent interior.

The 1959 sports assembly hall at the University of Illinois at Champaign-Urbana also stands all by itself, a headless, tailless concrete turtle with folded chitinous case (mentioned in Chapter 2). While Europeans have tra-ditionally designed labor-intensive thin roof shells, engineers in the United States—because of economic realities—tend to use more concrete, which requires less forming precision (i.e., less labor). Architect Max Abramovitz preferred the European approach in this case. He designed a 3½-inch-thick inverted cup that rests on a right-side-up bowl. This is inserted partially into the ground, so 15,000 fans can enter at the middle level. Since the bottom shell is supported by buttresses, the entire interior is unencumbered by supports. This structure recalls Frank Lloyd Wright's Annunciation Greek Orthodox Church in Milwaukee, built about the same time.

Alan Turner's 1987 engineering building on the University of California, San Diego, campus is an isolated architectonic masterpiece. The effect of its huge mass is relieved by means of multidirectional planes and balconies. A touch of red trim lightens the extravagant use of concrete, and large black horizontal ducts provide a diversity of form.

C. Y. Stephens Auditorium has been placed southeast of Iowa State's main campus and contributes little to it either spatially or botanically. Yet a structure of such strength cannot be overlooked. Its massive floating roof reflects the sloping ramps of the auditorium and the level of the concert stage. A curving cedar overhang makes a strong sculptural statement, while wide ribbons of white concrete and dark glass follow the roof angle. Emphatic vertical stair towers lend a touch of stability to this strikingly unbalanced form. Slickly designed catwalks and handsome hanging steps provide access. The auditorium was built in 1969 by architects Crites and McConnell and Brooks, Borg, and Skiles.

Finally, there are a number of major campuses in the United States that do not actually constitute missed opportunities but, at the same time, are not artistically worthy of much comment. While they may have outstand-ing individual buildings, these do not redeem the otherwise banal campuses. In this category we must include the Universities of Michigan, Mississippi, and Georgia as well as Ohio State and Southern Methodist Universities.

The Campus
as a Work of Art

Anyone who keeps the ability to see beauty, never grows old.
Franz Kafka

America's best campuses from the standpoint of planning, architecture, and landscaping are few in number, mostly because of faulty selection procedures. Whether this occurred at the beginning, middle, or end of their construction history, the majority of campuses sooner or later were visually savaged.

Which, then, of the 2,000 four-year campuses in the United States comes closest to approaching the aesthetic ideal? Which has handled its building design, its urban organization, and its outdoor work in such a way that there is a sustained visual achievement. "Sustained" is the operative word here: loss of direction is often the downfall of an otherwise good start. This is why we do not see some colleges with well composed centers included among the best 13 campuses. Not included at the top are classical Virginia, Gothic Chicago, delicate South Carolina, harmonious Emory, botanical Michigan State, monastic Harvard, exquisite Chapel Hill, and historic Brown.

The best campuses encompass the oldest and the newest, the urban and the pastoral, the private and the public, the coed and the non-coed, the science-oriented and the liberal arts, the distinguished designers and the unknown, the traditional styles and the modern (five medieval, five Renais-

sance, three contemporary). Those that have best met our criteria for good campus making follow in order.

Stanford University

Most designers will subscribe to this equation: The quality of their work is inversely proportional to the involvement of the client. The general rule is that once the program has been determined, the client's best interests are served by letting the designer have his or her head. Understanding this, the art collector Norton Simon is said to have made only one request when he hired architect Edward Stone to build a food processing plant: that Stone bring him the key when it was finished.

Stanford University near Palo Alto is an exception to the rule. In 1886 Leland Stanford had the temerity to face down Frederick Law Olmsted at the height of the great landscaper's career. Stanford, who was a U.S. senator at the time, persuaded Olmsted not to build the school back in the foothills that would have been ideal for one of his informal, parklike campuses. Stanford wanted a level site to accommodate a more orderly plan. And when Olmsted produced a double-arcaded, dense, formal plan with a peekaboo look at the foothills beyond, Stanford insisted that he rotate the quadrangle 90 degrees so the memorial church (to Stanford's son) would stop the eye to the south. This closed off the foothills view.

(It is an exquisite irony that, after this experience, Olmsted and the young Olmsteds who continued the firm after the old man's retirement in 1895 recommended more rigid approaches to planning; they were often ignored by college trustees who preferred informal garden layouts for their campuses.)

Stanford demanded a pretentious mile-long approach to the campus, extending the north-south axis; and he was determined to have his way architecturally using materials such as tile roofs. For a while, Olmsted rolled with the punches and played Michelangelo to Stanford's Pope Julius II. Though mission style is derived from Romanesque, Leland Stanford wanted a grander effect, namely, that produced by Henry Hobson Richardson. The senator hired Charles Coolidge to design the buildings. Coolidge and two other architects had inherited H. H. Richardson's practice in Boston. The young architect, who was at the start of his career, stood for Stanford's autocratic ways little more than a year and then, like Olmsted, was gone. All this, once again, boded ill for achieving a well-designed campus.

Stanford and his aides apparently had little idea of what each building's use would be. He was more interested in producing a monument to his dead son. If he had considered the variety of academic subjects that a university must undertake, he would probably have realized that it was an unachievable dream to cram classrooms, libraries, dorms, teaching laboratories, art studios, as well as engineering and other research into the modular spaces provided. (Students now divide themselves into "fuzzies," studying the soft

Successful compositions created by buildings, landscaping, and outdoor furnishings do not happen by accident. Stanford University's controlled environments, like the older one shown, have extended to areas outside of the inner quad. (Stanford News Service)

sciences in the inner quad, and "techies," students of the hard sciences located outside and to the west.)

In spite of these portentous events, the plan worked. Indeed, it is regrettable that Leland Stanford's ideas were not carried out after his death in 1893. Even without naturally growing trees, Stanford's inner quad is one of few campuses that can vie with the Harvard Yard in possessing a true sense of place. (Dorothy Regnery's book *An Enduring Heritage* contains a Coolidge drawing showing trees on the inner quad.)

Leland Stanford's convictions survived him neither in plan nor engineering. His wife Jane ordered the reinforcement in the new outer buildings of the quad to be deleted, and many of those buildings were damaged in the San Francisco earthquake of 1906. (The San Andreas fault line runs through the foothills behind the campus. Think what would have happened to the campus if Olmsted had had his way in locating it there!)

And the planned east-west extension of quads was never built; instead, newer buildings were placed outside the core almost as if centrifugal force had blown apart the tightly planned campus. No doubt these structures were to be connected by arcades someday, when the budget would allow. In the meantime, however, the desired collegial spirit, exchanging of ideas, and cross-fertilization of disciplines that comes with an orderly proximity is dampened.

The original quadrangle—an arcade of sublime repose, a Mediterranean court in America—is composed of Richardsonian Romanesque structures of even-textured sandstone blocks from leased quarries near San Jose. Squat columns surmounted by simple carved capitals (except for the memorial church's sinuous late-Norman capitals) support a red tile roof. It took armies of stonecutters to fashion some of the sandstone blocks into broken-faced ashlar and others into intricate decoration. The low structures have grouped transom windows in a medieval fenestration pattern of vertical openings with almost equilateral rectangles above; it is a pleasing Roman device that can be seen at the Forum of Trajan. The inner quad is a study in crisp and orderly drafting, a feat of lyric masonry. It has continuity without uniformity, harmony without affectation, scale without inhibition.

Stanford's grounds feature a few large sculptures by Henry Moore, Alexander Calder, and Gaston Lachaise that are used effectively to focus and delineate. The university owns one of the most important Rodin collections in the world. (The University of California, Berkeley, and MIT, in contrast, have many smaller sculptures decorating their campuses.)

The low, ground-hugging buildings desired by Olmsted and Coolidge were savaged by Leland Stanford when he insisted on a huge memorial arch at the campus entrance as well as a heavy tower on the memorial church, somewhat modeled on Richardson's Trinity Church in Boston (which, in turn, had been based on the twelfth-century Spanish cathedral in Salamanca).

Covered arcades are a trademark of Stanford University. They provide shelter from sun and rain and a mysterious cohesive element to regale the eye. (Edward W. Souza, Stanford News Service)

Coolidge wrote unhappily to Olmsted in May 1887, complaining that the Stanfords were insisting on an enormous entry arch and were determined to be rid of the "very qualities and reserve which we like." The great architect in the sky must have agreed, as both arch and tower were fatally damaged in the 1906 earthquake and never rebuilt. It was Leland Stanford, however, who had the last word.

After Stanford's main athletic competitor, Berkeley—their annual football game is the most important for both schools—constructed its beautiful Sather Tower in 1912, discussions began about a tower for Stanford. The Art Moderne–style Hoover Tower eventually appeared, both conceptually and stylistically interfering with the systematic rhythms of the campus.

Perhaps the ultimate significance of the 1887 Stanford campus plan is its possible proto-influence on the "City Beautiful" movement that came out of the 1893 Columbian Exposition in Chicago. The most important manifestation of the movement was the adoption of the Beaux Arts approach to planning, which mandates formal axes along monumental avenues lined with embellished buildings of breath-taking grandeur. The Beaux Arts style itself emphasizes unity of the whole and organizational clarity. For decades after the Columbian Exposition, campuses continued to adopt the Beaux Arts plan, if not the style.

Princeton University

The term *campus* was used for the first time ever at Princeton in about 1770, to describe the generous grounds around Nassau Hall. It may have been coined from a Latinism alluding to the Campus Martius of Ancient Rome, according to Stanford historian Paul Turner. Until that time, Princeton had used Harvard's term, *yard*. But by the middle of the nineteenth century, most colleges (except Harvard) were using the word *campus*.

Princeton is one of the dazzling scholastic places in this country. Its center, cannon green—where a cannon used in the War of 1812 is buried breech up—is surrounded by a plethora of styles: Georgian-Federal, Nassau Hall; Greek Revival, Clio and Whig Halls; Ruskinian Gothic, Chancellor Green Student Center; and Georgian, West College.

Yet somehow this green does not realize its large potential for eclectic failure: the space is perfectly scaled, the buildings are united in their high quality of design, and plantings soften the stylistic diversity.

It would be a nicely packaged summation of Princeton to say it is a gray-stone, white-trimmed, medieval revival campus. But that would be misleading. Princeton's uniqueness is based not only on its textural continuity, but also on an aura of richly decorated architecture that bespeaks the luxury of budgetary latitude. If all the stone tracery, heraldic shields, trefoils, bosses, crockets, and other medieval paraphernalia were not done so expertly, it might even be too much.

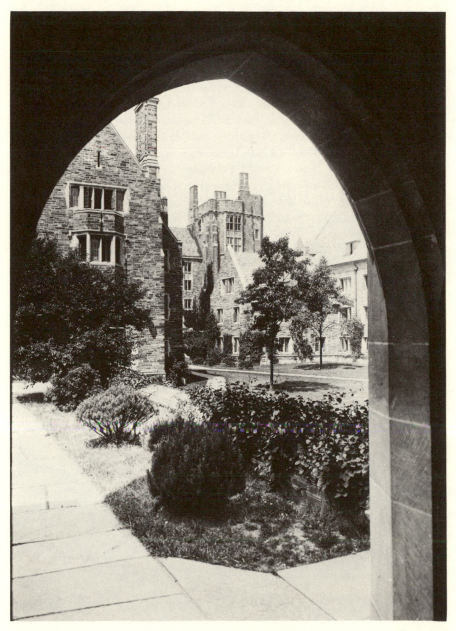

Even as Princeton creates pleasing medieval vistas, it goes the extra mile and embellishes with low coped walls and distinctive plantings. (Published with permission of Princeton University Libraries)

Furthermore, Princeton does something that should not be so difficult to do but is rarely seen. It places its structures, whether ancient or modern, so that they relate to one another in a spatially pleasing manner. This creates the many large and small open greens like McCosh Court that are a pleasure to pass through as well as hang out or study in. It was not always thus. Princeton was originally laid out in the axial, symmetrical mode preferred by early nineteenth-century planners. Thankfully, this notion gave way to the more picturesque landscaping ideas of Frederick Law Olmsted; structures no longer needed to be paired, to have a formal relationship to one another. In the late nineteenth century, Victorian pleasure gardens were suddenly in, and Princeton reflects this movement.

One unapplauded contributor to Princeton's rich feel was the architect William Potter, who designed (among others) the East Pyne Building in 1896, a carved marvel of a brownstone structure with statued and empty niches, gimcracks, and gewgaws. East Pyne represents the last of the Victorian Gothic buildings on Princeton's campus.

The first of the post-Victorian Collegiate Gothic structures with their crenellations and towers is Blair Hall. And Blair Arch is Princeton's signature. Not only do arches provide a segue into a new environment, but ideally they introduce a new experience—a change in campus style, a

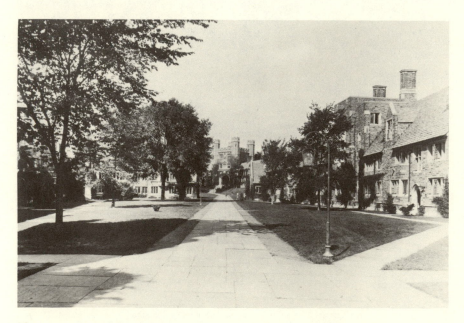

The turreted, crenelated, and machicolated Collegiate Gothic style that permeated American campuses in the late nineteenth century was never done better than at Princeton University. (Published with permission of Princeton University Libraries)

botanical alteration, a different approach to planning. In the case of Blair Arch, it signals a topographical variation, a drop-off to the campus below. This descent begins under the arch itself, with several steps down as one goes from north to south. Cope and Stewardson, known for their Gothic buildings at Bryn Mawr, designed Blair Hall in 1899. Gray foxcroft and limestone were used in preference to the brownstone of the Victorian structures. The Gothic arches at Princeton are not just empty tunnels, either, but are richly vaulted, ribbed, and bossed where the ribs meet.

For gargoylophiles, Princeton's medieval campus displays hundreds, all made available to the first medievals by the invention of the "modern" chisel in the eleventh century. The unseeing (blindfolded) reader on East Pyne symbolizes the school's purpose: opening the eyes of those who seek understanding. The monkey with a camera on 1879 Hall—more a humoresque than a grotesque—may be an apt metaphor for academic endeavor: playing with technology beyond its understanding. Then there is Guyot Hall, a veritable zoo for gargoyles; the walls of the biology wing are populated by living species, while the geology wing shows extinct animals. Stafford Little Hall has giants (symbols of virility) and figures with open mouths (a Romanesque motif). Since gargoyles, like all stonework, lose their minerals to acid rain, their featues are now becoming deeper, and they grow skinny and skeletonlike—in short, even more grotesque.

From 1756 when President Aaron Burr, Sr., brought what was then the College of New Jersey to Princeton until the beginning of the nineteenth century, Nassau Hall housed all the college's functions. The hall was named after King William III, who was "of the illustrious House of Nassau." Here the British army made its last stand, in the Battle of Princeton. Here, too, the Continental Congress (having fled mutinous troops in Philadelphia) sat in 1783—sessions that were attended by George Washington.

As is appropriate for an institution "deliberately designed for thinking," Princeton has placed throughout its campus a fine collection of heroic-size modern sculpture including works by Henry Moore, Louise Nevelson, Isamu Noguchi, Jacques Lipchitz, Pablo Picasso, Naum Gabo, Alexander Calder, Antoine Pevsner, and Gaston Lachaise. So, in addition to designing good buildings around attractive spaces, Princeton has highlighted the whole with these fine objects—thus leaving nothing to artistic chance.

Wellesley College

To memorialize his son, Henry Fowle Durant decided in the 1860s to build a school (as Leland Stanford would later in the century). Durant's school was to be for women, to "furnish the mind." In the early years of the twentieth century Wellesley's administration and trustees were keen on the idea of cutting the trees and leveling the hills to create a gridlike campus. One of campusdom's unsung heroes then stepped forward: Eliza Newkirk Rogers,

an architect in the school's art department, who organized the opposition. The undulating, glaciated topography of the Massachusetts countryside was preserved.

In its original immense building encompassing all college functions, Wellesley followed the form of Vassar; but in its rigidly pious outlook, it contained the heart of Mount Holyoke. The splendid isolation of Wellesley's pastoral campus is an example of what early landscape architect Andrew Jackson Downing referred to as the "natural, irregular English style."

From the days when maintenance people milked the college cows until the time when President Ellen Pendleton decided to pave the students' paths (rather than impose her own walkway design), and even thereafter, Wellesley planners have done everything right.

The focus of Wellesley's 550-acre campus is the Academic Quad. Here, in a place filled with what Downing called the "unshorn luxuriance of trees," is a perfectly scaled, intimate campus crossroad. John Greenleaf Whittier wrote a poem called "Norumbega" about the very first structure. The leitmotif of the quad's enclosure is red-brick Gothic Revival; its buildings have cleanly carved medieval doorways and copings of limestone. Though related by style and materials, their diverse massing avoids visual ennui.

The quad's west side was long in need of—and finally got—a proper void filler. In one fell swoop, this building solved planning, siting, and architectural problems. The planning problem was how to complete the quad using a site that starts at a level lower than its other buildings. The siting problem involved bringing students from the lower campus to the quad hill with the new building blocking the way. And the architectural problem was to make a modern structure that would relate to the traditional ones.

In 1958, architect Paul Rudolph designed the multistory Jewett Art Center/College Museum with a wide stair tunnel, a modern version of the nearby Gothic walk-throughs. Rudolph raised the building high enough to relate to the roofs of the quad's existing structures, and he used brick with concrete trim to match the brick and stone of the other quad buildings. It is a stunning success.

Part of the rightness of the layout and siting of Wellesley's buildings can be attributed to Frederick Law Olmsted, Jr., whose father helped design so many colleges in the nineteenth century. The younger Olmsted urged a grouping rather than scattering of buildings. Wellesley has succeeded where most campuses fail: integrating building additions without artistic mid-air collisions. It did so with the library, for instance, whose extension now hovers over Longfellow Pond (sardonically named when the famous poet failed to keep a speaking date).

And again it did so with the Schneider Student Center. Originally a music building shaped like an organ, it is now a gathering place with free-hanging balconies where students can eat. It also succeeded in expanding Sage Hall into the science center with a high-tech glass, steel, and concrete add-on,

even though the location of this complex defies Olmsted's caveat not to build on the meadows.

University of Colorado

Edwin Way Teale once said, "The world's favorite season is the spring; all things seem possible in May." He could have been inspired by the springtime vision of the University of Colorado (CU) campus in Boulder. The lush planting, the succession of flower bloom, and the many leaves bursting from a great variety of trees make all things seem possible here. But it was not always thus. Back in 1876, the Victorian mansard tower of Old Main was the only structure on the muddy, windswept slough at the confluence of the plains and the mountains. The entire school huddled around its fireplaces in midwinter, and it took physical as well as academic courage to attend CU. This was especially true for the president, whose rooms were in the basement.

Like so many campuses, CU's look is the vision of one man. Berkeley had John Galen Howard; LSU had Theodore Link; IIT had Mies van der Rohe. CU's redeemer was Charles Klauder of Philadelphia, who had made his reputation designing Gothic buildings at Wellesley and Princeton. The trustees expected him to bring Gothic to CU, as well. But Klauder was no automaton. He saw Colorado's robust territory and the Front Range of the Rocky Mountains and determined not to block it with tall buildings. He noted also the lack of regional traditions, which permitted him to go afield for appropriate styles.

And he remembered a photograph he had taken in Fiesole of a rural Italian farmhouse. He thought he saw a similarity in the Tuscan and Colorado countrysides and sold the CU trustees on an aesthetic shifting of gears. (Klauder's most effective argument was that his new idea would be cheaper than Collegiate Gothic.) Thus was born the unique CU style that, unless you look closely, seems to dominate the campus.

It would be a mistake to assume that Klauder slavishly followed what is essentially an Italian vernacular mode. He used gabled and tiled roofs only as a take-off point; he added a touch of Renaissance detail around openings; he created hail-proof hipped roofs and half gabled roofs and bookend roofs and dovecot chimneys, and all manner of his own creations to produce what could almost pass for an indigenous Colorado style. Sewall Hall is perhaps his best CU building.

Klauder used the university's leased sandstone quarries at Lyons (north of the campus) to wall up his creations; he split the warm native shale into long slices ranging in color from yellow to red to brown. The stones were laid in place untrimmed with weathered edges exposed and with wide mortar joints. Cut stone was utilized only around arched doorways and for trim. The wide use of this grainy material gives a tactile sense to the whole university.

Trellises, arches, and pergolas offer visual variety as students pass under them in their constant movement about campus. Here at the University of Colorado, there are a variety of leafy vaults. (University of Colorado photo by Ken Abbott)

But most of the old campus known as Norlin Quadrangle, which is on the National Register of Historic Places, was constructed before Klauder arrived. (It was named for President George Norlin, a professor of Greek literature who was a well-known boxer and more than once offered to settle disputes by mixing it up with students.) Norlin Quad is beautifully planted with an emphasis on evergreens to help student morale through the long Colorado winters. A constant gaggle of large black-and-white magpies keeps the eye from languishing.

The space is a ragged rectangle and a study in historicism. There is the Tudor-Gothic style of Mack Auditorium, the Renaissance Revival of Guggenheim Geography, and the Romanesque university theater. The last two structures were built in a conscious move toward eclecticism to offer many architectural styles for student exposure. This is a worthy goal that takes a

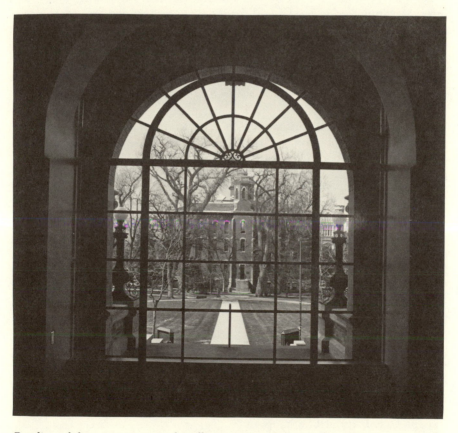

By dint of fine structures and well-proportioned space, the original area at the University of Colorado—Norlin Quad—holds its own against the newer campus. Here the university theater stares down mansarded Old Main across this agreeable space. (University of Colorado photo by Ed Kosmicki)

skilled hand and a lot of ivy to pull off. The theater, originally the main library, was the first building to turn the campus inward and form Norlin Quadrangle. Its fine contemporary east wing proves that old and young can live comfortably together. It is the best-realized structure on the quad.

Klauder did not have very much influence on this fine earliest space. His first campus building was Hellems, a multiroofed, multichimneyed symmetrical sandstone structure that set the tone for much of the campus construction to follow. The thick shrubs between Hellems, the chemistry building, and the union create an area that is one of American campusdom's magical spots. Within it, the terraced pool framed by a fine arcade addition to the union has become a favorite gathering place for students. A plaque there reads: "An outdoor people's space dedicated to the enjoyment of the campus community."

In order to assure the continuance of Klauder's architectural values, an internal planning office was established; the office is guided by a joint planning committee. In addition, outside consultants have been brought in from time to time. Even modernist Harry Weese built his astrophysics tower using Klauder's specifications. Weese filled the bays of the ten-story tower with Lyons sandstone and capped the whole with a red tile roof. Still, the work that followed Klauder's death in 1938 has not always matched his quality in relief and details.

How well does all of this work? There is an indisputable visual kinship throughout Klauder's campus. His hill-town forms, arcades, and loggias provide an agreeable backdrop for the urban spaces in his design. Like stage props delineating the areas in between, his structures play their parts well.

As architecture enclosing inside space, however, the style does not match the rich and interesting interiors found in Beaux Arts or Gothic Revival buildings. Klauder's interiors are generally formless and gloomy. He kept windows small to discourage the Colorado sun. The student union, for example (not a Klauder building, but following his lead), is typical in its beckoning aspect on the outside, with towers, balconies, and arcades; but it is less than exhilarating and almost cheerless within.

It should be remembered that, in judging a work of architecture, the interior space created by walls is the most important element, not the walls themselves. In appraising a campus, however, the exterior spaces and the backdrop structures that create them are what matter most. It is reasonable, therefore, to give CU high marks in campus making, for it meets this latter test with flying colors.

Indiana University at Bloomington

Indiana's "new" campus started out at Dunn's Woods near Bloomington in 1893 and never lost that sense of being a university in the woods. This was a matter not just of conservation (i.e., not "improving" what was there), but of aggressive cultivation. One of the unsung heroes of the effort was

William R. Ogg, who became groundskeeper in 1899. For the next 35 years, he searched the surrounding woods for appropriate replacements for campus trees that had died. Although nursery stock is now more commonly used for replanting, much of today's campus woods were transplanted there by William Ogg.

The original Crescent around Dunn's Woods is still there with such old medieval masterpieces as turreted Maxwell Hall and rusticated Kirkwood, but the campus has expanded into a typically Midwestern nonplan. Lack of formality, however, does not obviate the possibility of interesting and related urban spaces. And these abound at Bloomington. With the union acting as a hinge, the campus opens out on the other side of the Jordan River (shades of Michigan State crossing the Red Cedar River, Berkeley fording Strawberry Creek, and New Hampshire hurdling College Brook).

But unlike others, Indiana did not lose sight of its design goal and created urban and floral images as it went. The road to the library, for instance, delights the eye; it emerges at Fine Arts Plaza, which features Showalter Fountain with Ralph Laurent's sculpture "Birth of Venus." Among other structures embracing this plaza is the auditorium, with its murals by Thomas Hart Benton. This building, a modernized Collegiate Gothic, was designed by the New York firm of Eggers and Higgins, who also designed the National Gallery of Art in Washington, D.C.

Another plaza structure is I. M. Pei's triangular art museum made of colored concrete to look like limestone. Pei studied the traffic pattern from the main library to the union and found that a triangular shape was the most likely to fetch people into the museum. It has been described as a circle set inside a square. Coincidentally, I. M. Pei finds himself side by side again with Eggers and Higgins in Washington, as he designed the East Wing of the National Gallery.

Heading in the opposite direction past the huge and characterless classroom building Ballantine Hall, on the way to Third Street, one enters another hilly forest out of sight of any buildings. Little Red Riding Hood would have felt at home on this campus.

Indiana University is exciting. You never know what is coming up next. You must walk through hilly gardens and woods go get to classes, to dorms, to the library, to the union. Surprise is surely a worthy goal of design. It is more difficult, I believe, to develop an interestingly cohesive campus without the traditional axes or quads on which planners hang their hats. And it is more dangerous to try. Indiana succeeds, because its visual quality is largely based on the unexpected. This is true of three others on our list of the 13 best: The Universities of Colorado and Kansas, and the Evergreen College.

The Evergreen State College

The word *experimental* has an untried and untrue ring to it. Whether theater, dance, or architecture, experiments usually dead-end or take a long

time to debug, mature, and refine. Most of the experimental campuses that accompanied new ideas in teaching were artistic disappointments: Reed College, Antioch, New College, Oberlin, Santa Cruz, Hampshire College.

But one such campus is no disappointment. Founded on the book *The Experimental College*, in which Alexander Meiklejohn described his work at

Planners tease the eye at the Evergreen State College in Olympia, Washington. Partially hiding the campus with a grassy berm makes the visitor yearn to see more—a successful example of space manipulation. (Steve Davis, TESC Photo)

the University of Wisconsin from 1927 to 1932, the Evergreen State College became Washington's fourth state campus. (Administrators insist that its roots go back to Socrates.)

In 1968, the firms of Durham Anderson Freed, architects, and Quinton-Budlong, engineers, prepared a master plan for 1,000 acres the state had purchased for a campus in the heart of the Puget Sound basin, six miles west of Olympia, Washington's capitol. Not lost on the state acquisition committee was the natural setting in this western hemlock zone with views of the Olympic Mountains. Students now benefit from the careful planning work that was done at that time. Walking away from the campus center, one experiences the controlled scape melting into more informal planting and lawns and finally into undeveloped forest. Pavements spoke out from the central red square to the buildings and eventually become trails to outlying areas.

Except for its landscaping, there is nothing formal about this small bosky campus. Rather than take the easier route of a recognizable quadrangle, planners chose to place their structures in a manner that describes no known geometric form—but one that is exactly right for the site. As soon as you arrive at the oval bus stop, you know you are someplace special. You can tell by the siting of the concrete and glass buildings, and by the grassy berm that mischievously obstructs part of the sight line. And you can tell by the

The Evergreen College's random but cohesive plan combined with exquisitely designed concrete volumes and voids set in the arboreal drama of Olympia, Washington, shows that administrations can aspire to perfection even with all the complex demands of campus making. (Steve Davis, TESC Photo)

finely scaled red square—the main brick plaza where students move and, in warm weather, gather.

Though every structure is different, each relates to the other through their common materials and professional touch. The Evergreen core includes a campus activities building (CAB), science labs, recreation center, lecture halls, a communications lab, and others. The student gathering place in bad weather is the street cafe in the CAB.

The library's clock tower, a four-story concrete shaft, is the visual focus as well as the center of the red square. It is a frankly modern, off-center but not unbalanced work whose scale is right for the size and spacing of the other structures.

The design criteria established for the library building is instructive: "It should convey an inner strength, yet have a measure of reserve or mystery so that even those who work in it year after year may continue to discover refinements and responses. Details ought to express interior structure in its exterior delineation. Generous windows protected by substantial roof projections permit students to look into campus courtyards and the mountains by day. By night, it permits those outside to see in and be visually invited to enter."

The library architects, Durham Anderson Freed, succeeded in meeting these goals. The dignified concrete and glass building harmonizes with its natural surroundings and is warm in tone to counteract gloomy winter days. Columns and windows express interior structure; wall panels are treated in a manner to reflect surrounding tree bark.

The Evergreen does need more outdoor sculpture, however. Against the sophistication of this campus, it is sorely missed. Lacking also is a commitment to the existing master plan. Instead, new project needs are considered on an ad hoc basis—an evil portent for this school's aesthetic future.

Columbia University

Of all the campuses on our list of the 13 best, the only one that can be strictly characterized as Beaux Arts is Columbia University in New York City. More a manner of execution than a style, Beaux Arts design was primarily scenic (and expensive to build). Accordingly, its grand architectural fantasies (like Benard's Berkeley concept) found their way onto the drafting board more often than the building site.

Charles McKim of McKim, Mead and White won the campus commission over Charles Coolidge and Richard Morris Hunt, both of whom submitted multiple-quad plans. McKim's concept, influenced by eighteenth-century architect Etienne-Louis Boullée, was grander; it was a formal but adventurous plan: a collection of harmonious classic buildings of brick and limestone with equal cornice heights and fenestration—all this terraced around a massive Palladian focus. The east and west pallazo-scaled buildings were to be neo-Georgian, the north and south strongly Greco-Roman.

It almost happened that way, too, the emergent campus being surprisingly faithful to McKim's original drawings. But hope of actually completing the work according to McKim's orderly vision ended when University Hall was not completed. It was to be built north of Low Memorial Library, fleshing out that part of the campus; but, alas, Columbia constructed Uris Hall on the site instead.

The single high climax required by Beaux Arts is admirably provided by the rotunda of the 1897 Low Library. Expansive flights of steps start at College Walk and diminish in width as they climb through embellished landings and terraces. Crafts and sculptures along the way include Daniel Chester French's statue "Alma Mater." This piece, similar to one French did for the Columbian Exposition, is symbolically appropriate here, as it was the 1893 orgy of grand plaster palaces in Chicago that launched the Beaux Arts in the United States.

There are enormous urns and bronze lamp standards (copied from one at the Vatican Museum) resting on two cheek walls. The portico is framed with Ionic columns supporting an entablature surmounted by a balconied attic. Behind this is an octagonal drum (perforated by an arched window) whose cornice is decorated with modillion blocks. A dome caps the whole, making it one of campusdom's boldest and most perfect classic statements.

Sadly, Low's interior was to prove unworkable, and its life as a library was short. The main reading room inside the rotunda seemed like a good idea at the time, but its lighting was poor and the space had to be partitioned for other library and administrative purposes. Butler Library came to the rescue. And though by this time (1934) it was financially unjustified to do so, the trustees doggedly pursued the coherence of classic tradition called for in the McKim plan when they constructed the many-columned Butler. Based on the mausoleum at Halicarnassus, this enormous building is partially structured in steel and lacks the stylistic authority of Low's pure masonry.

Accommodating 18,000 students on 34 city acres requires an imaginative approach to growth. Like so many other campuses, Columbia did not distinguish itself with its postwar choices. The worst is Uris Hall, whose aluminum presence looms behind Low Library like a parody of the International style. The negative impact of Uris on the campus is mitigated by Peter Gluck's three-story addition, which fits into the space left by Uris's wings. With a sensitivity to scale, Gluck has built a limestone mass with strong fenestration whose front grillwork makes a passing allusion to the original business school behind it. As a rule, the filling in of treasured green space on an urban campus is not recommended. In this case, it is tolerable, however, because it renders Uris more acceptable.

I. M. Pei's 1968 plan to maximize the capacity of the campus proved too costly to be carried out. One element that was constructed is the Avery Library Extension, an underground facility between Avery and Fayerweather Halls. Modern ventilating technology makes this solution available, and when done with skill—as at Columbia—the results are satisfactory. To

dilute the somber experience of descending to the underground reading room, architect Alexander Kouzmanoff provided skylights. And to cover these lower rooms outside, a beautifully landscaped quad was created.

The Columbia campus succeeds as a work of art because it has avoided visual boredom, the pitfall of most formal grounds. Though not symmetrical, it provides a balanced plan of graceful and unexpected spaces, and its well-landscaped classical structures make a fine study in urban grandeur.

Mount Holyoke College

When it comes to decision making, Mount Holyoke Females Seminary (as it was originally known) got off to a bad start. South Hadley, Massachusetts, was chosen for its site over the more aesthetically desirable Sunderland and South Deerfield, simply because that community provided more funds. But founder Mary Lyon may be forgiven for this aesthetic indiscretion; she was forced to dun farmers on their way to town to get the seminary started.

Mary Lyon is a revered name in women's education. In 1837, after a career in teaching, she started what became one of the oldest women's colleges in the country. Mount Holyoke not only paved the way for many such institutions to follow—Wellesley, Vassar, Smith—but its (and their) graduates provided teachers and administrators as well.

The campus that emerged from such rude beginnings is a study in controlled informality. Open spaces vary in size and shape, and their invariably correct proportions are richly delineated with Dutch-influenced medievalism. The multiconfigured Mary Lyon Hall built in 1897 on the site of the original seminary building is a good neighbor to the Collegiate Gothic–style Williston Library. These buildings define the west boundary of the main polygonal quadrangle, their red-brown masonry joined by similarly colored mortar.

The east boundary is articulated by recent construction: the modern 1961 Eliot House, and Gettell Amphitheater with its curvilinear peristyle of brick piers and concrete roof stopping the eye. Graduation and other outdoor events are held here, with the great lawn behind the stage useful as added sitting room. These structures plus the art building show one or two stories to the quad (thus maintaining the scale), then drop down the hill to the east and become three and four stories. This approach accomplishes something most campuses cannot seem to do: expansion without a destruction of scale, without stylistic jarring, and without damaging the botanical composition. It is more than a matter of mere contextualism—the lining up with existing moldings and a mimicking of colors and textures. It is a genuine aesthetic extension, an extrapolation of spirit.

As a focus for this academic green, Mount Holyoke offers a first: the fenced grave of Mary Lyon, who died in 1849. The old observatory just to the north was abandoned when the height of the trees growing around it

The campus of Mount Holyoke is the very essence of place: mature buildings framed by mature trees and the space to make it work. (Clemens Kalischer)

made it impractical. What an interesting example of natural priorities over man-made ones! "Landscape," Henry James said, "is character."

Brigham Hall, with its stepped gables, and Porter and Stafford Halls outline the south side of the academic quad and also the north side of the circular residential green. The reddish-brown dormitory buildings surrounding the latter have wings and ells that, with clever landscaping, create mini-quads in themselves. On the east side of this circular green stands Blanchard Center, an excellent example of adaptive use—almost a palimpsest, in fact. This old 1899 gym has been opened up, cleaned off, and refurbished to reveal a great three-story space with wooden trusses supported by scrolled brackets. Narrow, beaded fir stripping sheathes the ceiling and wainscoting. It is a place of character, where students like to snack, dance, and play.

Separating the campus from Route 116 is a classy Gothic iron fence leading to an entry gate of cut reddish-brown sandstone and voluted iron. The stone is peened, giving it texture, and is joined by tooled red mortar to match the buildings. Ceramic inserts in the stone repeat the flourishes of the ironwork.

Among the surprises and delights characteristic of many of our best campuses are their bowers, dells, and concealed gardens. Behind Mary Lyon Hall and the Abbey Chapel is a secret formal garden that has a small monument with radial flagstone arms. Here there are evergreen shrubs surrounded by topiary bushes, and flowers. It is a sweet place on a campus of genuine repose. Perhaps the best time to appreciate these old grounds is early on a summer morning when the haze softens the edges as in a scumbled painting.

Rochester Institute of Technology

With all the elements that make up a college campus, it is hopeless to think that there could be an aesthetically flawless example. One that comes close, however, is the Rochester Institute of Technology. Nothing here was left to chance. Like the University of Massachusetts-Boston, aesthetic control at RIT was complete from the paving to the paintings, from the sculptured guardhouse to the rich interior of the information office; control even extended to the outside benches of molded concrete. RIT is an almost indecent collection of perfect components.

With space to plan, why is this a campus of dense urbanity? Try checking the snowfall data for Rochester, New York. The idea of moving students around a spread-out winter campus, and the thought of the budget needed for plowing, would lead any planner to opt for a close-in approach. And it was done without losing sight of the special needs of an urban campus. Using the same sense of space employed by McKim, Mead and White at Columbia University, coordinating architect Lawrence B. Anderson placed crisp modern structures so that physical movement is diverse and sight lines are ever changing. (Dorm students might be inclined to file a minority report, contemplating the cold walk from the residential campus.) While there are no roads on the internal campus, the vehicle entry circle is located near the information office, showing a simple yet unusual logic.

Sculpture has been extensively incorporated into this campus, and it is unique here in two ways: The works are sound contemporary pieces, not experimental (read funky); and they are mostly architectural sculptures—that is, made for the space allocated rather than commissioned as an afterthought. One example is the partially raised brickwork along a wall of the Carlson Building, a relief sculpture by Josef Albers. Others include Sheila Hicks's architecturally integrated basket-weave wall tapestry in the Eastman Building and Harry Bertoia's sculptured bronze planters in the

Walkways expand and contract at the Rochester Institute of Technology forcing students together in places and apart elsewhere. This dynamic movement prevents ennui as people move around the campus. José de Rivera's stainless steel sculpture can be seen at the end of the walk. (RIT Communications)

union. There are three-dimensional textiles by Dorian Zachai, a chrome monument by José de Rivera, and the largest sundial in the country by sculptor Alistair Bevington. The unerring choices made in acquiring these works is a measure of the perfect aesthetic vision that marks this campus.

All this control does not, however, inhibit creative touches. For instance, an interior glass wall in the union lounge overlooks the huge indoor pool; the constant movement of swimmers engages the eye. And there is the round walk-through opposite the Carlson Building to reach the north side of the campus. This is a brick campus—10 million Belden iron-spot bricks, as a matter of fact—and the continuity they provide is balanced by varied massing and window treatment in each building. Brick returns obviate the need for steel or concrete window trim, thus preserving the pure brickness of the campus. There is squared brick, angled brick, projecting brick, and splayed brick.

Walkways are asphalt and brick; and except for the chapel and art gallery, interior materials are humble concrete and block. But in the right hands, even this can be sensitive—hanging rich sculptural weavings against bare concrete in the union, for instance.

Landscaping elements, as is usual on an urban campus, are not plentiful; those that exist need more years to flesh out. Certain vistas suggest a cold de Chirico character, which can be depressing on a winter's day. Indeed, the lack of a sensuous presence may be the one fault this campus does have. But factored into the whole of a good designer's plan must be the human relief provided by the colorful presence of the students as they move along the walks. All in all, comparison with Chicago's Illinois Institute of Technology suggests itself. IIT is a vision of refinement in steel; RIT, a vision of refinement in brick.

SUNY at Albany

Edward Stone described today's architect as a "flute player in a boiler factory struggling to get across a few pure notes during a coffee break." In the last 20 years of his life, Stone's "pure notes" took the form of modern neoclassicism. His buildings had overhanging skylighted roofs (Renaissance) supported by a defile of delicate columns (Federal) with symmetrical, highly textured and sometimes perforated walls (Georgian).

Stone's period sequence started with art deco interiors, such as Radio City Music Hall. In the 1950s, he designed the U.S. pavilion at the Brussels World's Fair and the U.S. embassy in New Delhi (which even Frank Lloyd Wright praised). His Kennedy Center in Washington, D.C., reflects this later style.

And so does his dazzling one-of-a-kind State University of New York (SUNY) campus at Albany, built in 1961. Flying in the face of the new random approach to planning, Stone produced a formal masterpiece, but one that, in its rigidity and organic permanence, resists alteration.

Edward Stone's SUNY at Albany is a study in classical romanticism. The main rectangle is broken into subquads surrounded by four high-rise dorms with lower minischoolhouses around them. To the far left on the academic podium is the library, to the near left the student center, and in the middle the performing arts center. The entry circle is at the top. (SUNY at Albany)

The entrance paving prepares you for a refined visual experience with granite cobbles interlocking to form waves. Stone placed the essential university buildings—library, union, performing arts, humanities, social sciences, fine arts, life sciences—on an academic podium around a pool, and then hurled a concrete slab over the whole.

Supporting the overhanging roof, which is open over unenclosed areas and has glazed bubbles over interior ones, is a host of concrete columns reminiscent of the Temple of Karnak in Egypt. These columns are splayed at the top and lose themselves in the roof. Covering the campus like this guarantees circulation of students in more or less dry conditions. All structures are either pre-cast, as in the wall panels, or cast in place. Outside of this central campus are four 23-story residence halls, one at each of the four corners. They overlook their own cluster of classrooms, labs, and auditoriums. The white vertical mullions of these tall punctuation marks reflect the white columns of the main core.

Stone was a purveyor not only of beauty (he held that ugliness is sinful), but also of sound structure and utility. (Vitruvius called them "Beauty, duration, and convenience.") With 300 acres to select from, Stone chose to contain the academic center within an area of seven blocks, permitting

SUNY at Albany's rigidly formal campus composition does not inhibit its students, who wade in the pool of the main quad. This spring rite is signaled by the season's first operation of the great fountain at the base of the carillon tower. The event highlights HAP (Human Awareness Program) Week. (SUNY at Albany)

students and faculty to reach any place in a few minutes. And they can do it without crossing streets; exterior roadways and underground receiving docks make this possible.

Servicing 16,000 students with grace and elegance, Stone's contemporary romantic but rigidly ordered throwback of a campus is a bargain at $106 million.

Louisiana State University

In 1861 the Civil War snatched away Louisiana State University's first superintendent, William Tecumseh Sherman. He left to command Union forces, while most of the student body entered the Confederate ranks.

Sixty years later, the inadequacy of LSU's small downtown Baton Rouge campus caused an agriculture graduate to say that he had not even learned how to "collar a mule." Pressured by complaints like this, President Thomas Boyd promptly wrote a $500 personal check for a 60-day option on the 1,200-acre Gartness plantation bordering the Mississippi River. The race was on. Would the Louisiana legislature pass a bill appropriating the $82,000 to pick up the option?

The charm of campus walkways is a measure of planning success. Diversity of materials and variety of boskiness maintains interest as students wind through the Louisiana State grounds.

A barbecue was held at the Gartness Indian Mounds (now preserved in the center of campus) for the members of the legislature. According to a reminiscing article in the *Shreveport Times* of March 27, 1960, the LSU band and glee club performed; buttermilk, sweet milk, and coffee were served. It was the first "dry" barbecue in the history of Baton Rouge. The money was appropriated, and the school moved from what is now the state capitol complex.

Two mysteries shroud the early history of the LSU campus to this day. The first is now unanswerable: Why did the Olmsteds—son and nephew of

Frederick Law Olmsted—not complete their plans for the campus, which the LSU trustees approved in 1922?

The second is almost as obscure: Why did Theodore Link—hired to plan and design the campus in place of the Olmsteds—eschew the long French and Spanish tradition in favor of sixteenth-century Northern Italian Renaissance style? Link talked vaguely about climate and cultural heritage.

Added to this unpromising beginning is the fact that Link, who was 70 years of age when he signed on in 1922, died the next year. After that, many firms participated in development of the campus, starting with Wogan and Bernard of Baton Rouge. None of this would seem to bode well for producing a harmonious campus.

Theodore Link was a distinguished architect who had designed the Washington University Hospital, the St. Louis City Hall, and St. Louis's Union Station. Apparently, he was selected for this fact alone, since he had no known professional or political connection to the state—an unusual and wise choice.

Link's cruciform plan was more formal than that of the Olmsteds; it was a simple north-south axis crossed by a shorter east-west axis. A 175-foot bell tower modeled after that of the 1587 St. Giorggio dei Greci in Venice anchored the eastern cross, with the Hill Library on the opposite side. The nicely profiled Atkinson Hall—a veritable palazzo, with Roman Doric columns on the first floor and a romantic three-arched loggia above— terminated the southern end of the long quad. The churchlike, pedimented Foster Hall cum oculus windows stopped the eye to the north.

Although some elements of LSU are similar to the Stanford University campus of 30 years earlier—double-arcade quadrangles, buff-colored materials, red-tiled roofs, square fenestration (in Himes Hall)—it is probably not true that Link had Stanford in mind. LSU is a muted Renaissance, while Stanford is Romanesque Revival; LSU's main court is planted in a Renaissance manner, while Stanford's medieval court has only a few green pods; LSU's tower is in keeping with Northern Italian tradition, while Charles Coolidge was thinking in terms of low, ground-hugging buildings and never envisioned a tower for Stanford. (Hoover Tower came to Stanford many years later in a burst of misplaced hubris.) On the down side, it is true that both campuses failed the challenge of growing within the early visin of space as sanctuary. Buildings are spotted randomly around while attempting to maintain visual continuity through materials, color, and—for the most part—style.

Through all the confusion of plans and architects—LSU managed to retain its Mediterranean flavor. Link's quad and some of the buildings he designed constitute LSU's pièce de résistance. Grainy tan skins that cover the buildings with just a touch of Italian Renaissance symbols characterize his work. This finish is made by mixing aggregate in stucco and skimming it as a second coat over a first of plain cement, sand, and lime. The whole campus has a deliciously tactile look.

The quad includes Himes Hall with its Italian hill-town towers and a Baroque niche, a sign of things to come. Renaissance details even adorn the campus bus stops, which sport columns in Roman orders supporting hipped roofs of red tile. Two matching entryways show the elegant arch and shoulders that symbolize the Renaissance period. Andrea Palladio stalks this campus. (The Palladian window was, in truth, invented by Donato Bramante and codified by Sebastiano Serlio.)

The quad's planting, which was done in the 1970s by the firm of Henslee, Thompson, and Cox, is a cornucopia of botanical discovery. There are plants, grassy lawns, and ground covers as well as the original live oaks around the perimeter. Spaces are defined by low walls, while benches abound; walkways are angled, varying in width and made of plain concrete pavement alternating with aggregate concrete.

LSU is a botanical joy to behold at any time of the year. All species of greens and shrubs natural to Southern Louisiana are planted on the campus. Landscapers try for a continuous succession of flowers. Camellias bloom in December, azaleas in February, then spireas and quince followed by hydrangeas, crepe myrtle, oleander, and day lilies. Winter magnolias are most spectacular in February. The original Pfitzer junipers were trimmed in windblown form to protect from student traffic. Because of their rapid growth, pines are used these days to replace plantings taken for construction. Thoughtfully, landscapers plant fragrant trees like sweet olive and magnolia fuscata near entrances.

In 1930, Governor Huey Long began serious financial support for LSU. He was not always interested in academic buildings or expanding the faculty, however; his original concern was with the football team. In true form, Long declared, "LSU can't have a losing team, because that will mean I am associated with a loser." His efforts did help raise LSU to the level of a first-rate university, and the governors that followed continued this policy. (It is rumored that Huey Long bestowed so much of his bounty on LSU because a well-known school in New Orleans had not admitted him.)

Aesthetically speaking, the most barbarous event to defile the LSU campus took place in the 1950s. President Troy Middleton ordered that the new library be placed at the apex of the north-south, east-west cross. In one fell swoop, he blocked the siteline to beautiful Foster Hall, destroyed the original plan, and in the bargain, commissioned a poorly designed building that now dominates the quad. It looks as though it has never been introduced to its neighbors. And Middleton's excuse was this: "The students will have to trip over the damned thing."

An attempt—probably wrongheaded—to avoid this kind of mistake has been made under the state capitol historic district legislation, which mandates that all future campus construction at LSU will be done in the Italian Renaissance style. Since this law was passed, two successful buildings have gone up: the visitor's center, and the dinosaur museum. Both were designed in-house by the office of facility development. They combine the inventory

of Italian Renaissance elements—columns, keystones, and quoins—with modern window treatment.

But this kind of legislation does not address the Middleton Library's problem. Its placement and poor design quality would be perfectly acceptable under the new rule. So would the pretentious law building with its huge columns and tympanum, modeled after the U.S. Supreme Court. A sound selection procedure, with a campus architect approving all plans, would be a much better way to assure a high level of construction.

Proof that well-designed modern buildings do not fragment campus integrity is shown in the addition to the Howe-Russell Geoscience Building, made by LeBlanc and Dean of Baton Rouge, and in the college of design by Heinberg and Borcato of Alexandria, Virginia. Both accomplish their missions with élan. The college of design depends on massive volumes, while Howe-Russell employs strong architectonic elements for its vertical thrust. It should be noted that these structures and the beautiful union (discussed in Chapter 2) would not have been authorized under the new design-control rule.

Planners at LSU have not properly addressed the automania problem. Except in the main quad, one must everywhere walk across busy streets to go from one class to another. Nonmoving cars are as much of a campus burden as the traveling ones; they are parked on plazas and forums the way they are in European cities. And their pollution damages this otherwise excellent campus.

University of Kansas

As Franklin Murphy has said, "Everyone thinks Kansas is flat as a billiard table. As a matter of fact, eastern Kansas is rolling hills. . . . You begin to see the university ten miles away rearing up high on a hill—Mount Oread. Buildings flow down the sides of this hill into Lawrence. It is just absolutely beautiful."

These accurate words are from the University of Kansas's chancellor emeritus (whose name adorns the beautiful sculpture garden at UCLA, where he was also chancellor). But a winding ridge is not topographically promising for campus grounds. Planners often succumb to these limitations and produce narrow windy thoroughfares that are cloisterophobic and require students to double back whenever they go from dorms to classes.

Two things happened at Kansas to assuage this problem. First, there were no planners. George Kessler, a Kansas City landscape architect, proposed a plan in 1904 that did affect later landscaping, but not planning. Second, after the original buildings were constructed along Jayhawk Boulevard, the campus, uninhibited by its physical restrictions, plunged in both directions perpendicular to the ridge.

But when all is said and done, it is the old walkway past Henry Van

The buildings of the University of Kansas, at Lawrence, gather along the brow of Mount Oread's ridge and can be seen miles away. The campanile is in the foreground with Dyche Hall to its left and Fraser Hall to its right. (University of Kansas, University Relations Center)

Brunt's 1893 Richardsonian-style Spooner Hall, Siemens and Root's 1903 Romanesque structure Dyche Hall, and John Stanton's 1905 Greek Revival building Lippincott Hall that encapsule the aesthetic appeal of this campus.

Dyche Hall is the signature structure at Kansas. It is encrusted with Old World architectural elements like an arcaded loggia, multisided bays, balconies, gables and gablets, projecting and pinnacled pavilions, and a plethora of round arches (except for the modillion-blocked gable over the entrance, modeled after St. Trophime Church in Arles, France). And the tower, which can be seen from half the state, is a character piece of rusticated Oread limestone that soars past double rounded windows, steep gables, cornices, lunettes, and columns; then it is crowned with a steep multisided cone.

But look again. Dyche Hall's exterior is also ornamented with sculptured animal icons both real and mythical—the cowlike heads on the columns. This announces that inside resides one of campusdom's four best natural history museums. (The others are at Michigan, Berkeley, and Harvard. See Chapter 2 for a fuller discussion of the museum.)

Since 1866 when the college first taught 55 students a course on Xenophon's *Anabasis*, Kansas (which has been called the wheat-belt Berkeley) has preserved its wooded ridge. By following the ridge's turns, it has created

Landscaping and outdoor furnishings distinguish the University of Kansas. This fountain creates spatial flow on the eastern part of the campus. (University of Kansas, University Relations Center)

varied spaces within the bosom of these graceful curves. And the view from these slopes over the Kaw River Valley has charmed generations of visitors including Walt Whitman and Horace Greeley.

University of Wisconsin–Madison

It is not just the proximity of the University of Wisconsin to Lake Mendota that makes this campus a special place, but also the respect that planners and builders have shown for this huge body of water over the years. Its visibility from most places on the campus has been preserved. The union terrace with its Mediterranean shoreline overlooks it. The beautiful lakeshore path used by students on their way to class, joggers on their way to good health, and couples on their way to matrimony follows it.

Bascomb Hill, the original campus center, was planned as the municipal cemetery when the city of Madison was founded. Instead, the hill changed from graveyard to schoolyard when the university was established in 1848. The Bascomb Quad was laid out on an axis with the state capitol one mile to

Trees along the lakeshore path at the University of Wisconsin–Madison describe open arches as students enjoy a romantic idyll between classes. Preserving this lineal space along the main campus and Lake Mendota was a planning inspiration. (University of Wisconsin–Madison, News and Information Service)

the east symbolically linking the state's academic and political institutions—an ironic twist in a university known for its fierce protection of academic freedom.

The original modest campus plan was made by John Rague, a Milwaukee architect. In 1908 the trustees hired Warren Laird and Philippe Cret to rationalize the campus architecture and plan. Their recommendation was to follow the lead of the two original buildings, North and South Halls, and to render all future construction in their subdued astylar Renaissance style. Had the whole campus been constructed in this elegant but conservative Tuscan style (as compared to the lively Lombardy strains of the union), it would have had a profoundly different look.

Fortunately, this piece of architectural advice was ultimately not taken. Laird and Cret's campus layout, however, continued to dominate. That their restrained stylistic notions were unsound can be seen on Bascomb Hill, living proof that if scale and materials are controlled, architectural variety not only works but enlivens. All masonry and mostly sandstone, styles on the hill range from the Renaissance Revival of Bascomb Hall to the Victorian Gothic Revival of Music Hall and the Romanesque Revival of Science Hall (which the young student Frank Lloyd Wright helped to build). To turn back the clock and limit new buildings to neoclassical styles would be to ignore the march of aesthetic history, to deny sociological advancement, to reject technological discoveries. Had this been carried out, the campus would lack the visual diversity that informs today's stimulating University of Wisconsin.

Although many of the green openings that existed in the 1940s when there were 12,000 students have been filled in now that there are more than 40,000, the change was carried out with grace. New structures were carefully landscaped, and fresh plazas were created. Students still have visual surprises awaiting them. The social science building was constructed in 1962 around the 1934 carillon tower, creating a new spatial event between the two. Another example is the old muddy lower campus used for roughhousing and bonfires in the 1940s. It is now a popular gathering place with a well-proportioned paved plaza, benches, trees, a clock tower, and a red granite fountain.

Harry Weese's outsized 1966 humanities building (mentioned in Chapter 2) at the base of Bascomb Hill is a study in space manipulation. Made of concrete and stone, it is a mixture of balconies and tunnels, solid and void with vertical and horizontal movement. Much of this serves to dilute the impact of the building's large mass, and this tension makes it one of the campus masterpieces.

Appendix:
The Top Fifty
Campuses

	Urban Space	Archit. Quality	Land-scape	Overall Appeal	Total
1. Stanford	5	5	4	5	19
2. Princeton	5	5	4	5	19
3. Wellesley	5	5	4	5	19
4. Colorado	5	4	5	5	19
5. Indiana at Bloomington	5	4	5	5	19
6. Evergreen	5	5	4	5	19
7. Columbia	5	4	5	5	19
8. Mount Holyoke	5	5	4	5	19
9. RIT	5	5	4	5	19
10. SUNY Albany	5	5	4	5	19
11. LSU	5	4	5	5	19
12. Kansas, Lawrence	5	5	4	5	19
13. Wisconsin-Madison	5	4	5	5	19
Air Force Academy	5	4	5	4	18
U. Cal. Porter Col.	5	5	4	4	18
U. Cal. San Diego	5	4	5	4	18
Chapel Hill	5	4	4	5	18
University of Chicago	4	5	5	4	18
Duke University	5	5	4	4	18
Univ. of Illinois, Chicago	5	5	4	4	18
Univ. of Illinois, Urbana	5	5	4	4	18
Iowa State, Ames	5	5	4	4	18
Johns Hopkins	5	4	4	5	18
Michigan State	5	3	5	5	18
Univ. of Pennsylvania	5	4	5	4	18
Smith	4	4	5	5	18

	Urban Space	Archit. Quality	Land-scape	Overall Appeal	Total
Univ. of South Carolina	4	5	5	4	18
Swarthmore	5	5	4	4	18
Sweet Briar	5	4	5	4	18
Vassar	5	4	5	4	18
University of Virginia	4	5	5	4	18
Univ. of Washington, Seattle	5	4	4	5	18
University of West Florida	4	4	5	5	18
Arizona State	4	4	4	5	17
U. Cal. Berkeley	5	4	4	4	17
U. Cal. Los Angeles	5	3	5	4	17
U. Cal. Santa Cruz, Stevenson	4	5	4	4	17
Connecticut College	5	4	4	4	17
Emory University	4	5	4	4	17
Grinnell	4	5	4	4	17
Harvard	4	4	4	5	17
Kenyon College	4	5	4	4	17
U. Mass. Boston	4	5	4	4	17
Oberlin	4	5	4	4	17
Southeastern Mass.	5	5	3	4	17
SUNY Purchase	4	5	4	4	17
Union	5	4	4	4	17
Wake Forest, Winston-Salem	5	4	4	4	17
Washington University	4	5	4	4	17
William and Mary	4	4	5	4	17

Bibliography

Alberti, Leon Battista. *The Ten Books of Architecture*. Reprint of 1755 Leoni Edition. New York: Dover Publications, 1986.

Allen, Peter C. "Stanford University: An Academic 'Inner City.'" *Historic Preservation*. (April–June 1978): 30-36.

Architectural Forum, Issues on College Architecture. June 1926 and June 1931.

Atwood, Wallace. *The First Fifty Years*. Worcester, MA: Clark University, 1937.

Bartholomew, Karen. "The Design of a University." *Stanford Observer and Campus Report* (1987): 1-12.

Biemiller, Lawrence. "A President's Patience Yields a Masterpiece." *Chronicle of Higher Education* (December 10, 1986): 26-27.

_____. "California Campuses in the 80's: Playfulness and Human Scale." *Chronicle of Higher Education* (June 8, 1988): B5-B7.

Blake, Peter. *Mies van der Rohe, Architecture and Structure*. Baltimore: Penguin Books, 1964.

Blodgett, Geoffrey. *Oberlin Architecture*. Oberlin, OH: Oberlin College, 1985.

Bross, Tom. "Small Towns, Big Art." *Travel-Holiday* (January 1987): 29-30.

Brown, Albert Bush. "Image of a University—A Study of Architecture as an Expression of Education between 1800 and 1900." Ph.D. dissertation, Princeton University, 1958.

Bruckner, D.J.R., and Irene Macauley, eds. *Dreams in Stone*. Chicago: University of Chicago, 1976.

Bryan, John Morrill. *An Architectural History of the South Carolina College*. Columbia, SC: University of South Carolina Press, 1976.

Busch, Akiko. "New Notes in a Gothic Theme." *Food Management* (September 1988): 189-92.

Camper, John. "In Academic Circles, UIC Is Big League Player." Chicago Tribune (August 30, 1976): 1, 16.

"Campus Architecture." *Architectural Record* (January 1975): 123-44.

Campus Buildings That Work. Philadelphia: North American Publishing, 1972.

Cheek, Lawrence W. "A Style of Power and Grace." *Historic Preservation* (September/October 1989): 12-15.

Coles, William A., and Henry Hope Reed. *Architecture in America.* New York: Appleton-Century-Crofts, 1961.

Constancy and Change. A Self-study Report by the Evergreen State College of the Northwest Association of Schools and Colleges, 1989.

Cram, Ralph Adams. "Princeton Architecture." *American Architect* (July 21, 1909): 21-30.

_____. *The Gothic Quest.* New York: Doubleday & Page, 1918.

Curti, M., and V. Carstensen. *The University of Wisconsin, A History.* Madison: University of Wisconsin Press, 1949.

Curtis, William J. R. "Contemporary Transformations of Modern Architecture." *Architectural Record* (June 1989): 108-17.

Day, H. Summerfield. *The Iowa State University Campus and Its Buildings, 1859-1979.* Ames: Iowa State University Press, 1980.

Dixon, John Morris. "Respect for a Robust Environment." *Architectural Forum* (October 1966): 54-62.

Dober, Richard P. *Campus Planning.* New York: Reinhold, 1963.

Evergreen State College 1981 Master Plan. Unpublished.

Farber, Joseph C., and Henry Hope Reed. *Palladio's Architecture and Its Influence.* New York: Dover Publications, 1980.

"Fine Arts Building." *Arkansas Alumnus* (April 1949): 6.

Fitch, James M. "Wellesley's Alternative to Collegiate Gothic." *Architectural Forum* (July 1959): 88-95.

Fox, Stephen. *The General Plan of the William M. Rice Institute and Its Architectural Development.* Monograph 29 in the Architecture at Rice Series, School of Architecture, Rice University, 1980.

Fricker, Jonathan. "Louisiana State University: An Historic Campus Preserved." Preservation in Print (August 1989): 7-9.

Gardner, Helen. *Art through the Ages.* New York: Harcourt Brace, 1926.

Girouard, Mark. *Cities and People.* New Haven, CT: Yale University Press, 1985.

Githens, Alfred Martin. "Recent American Group Plan. Part III—Colleges and Universities." *Brickbuilder* (December 1912): 313.

Goldberger, Paul. "Yale's Architecture." *New York Times,* June 13, 1982, pp. 20-22.

Grimes, Susan, ed. *Brown University: A Microcosm of American Architecture.* Providence, RI: Providence Preservation Society, 1981.

Guinness, Desmond, and Julius Trousdale Sadler, Jr. *Mr. Jefferson, Architect.* New York: Viking, 1973.

Hamlin, Talbot. *Architecture through the Ages.* New York: G. P. Putnam's Sons, 1940.

_____. *Greek Revival Architecture in America.* New York: Oxford University Press, 1944.

Henderson, Archibald. *The Campus of the First State University.* Chapel Hill, NC: University of North Carolina Press, 1949.

Historical Handbook of Smith College. 1932.

"Infill to the Nth." *Architectural Record* (March 1987): 106-11.

Johnston, Norman J. "The Olmsted Brothers and the Alaska–Yukon Pacific Exposition." *Pacific Northwest Quarterly* (April 1984): 50-61.

Jones, John Paul. *The History of the Development of the Present Campus for the University of Washington.* Unpublished manuscript of 36 pages. 1940.

Kaplan, Sam Hall. "Diversity the Key to UC Irvine's Architecture." *Los Angeles Times* (June 13, 1987): 1, 8.

Kaufmann, Edgar, and Frank Lloyd Wright. *An American Architecture.* New York: Horizon Press, 1955.

Kaufmann, Emil. *Architecture in the Age of Reason.* New York: Dover Publications, 1955.

Kay, Jane Holtz. "Architecture." *Nation* (January 1, 1990): 27-28.

Kerber, Stephen. "William Edwards and the Historic University of Florida Campus." *Florida Historical Quarterly* (January 1979): 327-36.

Kimball, Roger. "Business as More than Usual." *Architectural Record* (April 1986): 120-21.

Klauder, Charles Z., and Herbert C. Wise. *College Architecture in America.* New York: Scribner, 1929.

Lane, Wheaton J., ed. *Pictorial History of Princeton.* Princeton, NJ: Princeton University Press, 1947.

Larson, Jens F., and Archie M. Palmer. *Architectural Planning of the American College.* New York: McGraw-Hill, 1933.

Lewis, Julius. "Henry Ives Cobb: The Grand Design." University of Chicago Magazine (Spring 1977): 6-15.

Maass, Jon. *The Gingerbread Age.* New York: Bramhall House, 1957.

McDonald, Bill. "USC Has Come a Long Way." Columbia, SC, *Impact* (December 5, 1976): B1.

Meiklejohn, Alexander. The Experimental College. New York: Harper and Brothers, 1932.

Morgan, Kitty. "Building a Reputation." *Orange County Register* (January 8, 1989): 2-5.

Mumford, Lewis. *The Brown Decades, A Study of the Arts of America 1865-1895.* New York: Dover Publications, 1931.

Nossaman, Allen. "Architectural History." *Colorado Daily* (February 23, 1961): 5.

Olmsted Brothers. *A Landscape Plan for the University of Florida. 1927.* Office of Planning & Analysis. University of Florida at Gainesville, 1974.

Orr, Gordon D., Jr., and Dorothy E. Steele. "Warren Powers and Paul Philippe Cret: Their Plans for the University of Wisconsin." *Wisconsin Academy Review* (March 1978): 11-16.

Osborne, Michelle. "The Making of the Early Bryn Mawr Campus," part 1. *Bryn Mawr Now* 2, no. 2 (November 1974).

Palladio, Andrea. *The Four Books of Architecture.* Reprint of 1738 Isaac Ware edition. New York: Dover Publications, 1956.

Parsons, Kermit C. *The Cornell Campus, A History of Its Planning and Development.* Ithaca, NY: Cornell University Press, 1968.

Partridge, Loren W. *John Galen Howard and the Berkeley Campus—Beaux Arts and the Athens of the West.* Berkeley: University of California Press, 1978.

Pavanti, Francesco. "The Design of Columbia in the 1890's—McKim and His Client." *JSAA* (May 1977): 69-84.

Pearson, Clifford A. "School Ways." *Architectural Record* (October 1989): 110-14.

Pei, I. M., & Partners. *Planning for Columbia University.* An Interim Report, 1968.

Pevsner, Nikolaus. *Pioneers of Modern Design.* New York: Museum of Modern Art, 1979.

Pierson, William H. *American Buildings and Their Architects.* Garden City, NY: Doubleday and Company, 1970.

Powell, William S. "The First State University." In *A Pictorial History of the University of North Carolina.* Chapel Hill, NC: University of North Carolina Press, 1972.

Price, Max. "Architect Changed Regents' Minds." *Denver Post,* January 16, 1983.

Pugh, Clifford. "75 Going on 100." *Houston Post Magazine,* October 18, 1987.

Reed, Henry Hope, and Edmund V. Gillon, Jr. *Beaux Arts Architecture in New York.* New York: Dover Publications, 1988.

Regnery, Dorothy. *An Enduring Heritage.* Stanford, CA: Stanford University Press, 1975.

Schlereth, Thomas J. "Schools of Architecture." *Preservation News* (September 1985): 15.

Schulze, Franz. "On Campus Architecture." *Portfolio* (August/September 1979): 34-39.

Schumann, Marguerite E. *Stones, Bricks, and Faces.* Durham, NC: Duke University Press, 1976.

Schumer, Fran R. "Amherst's Abundance of Hallowed Halls." *New York Times,* April 17, 1983, pp. 20-21.

Schuyler, Montgomery. "Architecture of American Campuses." *Architectural Record* (December 1909): 393-416.

————. "Architecture of American Campuses." *Architectural Record* (May 1912): 513-37.

Serlio, Sebastion. *The Five Books of Architecture.* Reprint of the English Edition of 1611. New York: Dover Publications, 1982.

Smith, G. E. Kidder. *The Architecture of the United States,* Volumes 1-3. New York: Anchor Books, 1981.

"Something New in College Campuses." *U.S. News and World Report,* (September 4, 1967): 54-56.

Telfer, D. Dean. "The Evolution of a Modern Urban Campus." *Columbia Today* (Fall 1977): 4-11.

Thomas, George. "The Architecture of the Bryn Mawr Campus." *Bryn Mawr Now* 5, no. 3 (February 1978): 8-10.

Tishler, William H. *American Landscape Architecture.* Washington, DC: Preservation Press, 1989.

Turner, Paul Venable. *The Founders and the Architects: The Design of Stanford University,* prepared for publication by the university art department. Stanford, CA: Stanford University Press, 1976.

————. *Campus.* Cambridge, MA: MIT Press, 1984.

"University of Arkansas Fine Arts Center." *Arkansas Engineer* 30 (November 1950): 6, 7, 22, 28.

Vitruvius Pollio, Marcus. *The Ten Books of Architecture.* Translated by Morris Hicky Morgan. New York: Dover Publications, 1960.

Walker, C. Howard. "The Inspirational Value of College Architecture." *Architectural Forum* (June 1926): 345-48.

Weller, Allen S. *100 Years of Campus Architecture at the University of Illinois.* Champaign, IL: University of Illinois Press, 1968.

Whiffen, Marcus. *American Architecture since 1780.* Cambridge, MA: MIT Press, 1969.

Index

Abele, Julian, and Duke University, 95, 96
Abramovitz, Max, and University of Illinois, 45
Air Force Academy, 36, 61, 63
Alabama, University of, 10
Alaska, University of, 40, 119
Albers, Joseph, and RIT, 142
Alberti, Leone Battista, 31, 75
Allen, Francis, and Vassar, 14
Allen, Terry, and U. Cal. San Diego, 67
Allison and Allison, and UCLA, 108
American Institute of Architects, 92
Amherst, 4, 15, 20, 76, 80, 117
Anderson, Lawrence B., and RIT, 142
Antioch College, 23, 36, 102, 104, 136
Architects Collaborative, and SUNY Purchase, 73
Arizona State University, 42, 45
Arkansas, University of, 42
Art Center College of Design, 63
Austin, Douglas, and U. Cal. San Diego, 29

Babbidge, Homer, and University of Connecticut, 116
Barnes, Edward Larrabee, 4; and SUNY Purchase, 73
Bates College, 56
Bauhaus: and Air Force Academy, 63; and Mies van der Rohe, 70
Beaux Arts, 36, 50, 82, 89, 126; and Air Force Academy, 63; and Berkeley, 16, 110; and Brown, 83; and Columbia, 24, 138, 139; and Duke, 38, 96; and Minnesota, 44
Bebb and Gould; and University of Washington, 112
Belluschi, Pietro, and U. Mass. Boston, 52
Benard, Emile, and U. Cal. Berkeley, 110, 138
Berea College, 4
Bergman, Mathes, and LSU, 70
Bertoia, Harry, and RIT, 142
Birkerts, Gunnar: and University of Iowa, 20; and SUNY Purchase, 73
Boston College, 15

Boston University, 52
Bosworth, William Welles, and MIT,
 10
Boullée, Etienne-Louis, and Columbia,
 138
Brandeis University, 4, 38, 118
Brewer, Marcel: and U. Mass.
 Amherst, 80; and Vassar, 85
Brick Institute of America, and
 Dartmouth, 41
Brooks, Borg, and Skiles, and Iowa
 State, 120
Brown, Nicholas, and Brown Uni-
 versity, 83-85
Brown University, 4, 42, 83-85
Bryn Mawr College, 17, 28, 36,
 86, 88
Bulfinch, Charles, and Harvard, 22, 81
Burgee, John, and SUNY Purchase, 73
Burgess, William, and Trinity, 54, 86
Burley, Robert, and Colby-Sawyer, 15

California, University of: Berkeley, 10,
 11, 16, 109, 110; Irvine, 64, 65, 102;
 Los Angeles, 49, 108; San Diego 29,
 34, 41, 65, 67, 120; Santa Cruz,
 Kresge, 33-34, 63-64; Santa Cruz,
 Porter, 109; Santa Cruz, Stevenson,
 110
California Institute of Technology, 112
Catalano, Edward, and MIT, 31
Caudill Rowlett Scott, 4; and Duke,
 29; and Governors State University,
 63
Centerbrook Architects, and Dart-
 mouth, 40, 49-52
Chicago, University of, 38, 50-52
Church, Thomas, and U. Cal., Santa
 Cruz, 4, 109
Ciampi, Mario, and Berkeley, 119
"city beautiful" movement, 10; and
 Stanford, 126
Clark University, 17
Clemson University, 96
Coast Guard Academy, 116
Cobb, Henry Ives, and University
 of Chicago, 50
Colby-Sawyer College, 15

Colorado, University of, 19, 21, 33,
 43, 102, 131-34
Columbian Exposition, 10, 50, 89, 126,
 139
Columbia University, 10, 17, 24, 50,
 119, 138-40
Conant, James, and Harvard, 81
Connecticut, University of, 116
Connecticut College, 34
Coolidge, Charles, 4; and Stanford,
 108, 122, 124, 126
Coolidge, Shepley, Bulfinch, and
 Abbot, and Harvard, 33
Cope, Walter, 4; and Washington
 University, 107
Cope and Stewardson: and Bryn
 Mawr, 36; and Penn, 54; and
 Princeton, 86
Cornell University, 41, 116-17
Cram, Ralph Adams, 4; and Princeton,
 38; and Rice, 23-24
Cram and Ferguson, and Sweet Briar,
 92
Cret, Philippe, and Wisconsin, 154
Crites and McConnell, and Iowa State,
 120

Dartmouth College, 40-41, 78
Davis, Alexander Jackson, and North
 Carolina, 95
Desmond, John, and LSU, 31
Desmond and Lord, and Framingham
 State College, 17
Downing, Andrew Jackson, and
 Wellesley, 130
Drexler, Arthur, and Oberlin, 16
Duke, James, and Duke University, 36
Duke University, 6, 29, 34, 36-38,
 95, 96
Durant, Henry Fowle, and Wellesley,
 129
Durham Anderson Freed, and
 Evergreen State College, 137

Earlham College, 3
Ecole des Beaux Arts, 10
Eggers and Higgins: and Indiana, 135,
 and North Carolina, 95

Eliot, Charles, and Harvard, 81
Elwood, Craig, and Art Center College of Design, 63
Emory University, 31, 97, 121
Evergreen State College, 21, 57, 67, 71, 135-38

Florida, University of, 3, 97
Florida Southern College, 73-74
Florida State University, 42
Framingham State College, 17
Franklin, Benjamin, and University of Pennsylvania, 54
French, Daniel Chester, and Columbia, 139
Fuller, Robert, and Oberlin, 22

Galanyk, Edward, and Smith, 41
Gaulladet College, 23, 60
Geddes Brecher Qualls Cunningham, and Stockton State College, 63
Gehry, Frank, and U. Cal., Irvine, 64
Georgetown University, 23, 57, 133
Georgia, University of, 43, 120
Georgia Institute of Technology, 97
Gibbs, James, and Harvard, 38
Gilbert, Cass, 4; and Oberlin, 20, 22 102, 104
Gluck, Peter, and Columbia, 139
Goodhue, Bertram: and Chicago, 38; and Rice, 23
Goucher College, 11, 117-18
Governors State University, 63
Grinnell College, 17, 104, 107
Griswold, A. Whitney, and Yale, 42
Gropius, Walter, and Harvard, 81

Hall and Morris, and Emory, 97
Halprin, Lawrence, and Air Force Academy, 63
Hampshire College, 4, 80, 136
Harper, Robert, and Williams College, 77
Harrison and Abramovitz, and Brandeis, 38-39
Hartford, University of, 34
Hartford Seminary, 63

Harvard University, 3, 4, 10, 17, 22, 33, 38, 42, 68, 78, 80-83, 119
Haverford College, 87-88
Hawaii, University of, 119
Healey, Father Patrick, and Georgetown, 57
Heinberg and Borcato, and LSU, 150
Henslee, Thompson, and Cox, and LSU, 149
Holy Cross, 57
Hornbostel, Henry, and Emory, 31, 97
Howard, John Galen, and Berkeley, 110
Hunt, Brian, and Smith, 41
Hunt, Richard Morris, and Harvard, 81
Hutton, Addison, and Bryn Mawr, 86

Illinois, University of, 17, 29, 45, 103-104, 120; at Chicago, 4, 21, 48, 67-68
Illinois Institute of Technology, 10, 20, 68, 70-71, 144
Indiana University, 11, 41, 101, 134-35
Innocenti and Webel, and South Carolina, 15
Iowa, University of, 20, 22, 45, 101
Iowa State University, 22, 29, 44-45, 101, 120
Ivey and Crook, and Emory, 97

Johns Hopkins University, 11, 89-90, 119
Johnson, Philip, and SUNY Purchase, 73
Jones, A. Quincy, and U. Cal. San Diego, 41
Jones, John Paul, and Washington, 112
Justin-Pope Associates, and Hampshire, 80

Kahn, Louis: and Yale, 42; and Bryn Mawr, 87
Kansas, University of, 40, 150-51
Kemp, Bunch and Jackson, and University of Florida, 97
Kentucky, University of, 118
Kenyon College, 107
Kessler, George, and University of Kansas, 150

Klauder, Charles, 4; and Colorado, 21, 133-34; and Princeton, 33
Kling, Vincent, and Swarthmore, 87
Kouzmanoff, Alexander, and Columbia, 140

La Farge, John, and Vassar, 85
Laird, Warren, and Wisconsin, 154
Larson, Jens Frederick, and Dartmouth, 78
Latrobe, Benjamin, 3; and Princeton, 22; and Virginia, 91
Laurent, Ralph, and Indiana University, 135
LeBlanc and Dean, and LSU, 150
Le Corbusier, and Harvard, 82
Link, Theodore, and LSU, 148
Long, Huey, and LSU, 149
Lord and Hewlett, and Smith, 80
Louisiana State University, 20, 31-32, 70, 146-50
Lyles, Bissett, Carlisle, and Wolff, and South Carolina 15
Lyon, Mary, and Mount Holyoke, 140, 142

MacNeil, Hermon, and Clark University, 17
Maier, Richard, and Hartford Seminary, 63
Maine, University of, 118
Maryland, University of, 10, 38
Massachusetts, University of: Amherst, 20, 34, 64, 80; Boston, 15, 52, 54, 64, 142
Maybeck, Bernard: and Berkeley, 132; and Mills College, 132
McCoy and Hutchinson, and Missouri, 56
McGill University, 44
McKim, Charles: and Columbia, 138-39; and Harvard, 42, 82
McKim, Mead and White: and Amherst, 117; and Columbia, 50, 138; and Illinois, 103; and Vermont, 31
McPherson, Mary, and Bryn Mawr, 28
Meiklejohn, Alexander, and Evergreen, 136-37

Mercer, Max, and Antioch, 102
Metcalf and Associates, and Georgetown, 57
Michigan, University of, 120, 151
Michigan State University, 3, 21, 42, 100, 102, 117
Middleton, Troy, and LSU, 149
Mies van der Rohe, Ludwig, 10; and IIT, 20, 70-71
Mills, Robert, 3; and South Carolina, 93
Mills College, 3, 21-22, 112
Minnesota, University of, 44
Mississippi, University of, 120
Missouri, University of, 20, 56-57, 102, 117
MIT, 10, 31
Mitchell-Giurgola, and Swarthmore, 87
Moore, Charles: and U. Cal. Irvine, 64; and U. Cal. Santa Cruz, 63, 110; and Williams, 77
Moore and Hutchins, and Goucher, 118
Moore and May, and Florida, 97
Morgan, Julia; and Mills, 112
Morgan, William, and Florida, 97
Morse, Alpheus, and Brown, 83
Mosher, Robert, and U. Cal. San Diego, 66
Moss, Eric, and U. Cal. Irvine, 64
Mount Holyoke, 4, 45, 78, 80, 82, 140-42
Muchow, W. C., and Colorado, 75, 119
Murphy, Franklin, and UCLA, 150
museums, 40-42

Naval Academy, United States, 10, 36
Netsch, Walter, 4; and Air Force Academy, 61; and IIT, 70
New Hampshire, University of, 78
New York, State University of: at Albany, 144-46; at Buffalo, 42, 71; at Purchase, 71-72
Norlin, George, and Colorado, 133
North Carolina, University of: at Asheville, 3; at Chapel Hill, 43, 93, 95-96
Northeastern University, 52
Notman, John, and Princeton, 22

Notre Dame, University of, 4

Oberlin College, 16, 20, 22, 102, 104
Ogg, William R., and Indiana, 135
Ohio State University, 120
Oliver, Adam, and Michigan State
 University, 100
Olmsted, Frederick Law, 34; and Bryn
 Mawr, 86; and Cornell, 41; and
 Florida, 97; and Gallaudet, 60; and
 MSU, 100; and Smith, 78; and
 Stanford, 122, 124, 126; and U. Cal.
 Berkeley, 110; and U. Mass.
 Amherst, 80
Olmsteds: and LSU, 147-48; and
 Oberlin, 104; and Washington, 112;
 and Wellesley, 130

Parker, Thomas, and Rice, and Johns
 Hopkins, 89
Patton, Norman, and Oberlin, 104
Pei, I. M.: and Columbia, 139; and
 Cornell, 117; and Indiana, 41, 135
Pennsylvania, University of, 54, 86
Pennsylvania State University, 19
Pereira, William, 4; and U. Cal.
 Irvine, 64; and U. Cal. San Diego,
 65
Petersen, Christian, and Iowa State,
 101
Pittsburgh, University of, 11
Platt, Charles, and Illinois, 103
Portland State University, 50
Portman, John, and Emory, 31, 97
Potter, Edward, and Union, 60
Potter, William, and Princeton, 22,
 29, 45, 128
Princeton University, 4, 8, 19, 29, 33,
 38, 86, 126, 128-29

Quinton-Budlong, and Evergreen, 137

Rague, John, and Wisconsin, 154
Ramée, Joseph Jacques, and Union, 59
Ratcliff, Walter, and Mills College, 112
Reau, Louis, and Union College, 60
Reed College, 76, 104, 136
Renwick, James, 3-4; and Vassar, 22,
 85

Rhode Island School of Design, 4
Rice University, 23-24, 88
Richardson, H. H., 83; and Harvard,
 82; and Stanford, 119-20; and
 Vermont, 31
Richardson, Severns, and Scheeler, and
 Illinois, 103
Ritz, Richard, and Reed College, 76
Rivera, José de, and RIT, 144
Robert and Company, and Emory, 97
Roche, Kevin: and U. Mass. Amherst,
 21, 80; and Wesleyan, 41
Rochester Institute of Technology, 36,
 56, 71, 73, 142-44
Rockefeller, Nelson A., and SUNY,
 118
Rodin, Auguste, and Stanford, 124
Rogers, Eliza Newkirk, and Wellesley,
 129
Rogers, James Gamble, and Yale, 33,
 56
Rudolph, Paul: and Emory, 97; and
 SMU, 71; and SUNY Purchase, 73;
 and Wellesley, 130
Ruskin, John, 6

Saarinen, Eero: and Chicago, 50; and
 MIT, 31; and Vassar, 85
St. Regis College, 4
Salem College, 93
Sasaki, Dawson, DeMay: and Colo-
 rado, 119; and U. Mass. Boston, 52
Schooley, Caldwell Associates, and
 Antioch, 36
Shepley, Bulfinch, Richardson and
 Abbott, and Vassar, 85
Shipper, William, and Princeton, 32
Siemens and Root, and Kansas, 151
Skidmore, Owings and Merrill: and
 Air Force Academy, 61, 67; and Art
 Center College of Design, 63; and
 IIT, 70; and UIC, 67; and Yale, 17
Skidmore College, 76
Smith, Robert, and Princeton, 22
Smith College, 34, 41, 78-80
South, University of the, 116
South Carolina, University of, 15, 42,
 76, 93, 95-96, 121
South Carolina College, 33

South Dakota, University of, 19
Southeastern Massachusetts University,
 67, 71
Southern California, University of, 49
Southern Methodist University, 120
Stanton, John, and Kansas, 151
Stern, William, and U. Cal. Irvine, 65
Stevens and Wilkinson, and Emory, 97
Stewardson, John, and Bryn Mawr, 36
Stockton State College, 63
Stone, Edward, 122; and Arkansas, 42;
 and South Carolina, 15; and SUNY
 Albany, 144-45
Stubbins, Hugh, 4; and Princeton, 33;
 and U. Cal. Santa Cruz, 109; and U.
 Mass. Amherst, 34
Swarthmore College, 17, 19, 22, 30,
 45, 87
Sweet Briar College, 92

Taylor, Joseph, and Bryn Mawr, 86
Tefft, Thomas, and Williams, 77
Tennessee, University of, 116
Texas, University of, 4, 29
Tiffany, Louis Comfort, and Vassar, 85
Trinity College, 54, 86
Trumbauer, Horace, and Duke, 38,
 95-96
Tsutakawa, George, and UCLA, 109
Tufts University, 17
Turner, Alan, and U. Cal. San Diego,
 120

Union College, 59-60

Van Brunt, Henry, and Kansas, 150-51
Vassar College, 14, 22, 34, 38, 85
Vaux, Calvert: and Bryn Mawr, 86;
 and Vassar, 85
Venturi, Robert: and Oberlin, 102-3;
 and U. Cal. Irvine, 64

Venturi and Rauch, and SUNY
 Purchase, 73
Vermont, University of, 31, 36
Virginia, University of, 3, 39, 61,
 76, 90-92, 121

Wake Forest University, 92-93
Warnecke, John Carl, 6; and Berkeley,
 16, 102; and Georgetown, 57; and
 Santa Cruz, 110
Warner, Burns, Toan and Lundy, and
 Oberlin, 16, 104
Washington, University of, 49, 57,
 112-13
Washington University, 11, 17, 20, 22,
 38, 74, 104, 106-7
Weese, Harry, 4; and Colorado, 21,
 134; and U. Mass. Boston, 52; and
 Williams, 76; and Wisconsin, 41, 154
Wellesley, 10, 20, 83, 85, 129-31
Wesleyan University, 6, 41
West Florida, University of, 98, 100
West Point, U.S. Military Academy,
 11, 116
Wheaton College, 4
White, Stanford, 4; and Amherst,
 117; and Illinois, 20
William and Mary, College of, 8, 90
Williams College, 30, 76-78, 117
Wisconsin, University of, 20, 22, 29,
 34, 153-54
Wogan and Bernard, and LSU, 148
Wright, Frank Lloyd: and Arizona
 State, 45; and Chicago, 52; and
 Florida Southern, 73-74; and
 Wisconsin, 154
Wyoming, University of, 3

Yale University, 10, 18-19, 33, 42, 54,
 56, 76, 88

About the Author

THOMAS A. GAINES has lectured and written extensively on architectural and landscape design since retiring as head of a design and construction company. He is a contributor to such periodicals as *Historic Preservation Magazine*, the *Journal of Environmental Design*, the *New York Times*, and *The Washington Post*.